"To see more is to become more."
—Teilhard de Chardin

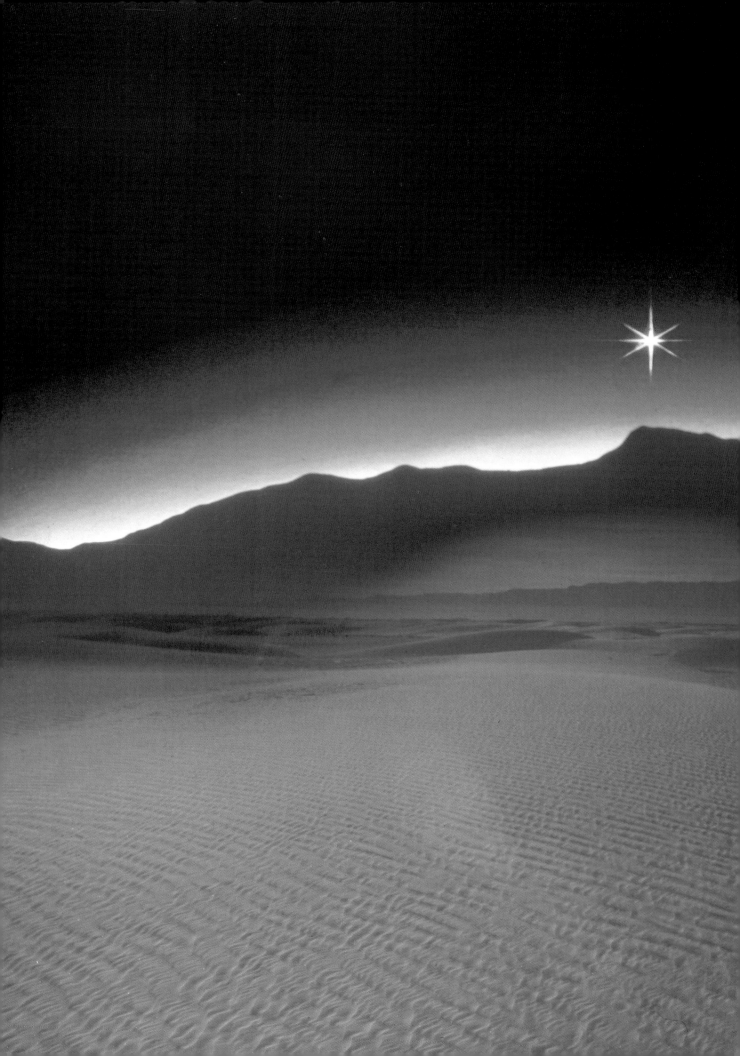

FOCUS ON
SPECIAL EFFECTS

Don and Marie Carroll

AMPHOTO BOOKS
An imprint of Watson-Guptill Publications
1515 Broadway, New York, N.Y. 10036

Previous page
The desert, Death Valley on the California-Nevada border, was
photographed with a 20mm lens shortly after dawn. The
mountainous, curved horizon was photographed with a 50mm
lens, using black paper mountains lit from behind with strobe in
the studio. The star is a piece of metallic glitter on a black velvet
background, photographed with a 50mm lens and six-star filter,
and lit with tungsten light. The three images were montaged
together in the darkroom, and the dusky blue evening color
created in the dichroic enlarger.

Published in New York, New York by Amphoto Books:
American Photographic Book Publishing, an imprint of
Watson-Guptill Publications, a division of
Billboard Publications, Inc., 1515 Broadway,
New York, N.Y. 10036

Library of Congress Cataloging in Publication Data
Carroll, Don.
 Focus on special effects.
 Includes index.
 1. Photography—Special effects. I. Carroll, Marie.
II. Title.
TR148.C37 1982 778.8 82–8839
ISBN 0-8174-3885-8 AACR2

Designed and edited by October Press, Inc.
Edited for Amphoto by Michael O'Connor and Marisa Bulzone
Graphic Production by Hector Campbell

Manufactured in Japan

Technical note:
As this book was in preparation, the
method of designating film speeds was
in transition from the familiar ASA
system to the new ISO system. The
ISO rating system combines the old
ASA and DIN systems. For example,
a film rated at ASA 400 (27 DIN),
will be expressed ISO 400/27°, or
simply ISO 400. In this book,
the familiar ASA rating system is used.

First Printing, 1982

 2 3 4 5 6 7 8 9 / 87 86 85 84 83

ACKNOWLEDGMENTS

We are exceedingly grateful for all the help we have received on this book, and realize how difficult it must be to make an Academy Award speech! We would especially like to thank:

Vera Webster, for her encouragement, support, and guidance. She conceived the workshop that became *Focus 2000*, and without her, we would not have written the manual that became the basis for this book.

Donna Loughran, field director for *Focus 2000*, who worked tirelessly to make the workshops a success.

Townsend Keifer, whose publicity ideas we depended upon.

Donna Vicari, whose wonderful wit and advice to stand in the sun kept us from insanity.

Elan Long, who worked steadfastly in the office.

Dr. Andrew J. Cannistraci, for being such a cooperative and helpful dentist-subject.

Ira Shapiro, for producing *American Showcase*, which kept the jobs coming in when Don was too busy working on the book to think of business.

Larry Fried and the staff at The Image Bank who also helped business.

Heinz Sirkin for his ideas and suggestions on the cover design.

Beverly Forrest, a beautiful woman who is also an attorney, and who was the model for the cover.

Fred Schmidt of *Photomethods* magazine, who through his interest in Don's work was instrumental in finding us a publisher.

Tino Poori, who believed in us and took the book for publication.

Michael O'Connor, our editor at Amphoto, who allowed us the creative freedom to make the book what we envisioned.

Mark Iocolano, of October Press, whose suggestions and editing improved the text.

Diane Lyon of October Press, whose layout and design for the book made it beautiful, and whose patience and devotion are much appreciated.

All those front projection manufacturers who lent equipment for testing, including Nord Photo Engineering, Tekno of N.Y., Dr. Henry Oles of Environmental Projection Systems, and Ed Haughawout of H&H Camera Products.

Paul Yafcak of Fabucolor who helped prepare prints.

Fred Pflantzer of AZO Color Lab who developed the cover prints.

Bernie Danas of Spiratone who was unfailingly encouraging, informative, and helpful in supplying Don with various camera accessories and experimentation.

Duggal Color Projects for their consistent film development.

The late Fred Simmon, of Simmon Omega, a charming gentleman, who was generous in supplying equipment for testing.

All those art directors who ideas sparked Don's imagination, and who contributed to the images in the book.

Joseph Probst, Marie's father, who knew we could do it, even 'way back when.

Suzy and Cash, our two dogs, who took Don for inspirational walks every evening, and who were patient when dinner was late.

CONTENTS

When I carried the roll of New York moons across the country to double expose on our vacation, the sunset in Arizona was one of the views we deemed worth coupling with a moon. Because the mountains were in deep evening silhouette against the setting sun, the lower two-thirds of the transparency remained black. At the time I shot the sunset over the moon, I realized I would double expose or montage these elements with a third element, but at that time did not know what the third element would be. After I returned to New York, I decided some months later to use the sunset as background for a nude I would shoot in the studio. I used a delicate rim light to outline the model's body, simulating the tender fading light of the sun. The background was brown seamless paper, but I shaded the top of the paper so that it would fade to black, providing a self-mask for that area of the montage. Both the moon and sunset and the nude were shot on Kodachrome 25. The montage was made onto Ektachrome duplicating film. It was a very simple montage, each element completely self-masking.

INTRODUCTION

Photography is a method of communicating. Just as with the expression of a verbal idea, there must first be a thought, a concept of what is to be said. Sometimes the thought is unclear at first, or difficult to put into words. A photographic concept may be at first unrefined and vague, and you may not know how to bring it to fruition on film. Sometimes a thought is complex or abstract, and language does not provide the vocabulary to express it completely. If the photographic concept is complex, you must expand your vocabulary of techniques in order to produce the concept on film.

I turned to special effects photography because I could not produce, by the usual photographic means, the images and concepts I wanted to express. Learning special effects techniques was for me a way to express imaginative abstractions on film. The speaker who can convey thought in basic words, simple construction, without the use of jargon or "double talk," best exhibits a true and whole grasp of communication. Although I am aware of and knowledgeable about many photographic techniques, and may use each of them at one time or another, I still always seek the simplest method, the briefest technique that will express my concept.

Admittedly, the simplest method may on occasion still call for the combination of a half dozen or more steps. If you are aware of exactly what each technique contributes to the end result, you can pick and choose your creative tools with confidence. The exercise of technique for its own sake is fruitless. A mental review of techniques that are second nature to you can change the way you approach any creative idea.

When I first decided to become a photographer, I took pictures of whatever and whomever appealed to me. I felt that I had a viewpoint about what I photographed, but the images on film were disappointing. I seemed to have no discernible photographic direction, no particular style. At the time I intended to photograph only fashion and beauty, mainly because I saw it as a perfect way to meet pretty girls. (It worked too. I met Marie when she came to my studio as a model, and we were married two years later!) However, none of my images had the power to evoke the delight and excitement that had seemed to be present in the shooting session. They were flat; they had no life of their own. In short, they failed to communicate.

I began to study the pictures in current fashion magazines. I clipped out those photographs that especially expressed what I felt was the essence of fashion or beauty. I did not try to analyze particularly why any image attracted me, the fact that it did was enough for me to clip it out. When I had collected dozens of loose pages, I spread them randomly across my studio floor and got up on a ladder to view them as a whole. After I had spent several hours hunched over on the top of the ladder, studying the images below, I realized that what all the images seemed to have in common was a glowing use of lighting and a certain way that movement was incorporated into the shots.

When that realization finally dawned on me and I had studied them a while longer to clarify my vision of them as a whole, I thankfully came down from the ladder and began to study the pictures with a magnifying loupe. I concentrated on the reflections in the models' eyes, because they revealed what type of light had been used. In some I could see the sharp reflection of a white umbrella, in others a broad bank light. If there was more than one point of light in the eye, I tried to infer the placement of the lighting sources and decide what type of lights were used. I observed the differences and similarities that various kinds of lighting produced on skin and clothing. In fact, I spent days studying the reflections in eyes.

I lived in Hollywood at the time and luckily there were many aspiring actors and actresses who were eager to have photographs for their portfolios. They were willing to sit patiently while I painstakingly made minute changes in my lighting, intently studied the reflections in their eyes, and observed the effect of the light on their faces. I had no intention of copying the images I had seen in magazines, but I needed to understand the techniques that made those effects possible. Eventually my own style began to emerge, and I was pleased at last with the images I saw on the film.

Just as dancers study the movements of other dancers to refine and add to their own style and ideas, so photographers observe and appreciate the pictures made by others. A beginning dancer may try to imitate the movements of the dance teacher. A beginning photographer can learn much about technique by trying to execute the style and effect of an admired photograph. If you do this, study the image carefully before you shoot. Always try to improve the shot and incorporate the technique into your own work. However, remember that the concept belonged to someone else, so never try to present the image as your own idea. A friend of mine, who is now quite a successful photographer, learned this lesson the hard way. When he was starting, he enhanced his portfolio by trying to duplicate the ads he admired. Unfortunately, he actually included these copies in his portfolio instead of using them only to expand his knowledge. Of course, he eventually showed the portfolio to an art director who had conceptualized one of the original ads, and who told him in no uncertain terms about the ethics involved. It caused my friend a great deal of embarrassment. To copy another photographer's image or overall style exactly is never really worthwhile. When you imitate another's work without adding something of your own, you are at best only a second-class copy of the original. That should never be your goal.

I believe that commercial photographers and artists are some of the most creative and talented people in the world. I have little patience for the faddish photography that passes for "art," because I find it largely uninteresting, and successful only because of public relations and media hype. A good commercial photographer must deliver a creative, technically excellent photograph on demand. This photograph may not even have been his or her own idea at its conceptualization. The commercial photographer must produce an image that will satisfy both client and art director, as well as himself.

I will not take a job for which I feel I am not totally qualified. If I see that my style will not work for the shot, or that my knowledge or equipment is not the type required to produce the result wanted, I prefer to recommend that another photographer do the job. At the same time, I will not accept a job if I cannot

Originally shot as a cover for *Electronics* magazine, this image was later used by *Omni* magazine to accompany an article. I wanted to express the concept of communication between Earth and an electronic satellite, and decided to do so with the symbolic gleams and the bare relay board. The elements of earth and moon were combined with the relay board through multiple exposure.

I photographed the electronic relay board outdoors in bright sunlight, because I wanted a contrasty source of light. I placed the board on black velvet to provide a black background for the multiple exposure. The board stood at an angle with the help of wadded newspaper beneath it. Although I expected to vary the camera angle slightly with each frame of film, the general position of the board would remain the same, so I sketched it on the viewing screen of the camera as a guide for positioning of the earth and moon.

I used a 20mm lens with Hoya spectral burst filter, changing the angle of shooting until sunlight gleamed from the relays to produce the filter effect. I shot 36 exposures, rewound the film and realigned it for multiple exposure, and replaced the relay board with a cutout of the earth that was 8 inches in diameter. I placed a tiny piece of metallic glitter on the very edge of the cutout. After again sketching the position of the element on the camera's viewing screen, I used a 50mm macro lens with the Hoya spectral burst filter for the next set of exposures. The final element, the moon, was exposed from a transparency I had in my stock file of the moon against a black sky, originally photographed with a 300mm lens. The moon was added to the image through the use of a duplicating device. Placement of the moon was simplified because I had the grease pencil sketches of the other elements on the camera's viewing screen.

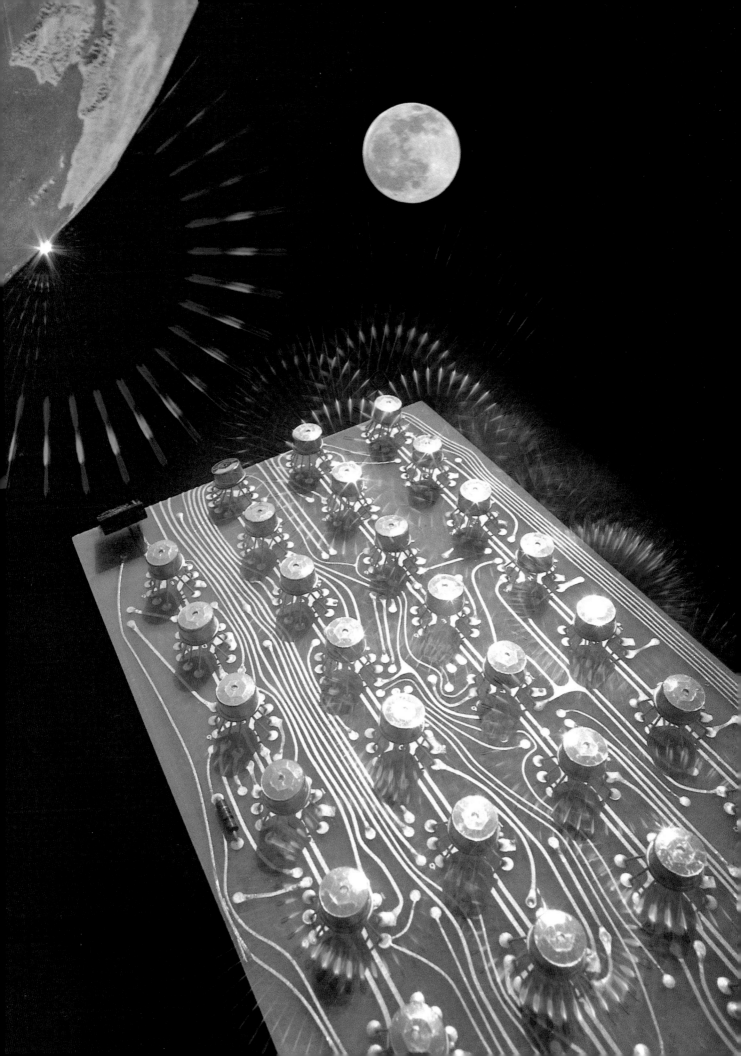

respect the idea, product, or theme. When I have reached an agreement with a client with regard to my fee, my sole intent is to produce the very best photograph possible. Therefore, I want to feel good about the job. For example, since both Marie and I are vegetarians, and because I like animals, I will not photograph meat or furs. There certainly have been times when I have been tempted to photograph various products or to express ideas with which I could not feel comfortable, but I find that I never regret turning a shot down on principle. Something better always seems to come along, and had I done the shot against my better judgment, I know I would not have been able to give it my best effort. I would be unhappy any time I saw it reproduced. When I deliver the final shot to the client, I want to know that I am delivering the very best image I can make. I want it to satisfy me.

This is not to say that I refuse to consider the satisfaction of the client. Far from it. Once the job is accepted, I am committed to listen carefully to the client's wishes about the image. Any photographer who works commercially must do the same, or he will shortly have no clients at all to consider! Occasionally, however, the client is not well versed in photography. Sometimes a client requests that the photographer provide a visual concept to fit a certain theme or product. It is the photographer's obligation to thoroughly discuss all ideas with the client, to clearly explain what can and cannot be done photographically, and to settle with the client on a mutually acceptable visual approach.

It may sound like an absurdly simple assignment, for example, to be asked to shoot a photograph of a friend's cat. If you see the cat as a fat lazy fellow who wallows in cat food and seldom has a kind meow to say, you will inevitably be influenced by your feeling to present the cat in that light. You may then discover that your friend sees the cat as being witty, persnickity, and full of personality. You may be paid for your photograph, but it is doubtful you will be recommended to any other cat owners by your friend, even though the photograph may have been technically superb. People who own companies, and art directors whose jobs may depend on a single campaign's success, are even more touchy about the proper presentation of their product.

Usually the art director or client has a fairly clear idea of how the photograph should look. Generally the photographer will be given a layout drawn to show perspective and scale, demonstrating exactly what the photograph must look like. The layouts I am given most often include some special effect, and it is up to me to say whether the idea can actually be done photographically. If I see technical difficulties, I may suggest certain changes, or add further refinements. I don't hesitate to suggest changes that will make the job more difficult for me to execute, as long as I feel it can be done within the allotted time and budget, and especially if I know the changes will make the image more exciting. Even when working under time pressure, I have found that deadlines can sometimes be extended by a day or two if the extra attention will make the photograph better. I know also that if the image is exciting, people will spend more time looking at it, have more time to absorb the client's sales message, and may be more inclined to buy the client's product. The client will see sales revenues rise, will pass the happy word to the ad agency, which will commend the art director, who in turn will be happy that I was chosen as the photographer on the ad. I will then get more work from that art director and be able to demand a higher fee.

I love to do special effects photography. I would probably be playing with it as a hobby if it were not my career. However,

although the ego gets its pleasure by seeing a well-completed work, the body wants more concrete rewards. I want to get paid well for what I do. I put a great deal of time into each image, and I know better than anyone that I deserve the highest fees I can command. A photographer I know in New York is one of the finest and most creative minds I have ever seen, and an excellent technician besides. However, he refuses to accept a client or an art director's suggestions for changes in his work, and he views payment for his talent as prostitution. As a result, he periodically drops from sight because he cannot make a living with his photography and is unwilling to work at something else. I work well when I do not have to worry about paying bills, and I believe the theory of the starving artist in the garret is picturesque but too uncomfortable to be conducive to freedom of creation. Besides, the reality of commercial photography is that the image that wowed 'em last month is in a magazine that gets tossed in the garbage this month. The exhilaration of seeing your work in print soon passes, and the challenge is only to move on and continue to create. Therefore I like to retain rights to my images so that I can resell them several times over, providing me with money enough to buy more film and wow 'em again!

Wowing 'em is the fun in the creative process. The creative process works partly from intuitive flashes of insight, partly from practice, and partly from just plain work. My ideas are often spurred by one word or phrase from the client or art director. The art director may say, "I need a shot expressing the idea of an expanding intellect." That order, in fact, was the trigger for the photograph that appears on the cover of this book. The key words, "expanding intellect," immediately brought a picture to my mind of expanding bands of color around the model's head. As I thought about the image, I decided to use montage as the process. I also liked the concept of the face seeming to float in space against the black background. A black background is also preferable for self-masking in montage. I shot the image using several different colors for the expanding bands, but blue seemed best to express the cool intellectual vibration. In the process of shooting, I had the idea to make the model's eyes appear to be closed in meditation, but at the same time to be open as if to an inner awareness. Later I decided that I wanted the hands to be exactly the same, so I used one hand and made a mirror image of it for the other. Later, when we decided this was the right image for the cover of this book, I decided to float the camera between the model's hands to express clearly the idea of special effects in photography. The techniques I used expressed the concept and allowed me to communicate with you.

One of the simplest and best ways of communicating is by using symbols. If you can find a clear and concise symbol to express a theme visually, your creative concept will be that much easier to bring to film. Avoid clichéd or overly obvious ideas, but look for a way to express the essence of the thought in a fresh and exciting image. When asked to illustrate an article, I read it carefully, even though it may be on a technical subject about which I have little knowledge or understanding. Almost inevitably there will be some word or phrase that cues a visual image for me. If nothing in particular strikes me, I ask myself what brief phrase would express the essence of the author's message.

Once I have a basic idea, I make several rough sketches of what I want the finished image to look like. This step is extremely helpful, and its value should never be underestimated or overlooked, especially by a photographer beginning to learn special

effects techniques. Don't worry about the quality of the sketch. My drawings are often merely stick figures against the most rudimentary of backgrounds, and sketched on a paper napkin while I take a coffee break. Let your imagination carry you. Never tell yourself that what you want to achieve is photographically impossible; you will be defeated before you begin. Challenge your abilities and improve your knowledge of techniques so that the wilder the idea, the better. If you can sketch it, there should be some way to produce it on film.

When the sketch is complete, even if it is only a series of squiggles meaningless to all but myself, I take time to study it carefully. Refining and clarifying an idea with a pencil eraser is simpler than discovering that the process should be reworked when six steps have already been completed. Try to imagine the sketch in its final form as a photograph. I mentally hang it on the wall, asking myself if it really satisfies and expresses the concept. Because it is always better to refine an image than to confuse it by elaboration, I ask myself what elements, if any, can be removed from the whole while still retaining the symbolic essence and fully expressing the total concept. When I shot the photograph that is on the cover of this book, I also did a version showing the model in a colorful blouse with a background of windswept ridges of desert sand. The image was pretty, but not nearly as clear or powerful as the simpler version.

After the sketch is complete to my satisfaction, I make a list of elements needed to complete the image. As I decide the techniques and processes by which each image will be produced, I can review the list and decide whether I may already have photographs in my stock file that can be used, what additional elements must be shot, and if any set construction or special equipment is necessary. Because some of my images are complex and require a combination of techniques, the list helps me clarify time and cost factors as well.

I like to think of perfection as my goal, although I realize that nothing in life is perfect. If the final image does not meet with my approval, I reshoot. If I have a job deadline to meet, I may work long hours doing tedious, exacting techniques. I therefore take great care to keep a careful account of all pertinent data, so that if and when I must repeat any or all steps, I know exactly how to vary the procedure to bring the image closer to perfection.

Even with all the care I take, retouching is sometimes necessary. I take it as a personal challenge to avoid the necessity for it as much as possible, but am realistic enough to realize that there are times when a retoucher can easily solve a minor problem on the photograph that might take me many more hours of work. The final image is the only truly important consideration, and a photographer cannot let his or her ego stand in the way of producing the best image possible. Perhaps I accept the necessity of retouching so easily because I constantly tamper with what may be considered normal or real. In combining a sunset from Maine with a landscape from Colorado, I know that an equally beautiful sunset has at some time appeared over the landscape anyway, and I am only giving another interpretation to reality.

In interpreting normal reality, I like to keep the image just within the realm of possibility. For example, any double-exposed moon over a landscape is never allowed to become unnaturally huge. We have all witnessed a rising moon, magnified by the Earth's atmosphere and larger than usual. The moon I place over a landscape may be just on the edge of that magnification, but to take it over the edge would defeat the illusion of unusual reality.

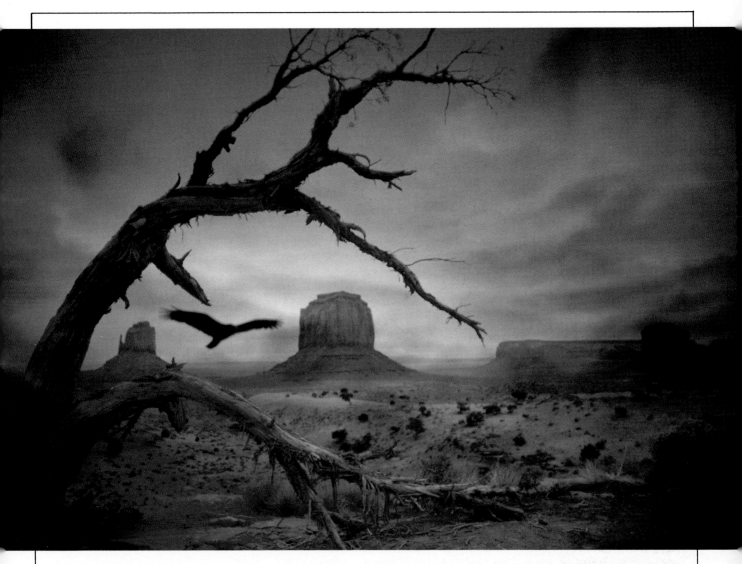

Our trips in the western United States have always been marked by the effort to see as many photogenic places as possible within the time allowed, preferably arriving just before sunset. That way, we catch the beautiful slanting light of late afternoon with its dusky color, and have the opportunity the following morning to again photograph in slanting light from a cool yellow dawn. Unfortunately, we arrived at Monument Valley, Utah, one evening in a drizzling deep twilight. The next morning was too overcast and drizzly to be worth getting up early for. We finally entered Monument Valley midmorning under gray skies, worried that our tires might sink into the soft red dust of the road, and wondering if it was going to be worth the effort. It was.

We followed the sometimes tortuous road, rarely seeing any other car, and stopping often to take pictures or just to sit and enjoy the expansive peacefulness. One of those stops was made to photograph the twisted tree against its background of a distant mesa. I used a 20mm lens to capture as much of the wide land as possible. Many months later, back in New York, I found time to sit at the light table and combine images.

I chose to take the Monument Valley tree and landscape, combining it with a 20mm sunset from San Diego. That added the color I hadn't found in the sky that day in Utah, but the image needed something more. I added the buzzard, originally photographed with a 300mm lens somewhere in the Southwest on another overcast day. The color and contrast were intensified by duplicating the sandwich later onto Kodachrome 25.

Flying saucers, expanding mental waves, neutrinos radiating from the sun, while not commonplace visual experiences, are within the realm of possibility, and therefore can be used to communicate ideas. Creating an image that is far beyond the normal understanding or visual experience of the viewer defeats communication. I don't mind if people wonder how I made a photograph, but if they ask "what is it?" or "why did he do it at all?" the picture is a failure.

So far I have been discussing successful communication. Yet all of us have experienced the feeling of frustration when we fail to communicate. We may be just bursting with emotion, but cannot find the words to make someone understand the profound depths of our own feelings. Perhaps we fear saying too much, or being misunderstood. In the attempt to communicate photographically, there are times when the very same resistance occurs. Whether this is because we lack the technical knowledge or because we hesitate to give freedom to our imagination, we cannot seem to make the breakthrough from a theme to a concrete image on film. We have a mental block.

If you feel unsure of your ability to visualize mentally, perhaps your mind needs practice in forming visual images. Find a quiet place and relax with your eyes closed. Imagine a television or movie screen before you, waiting for an image. Mentally create an image on the screen. Anything bright and colorful will do. See a bright yellow lemon floating against a red background. Mentally change the background to blue, then to a series of columns in perspective. Cause the lemon to revolve and spin through space, past planets and comets. Bring it close to you, noticing the texture of its skin. Does it have the producer's name imprinted? What color is the ink? Let the lemon split in quarters. Notice the droplets of juice that spurt from it. Bring one quarter to your lips, smell its tangy odor, then take a deep bite. If you just began to salivate in anticipation of the lemon's tart taste, you are most successful with mental imagery. It is a facility that anyone can learn. Usually I get an immediate flash of visual inspiration. Sometimes ideas rebound off each other so quickly that my mouth can barely keep telling the many variations I can envision. However, there are times when my mind is a total blank.

Even when you are adept at mental imagery, have a good, fertile imagination, and a symbolic way of thinking, there are times when a particular theme resists forming into an image. You may know what you want to say, but not how to say it. As with any frustrating experience, the best solution is often to remove yourself for a time from the issue, and let the mind relax. If an art director is waiting on the other end of the telephone for a pearl of wisdom, I ask for a day to think it over. You may find it helpful to let your mind relax through physical exercise or meditation. I usually take my dogs for a long walk in the evening.

Never tell yourself, "I just can't think of anything!" You will become so fixated on the impossibility of thought that you will effectively block it. Rather, tell yourself confidently and optimistically that the idea will come, and that your imagination and ability improve with each use.

Ideas, after all, are all around us. They only wait for our grasp. If you get an idea and play with it, but for one reason or another do not put it on film, you can bet you will soon see the same style or concept appear in the work of another photographer. This may be a vote for Jung's "collective unconscious" where all knowable information is available. It may merely be the result of common influences and fashions in art or photography.

Whatever the cause, I have seen time and again an idea I could not find the time to do appear at a later date. It may be slightly changed or altered by another's style, but it's still basically the same idea. The other photographer did not copy it from me, but simply had the good sense to put on film an idea we both had at about the same time. Neither one of us told the idea to a common friend. It was only that the time was right, the vibrations were available, and we were both in tune with them. Naturally the photographer who shoots the concept is the one who gets the credit, and rightfully so. If you hug an idea to yourself, promising to actualize it at some future time, be confident enough in your abilities to release the idea if you see that someone else has done it already. You will certainly not have only one idea in a lifetime.

The only hesitation I have about discussing my ideas relates to talking them away. I have no fear that someone else will steal them; I believe I will be creating for a good many years yet. However, I know that ideas can be talked out so that they seem to be somehow actualized in the very act of retelling them over and over. Soon the mind says, "Enough of that idea!" and, excellent though it may be, the idea is never actualized on film. If you have a photographic concept, sketch it, think about it, but keep your mouth shut. Then when it is properly and thoroughly formed in your mind, waste no further time. Put it on film.

Do not worry that your skills are not good enough to produce the idea you have. Practice is the only way you will improve them. You bring something unique to photography—yourself! Who I am as a person has led me to this form of self-expression. The same is true of you. Your dreams, aspirations, your education, intelligence, compassion, sensitivity, awareness, your moods, your physical well-being, these and a thousand other factors are brought to bear, often unconsciously, when you express yourself through photography. Every aspect of yourself, everything that makes you who you are, can be useful to draw upon for creative expression.

None of us can create in a vacuum without mental input. It's not the technique that makes the unforgettable image, but the mind that uses the technique. A photographer must make a concerted effort to see beyond the surface, to be aware, to absorb. Seeing more deeply, we become more aware, and only then can we reach within ourselves to create an image to touch the imagination of others. Open your Self. Your creative energy will grow, and your photographs will flourish.

LIGHTING

When I was struggling to become a good photographer, I was in some awe of successful commercial photographers. I thought that their superior equipment and huge studios were the reasons their photographs were successful. One afternoon I went with a friend to visit a very well known Los Angeles still-life photographer. His studio, with its marble and terrazzo floor, its shining white walls, and its full complement of brand-new sophisticated equipment, gave me more than a twinge of envy. I noticed, however, that he had a single still life positioned on a table at the far end of the studio. "Oh that," he said, dismissing it with a wave of his hand, "that's part of the campaign I'm doing for one of the ad agencies." At the time, I would have been thrilled to do any work for the agency he named, and the thought of having a whole campaign to shoot was dazzling. Surely, anything worth thousands of dollars in photo fees would be shot with the best equipment, the greatest care. I drew closer to the table to study the lighting this famous photographer was using. There stood the product, and on two poles, one on either side, were two small clamp-on aluminum reflectors, exactly the type I had back in my own little studio. The bulbs inside them were nothing special, either. I looked. They were the same type of bulb I had purchased at a corner super-market. And yet this very successful photographer thought such simple lighting good enough to shoot an important campaign. It taught me that the result is what counts, and that the equipment used is only a means to that end. The simpler the equipment, the better.

A few years ago I met a young man who wanted to work as my assistant. He'd been working, he explained, for a portrait studio in one of the outlying boroughs of New York City, and he had learned all about portrait lighting. He knew, for example, that once the lights had been properly positioned, the entire graduat-ing class could be filed through the auditorium and photographed without any need for changing the light. I didn't know whether to laugh or cry, but I think I did grip my heart to keep it from sinking.

The entire essence of lighting is change, and a photographer should have a sensitive understanding of the need for change in lighting the individual subject. Just spend a lazy day watching how the natural light from the sun can change the character of a tree. At midmorning the sunlight seems to gently wash over the tree, leaving no hard shadows, but a subtle surrounding glow of light. By noon the sun has burned off the morning haze, and the light slides hotly through the leaves to produce a strong pattern of highlight and deep shade. At sunset the tree is touched with slanted gold, the texture of the bark standing out in highly shad-owed relief. Each time of day is beautiful but different, and only one particular time may express the effect you want to capture.

The ideal objective of flash or tungsten light is to imitate natural light so perfectly that it would seem the subject has not been artificially lit at all. When the skin of a beautiful person glows, it should appear to glow from the essence of inner beauty, not because you checked the exposure a dozen times as you moved the light and spent a half hour shifting its direction minutely while you shot a dozen Polaroids. The artifice is in making the artificial appear genuine.

When you light any subject, take your time. Move the light slowly and watch the subtleties of change in shadow and lumines-cence flow on the subject. Never hurry and light haphazardly, ignoring the importance of the effect of lighting to the photo-graph. Facility demands many hours of observation and practice.

The original silhouette was 2-feet high, cut out of black paper by art director Heinz Sirkin. I taped the silhouette to a 4′×8′ sheet of white translucent plastic, and placed a repetitive strobe behind the plastic and aimed it at the camera. I placed the camera 6 feet in front of the plastic, and positioned the image in the center of the frame, so that when I zoomed with a 35–105mm lens the largest zoom image almost filled the frame. Using ten flashes per second, I made a one second exposure while zooming from 105mm to 35mm. Various gels were taped together sequentially, and an assistant passed them rapidly in front of the light as I shot. The film was Kodachrome 64.

The eye, drawn originally with the silhouette, was an element I did not want to appear to expand. I blacked it out in the shooting, but photographed in on a piece of 4×5 Kodalith film so I could add it to the image later. In the darkroom I montaged eye and silhouette together, holding a Motion Maker filter under the enlarger to provide the streaking effect for the beam of light emanating from the eye.

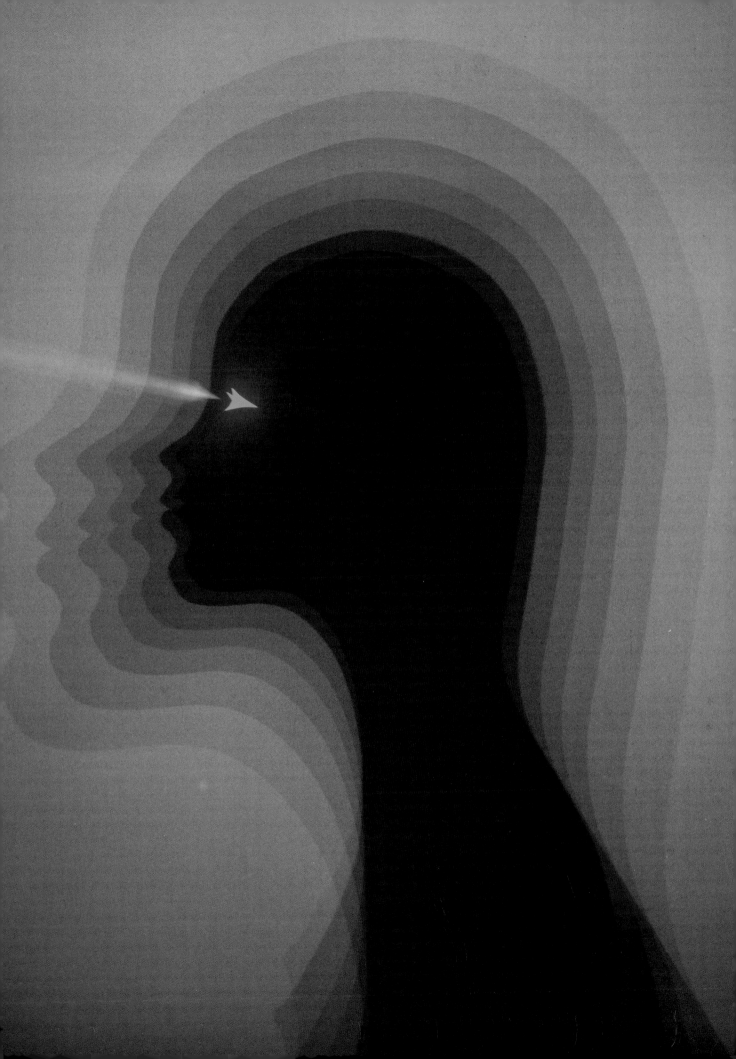

Even busy, working professional photographers find time to test with models or still life, exploring the possibilities of new ideas.

Taking time to observe the nuance of lighting is easy enough when working with a still life. When the subject is a person, bear in mind that the model does not have the opportunity to watch the delicate shifting of the light, but is obliged to sit in one position while you mumble and tisk, seeming to take forever to find an effect that satisfies you. It helps if you can occasionally remember to murmur, "Wonderful!" This allays the subject's growing suspicion that his or her face is hopelessly unlightable. Besides, a compliment can add much of the inner glow you seek, and no matter what the difficulties of the day or the particular job, I never fail to tell the subject enthusiastically, "You look great!"

This tactic does not work with robots or flying saucers. When the subject can't contribute, it is up to the photographer to supply the glow, inner and outer, through lighting. When I work in putting together a special effects photograph, some of the lighting I achieve can look complex, difficult, or even impossible to duplicate. Lighting such as this may actually be the result of lighting each individual element separately, then combining them into the finished, complex image. In doing this kind of complicated image, it is crucial that you have a clear idea of the final result you seek. No one element should look incongruously lit. Each should look like a naturally lighted, cohesive element of the whole.

The day that young man came looking for an assistant's job, I gave him something I considered far more valuable. I revealed to him the "Great Secret" of lighting, which I now impart to you, and it is that there is absolutely no "Great Secret!" There is only diligent observation, painstaking practice, and a concentrated effort toward awareness of every nuance. I can give you suggestions and lighting diagrams, but I cannot stand beside you and suggest that the light position be varied by a foot here, an inch there, for the best effect on the subject. Only you can do that.

Because lighting techniques are an integral part of all my photographs, no matter what "special effects" I use to put them together, we shall discuss the basic lighting techniques individually with several of the photographs throughout the book.

This imaginative concept, solved with darkroom montage, called for "impossible" lighting. I divided the image into five projects: hand, keys to horizon, floating computer screen, starburst, and type at the bottom.

The actual computer keys were too dark. I made keys from clear plastic cubes and transfer lettering, then applied them with double-faced tape on a sheet of translucent plastic. The area surrounding the keys was masked with black paper, so the light positioned beneath them came through keys only. The hands were lit from above with a light bounced from an umbrella, and shot with a 50mm lens. The original layout showed two positions for each hand, but a test Polaroid made me decide on a single exposure for cleaner composition.

The keys to the horizon were the same masked cubes without lettering.

A repetitive strobe beneath them fired 12 flashes per second as I used a zoom lens from 105mm to 35mm during a 3 to 4 second exposure. The time was varied to produce different effects. An 80B gel on the camera lens provided the blue color.

The computer terminal was covered, screen included, with black flocked paper, leaving only the gray frame of the screen visible. It rested on the same black material that was also curved and cut to make a horizon line. (See page 108 for a drawing of the horizon and lighting technique.) Light was bounced from an umbrella positioned above and slightly in front of the terminal. The dark blue background beyond the horizon was lit from beneath the table with a light covered with a blue gel for additional color saturation.

For the glow around the screen, I

used a narrow band of front-projection screen material that is highly reflective, but only along a direct axis to the light source. A ring light directly around the 50mm lens produced that axis, and a diffusion filter supplied luminosity for the glow.

The starburst was photographed once and printed three times into the montage. I used a star-effect filter to photograph a single piece of metallic glitter against black velvet, lighting with tungsten for golden color on the daylight-balanced Kodachrome 25.

For the lettering, I had type set, then photographed it with 4×5 Kodalith film, producing clear letters in a black background. Blue gels were placed behind all but the selected letters and I rephotographed the Kodalith on the light table, using a diffusion filter for added glow. Art director: Michael P. Szymanski.

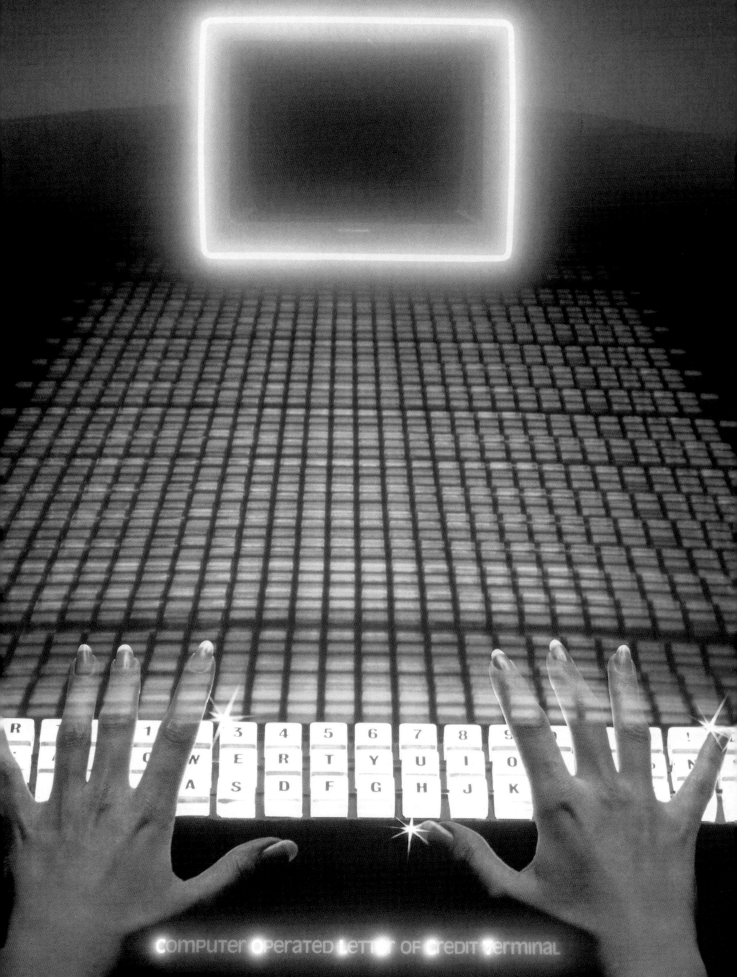

COMPUTER OPERATED LETTER OF CREDIT TERMINAL

POINTS OF VIEW

The beginning photographer is a snapshooter, photographing everything and anything that has even momentary appeal. This is as it should be. It is necessary to understand through experience the possibilities and limitations of equipment in all situations, and it is also necessary to discover which subjects have the most lasting appeal for you. What you choose to shoot and how you choose to shoot it should define your own view of the world. Whether your viewpoint is realistic or fantastic, optimistic or pessimistic, the view you present should reflect your own intelligence and insight.

Most photographers never get beyond snapshooting. They shoot portraits in imitation of one style, landscapes in imitation of another, but neither has any originality. A photo of the Grand Canyon may or may not be more appealing to the viewer than one of Aunt Tillie, but it is impossible to define the subjective outlook of the photographer from either photograph.

A photographer begins to develop a point of view when he or she eliminates elements from the image. Although these elements may be attractive or interesting in themselves, the photographer eliminates them because they detract from the point of view the photographer wants to present. One should not use too many words to say something that can be stated simply.

Before you can speak this visual language, you must understand the subtleties of the words—the nuances of the lens. Lenses of different focal lengths provide the opportunity to use different visual words to construct an image. Each type of lens can be used in many ways, but a lens can aid in your interpretation of images only if you understand the characteristics of the lens. More than any other equipment-related decision, the focal lengths of the lenses you choose and the manner in which you use them define your point of view and photographic style.

My first big commercial advertising job as a photographer was shot with a Bausch & Lomb 5-inch, 125mm lens. I had bought it for $1 from a grab bag in a Los Angeles camera store, mainly because it was encased in heavily tarnished brass. I thought it would look good when I polished it and put it on an old 4×5 Speed Graphic camera I had rescued from another photographer's junk pile. The lens was uncoated except for about 30 years' worth of dirt and pollution.

I got the advertising job through an acquaintance who asked me if I would be willing to shoot a picture of orange juice for J. Walter Thompson. At the time, I was unaware that JWT was one of the world's largest advertising agencies. I thought J. Walter was a friend of his and, happy to do him a favor, agreed to shoot the orange juice. He asked me what I wanted for a fee, and I hesitantly asked for $50, immediately regretting such an extravagant demand when I saw his face fall. He asked if I would accept what he could pay me, and reluctantly, I agreed. He immediately advanced me the $50, which I needed desperately to buy film and have the electricity turned on again in my studio. Overjoyed, I set about refurbishing the lens in anticipation of the shooting. I took it apart for a cleaning, and there, on the retaining ring, was a repair date written in pencil. The lens had last been repaired in 1898! I cleaned and polished the lens, photographed the orange juice, and was in my ignorance and innocence rewarded with beautiful photographs, perfectly color balanced and beautifully lit. My acquaintance paid me the majestic sum of $500 and asked me if I was satisfied. Satisfied! I was delirious with joy and already counting the rolls of film $500 would buy. "Good," he said, "because I just got $2000 for delivering the picture to J. Walter Thompson, and that means I made a $1450 profit. This is your first lesson in the business of photography," he admonished me, "always know the market value of your photographs, and never underestimate your own work." It was a lesson I much appreciated, and I have since profited by as well.

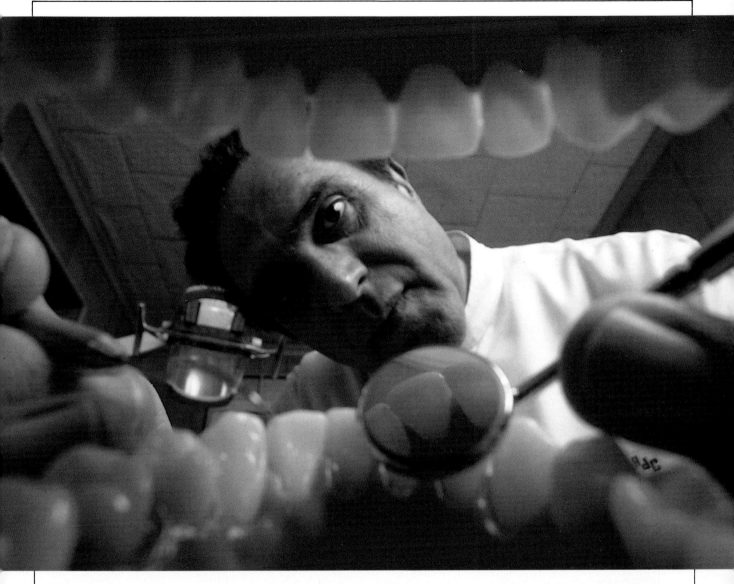

My dentist had a large set of dentures that he used to show people how to properly care for their teeth, and I thought it might be amusing to shoot something from the teeth's point of view. When the shot was used later to illustrate an article on tooth care, patients and friends enthusiastically called my dentist, and we were both pleased at the positive response.

I taped the lens in place inside the dentures, sat in the dentist's chair, and had him work as he normally would. Lighting was supplied by two studio strobes and umbrellas behind and on either side of me.

With a 20mm lens (above), the view is most believable, and is the version I prefer.

The picture at far left was shot with a 7.5mm auxiliary fisheye lens on a 50mm system lens.

The center picture was made with a 15mm lens.

I also borrowed the dentures to shoot some stock shots of food.

Selecting Lenses

HOW MANY LENSES

You should own very few lenses when you begin as a photographer. Quantity is far less important than quality. Many highly paid photographers who travel around the world on assignment have learned to pare their equipment to a minimum, and probably carry fewer lenses than the equipment-laden hobbiest who will often miss a shot while trying to decide which lens to unload from a bulging camera bag. When I go out to shoot I have a specific idea in mind, and carry only the lens I know will be used for that shot. I dislike toting bags, so if the equipment will not fit in pockets I would as soon leave it in the studio. Having too many lenses can be confusing, and a photographer can become too concerned about covering all possibilities with various lenses rather than covering one possibility exceptionally well. Before investing in a second lens, become proficient with the single lens you own, learning its limits, its capabilities, and how it functions in a variety of situations.

FOCAL LENGTH

The purpose for which the lens is to be used should dictate what lens is purchased. A standard, or normal, 50mm lens for 35mm camera format is probably the best beginning lens. It is faster for shooting in available light situations, good for candids, and fine for landscapes. More good photographs have been shot with a 50mm lens than with any other. When you are ready to progress to a second lens, ask yourself what you most want to photograph. A wide-angle lens from 20–40mm is best for landscapes. A longer 85–200mm lens is excellent for portraits. Telephotos are perfect for shooting sports or for photographing distant wildlife. You may want to work with distortion, and choose a wide-angle or a long telephoto for their inherent properties. However, if this is your intent, remember that all novelty pales with use, and nothing is more boring in a photographer's portfolio than exaggeration for its own sake.

The second lens you buy should probably be either one-half or double the focal length of your normal lens. Perhaps a 28mm wide-angle, or a 100mm telephoto might be a logical next choice. I heartily advise that you not choose an extreme wide-angle, although buying a very long telephoto is fine provided that you have a clear idea of what you intend to use it for.

COST

Cost is often the determining factor in the purchase of a lens. If you can afford to buy lenses made by the manufacturer of your camera, by all means do so. These lenses are designed to be perfectly compatible, physically and optically, with the camera body. Few expensive lenses are of poor quality, but any lens manufactured within the last five years probably has computer-designed optics, and should be of excellent optical precision. Obviously if the choice is between a $400 and a $40 lens, the more expensive lens will almost inevitably be better in optics and design. The main difficulty with cheaper lenses is often not their optics, but rather the fact that their mechanical parts often cannot withstand constant use.

The manufacturer's suggested list price is an arbitrary price. You should be able to purchase any new camera or lens for at least 20–30 percent less than the suggested list price. Read reports in camera magazines so that you will be knowledgeable about what you are buying and what you should expect from equipment in the way of performance, features, and price. Photo magazines often list new and used equipment prices in the advertising section toward the back of the magazine, and this list can be an excellent source of information about the current market value of equipment. When you are ready to buy, compare prices from one camera store to another. You will discover that the store with the loudest advertising campaign is not necessarily the store with the best price. Often a photo store is promoting sales of whatever equipment is currently offered to the store under a manufacturer's discount. Do not be afraid to bargain with sales people for the best price. Do not feel pressured. Cameras are always available, and it is better to buy exactly what you want than to allow yourself to be talked into buying an electronic marvel that will, in the long run, not take any better photographs than the equipment you originally intended to buy.

Your photographic equipment should serve you much as a writing utensil serves a writer. A camera is merely an instrument for you to use to record your creative images on film. I have sometimes ground my teeth in frustration overhearing sales people give totally inadequate and misleading information to a customer for the sake of selling overpriced equipment. I have seen customers persuaded to trade in perfectly fine equipment for the latest gadget to appear on the photographic horizon, when what the customer really needed was advice on how to make better use of the equipment he owned. I cannot forget the woman from Texas who asked me what camera system she should buy. She had a full Leica system, but, she confided, it just wasn't giving her good photographs. Of course what she needed was not a new system, but a way of sharpening her own visual and creative outlook. I have often found that photographers who are "equipment freaks," knowledgeable about every nuance of every camera, lens, film type, and filter, usually produce the least creative and most clichéd images. Do not be one of them. Use your equipment, get to know it as you know a friend, but always be aware that the equipment is only a means to a creative end.

As a beginning photographer in Los Angeles, I often went without food in order to buy and process a single roll of film. My total equipment investment rested in a single camera, a Mamiya C3 twin-lens reflex with the shutter speed built into the leaf shutter of the lens. Unfortunately, the shutter was broken, and I was broke. The shutter would only work at a speed of 1/500 sec., and I could not afford to pay $30 for a lens repair. Indoor shots done with electronic flash could be synchronized with no problem, but any outdoor shots had to be done on a clear day with the lens wide open. I hustled to get work, but the biggest effort of all had to be put into convincing the client that a soft, out of focus background was exactly the look the photograph needed. I was unable to afford to have that lens repaired for over a year. I became a great salesman on the out-of-focus background look, and in fact that broken lens helped me to develop a style, appropriate for the time, that I might not otherwise have been able to find. It certainly taught me that equipment is not the answer to creativity and with imagination, a photographer can work around equipment limitations.

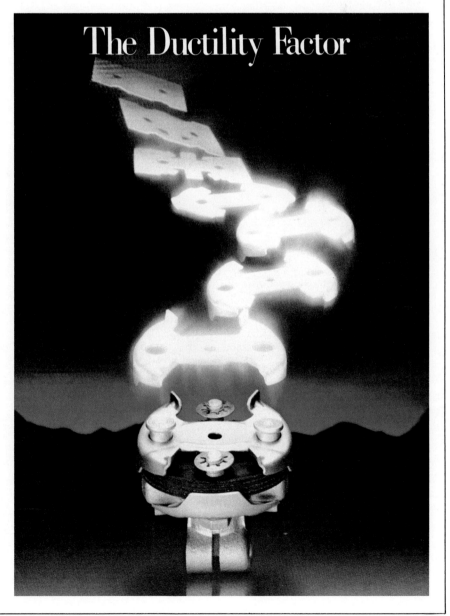

The Ductility Factor

This was a double exposure done for General Motors. The metal pieces they sent me were a dull gunmetal gray, so I sprayed them with silver paint for a brighter reflectance. I placed the large main piece on a foiled board, the back of which was sprayed black to blend with the paper used for the mountainous horizon. I lit it with a single strobe head, diffused with tracing paper, placed directly over the part. The horizon light was supplied by a strobe beneath the tabletop, aimed up toward the blue seamless paper background. I made the first exposure with a 50mm lens. The individual parts floating down were done as a single exposure with a 24mm lens against a background of black velvet. Each piece was put on a black wire (from a coathanger), and positioned in perspective with the wires inserted into foam covered with black velvet. I used a Mist Maker filter for additional luminosity on the metal. Art director: Bruce Wilmoth.

How Lenses Affect Your Images

IMAGE SIZE

The image size of a photograph naturally varies with the focal length of the lens used. A subject at any given distance will appear smaller when shot with a wide-angle lens and larger when shot with a telephoto. When planning special effects combining elements, this lens characteristic is especially useful for sizing relative elements within the finished image. For the photograph of the man in the coffee cup, I chose a wide-angle lens to shoot the model. The lens was chosen simply because I intended to place the small image of the man and mattress within the larger image of the coffee cup, which was photographed with a 50mm macro. For the photograph of the three flying saucers above the road, I chose three lenses of different focal lengths to photograph a single saucer in multiple exposures. The three focal lengths offered sizings that would create the illusion of three flying saucers at different distances down the road. With these ideas in mind, it is important for any special effects photographer to be aware of the possibility of using the image size offered by any one lens, and precon-ceive the result within a creative combination of elements.

ZONE OF SHARPNESS

It is important to remember that no matter what the *f*-stop selected for exposure, when you view the subject through the viewfinder before pressing the shutter release, the diaphragm is opened to the widest possible aperture. This permits you to easily see the image you plan to photograph, but it does not allow you to see exactly what the depth of field will do to the image at the *f*-stop you have chosen. The

The golden wheatfield was photographed with an 18mm lens in Oklahoma, the sun with a 500mm lens from the roof of my apartment building in New York, each on Kodachrome 25. Montaged, they provided a wrap cover for a book called *The Grain Trade*.

In the darkroom, I placed the wheatfield into the enlarger first, as it was the more important of the two elements, its horizon line determining where the sun would be positioned. I used Ektachrome duplicating film for the montage material. Because the wheatfield was photographed under a flat blue sky, I held that area back from exposing. The wheatfield needed only a slight amount of orange filtration since it was already so warm and golden, and I easily dialed the proper filtration on the dichroic enlarger.

Using the guide sketch to position the sunset in relation to the field, I selected for printing only that portion of the slide that showed the sun itself, huge and glowing, within a long thin area of sky in keeping with the intent to make the image fit for a wrap book cover. Part of the original sunset image was eliminated from the montage, and I held back the area of the sun that would have printed below the horizon line.

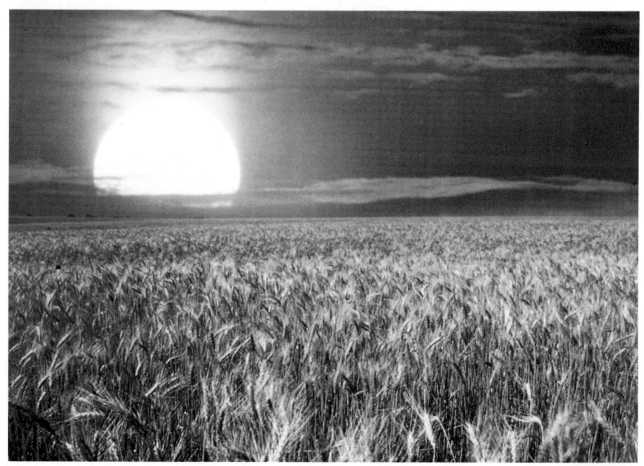

footage marks on either side of the focusing ring of the lens will indicate depth of field, but in photography an intellectual knowledge of how the image should appear cannot compare with a visual knowledge of how it actually looks through the viewfinder. Always depress the camera's depth-of-field preview button to cause the diaphragm to close to the aperture selected for shooting. The view through the viewfinder will grow darker according to the size of the *f*-stop selected, and the actual depth of field will become visually apparent.

I shot the legs for my own portfolio with a 28mm lens. A wider angle lens would have made the foot too broad, the knee too tiny. A narrower angle lens would not have given the distortion I wanted. The legs were lit with an umbrella and strobe directly over the knees. The photograph was later used by Canon when they were running the "Canon Photographer of the Month" series of ads. Art director for the ad: Koriyama.

This was a multiple exposure using two lenses. The computer in the center was placed on a silvery-blue piece of illustration board, lit with one umbrella directly over it, and shot with a 15mm lens. The circuit boards were similarly lit, placed against black velvet for a self-mask, and photographed for a one second exposure while zooming with a 35–105mm lens. The strobe flash produced the clear image, the tungsten modeling light gave the golden tone for the image at the end of the zoom. The shot was used for *Popular Electronics* magazine. Art director: Ed Buxbaum.

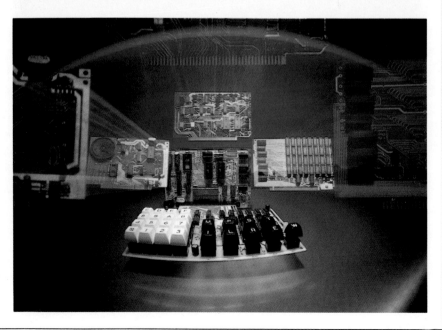

Perspective and Distortion

PERSPECTIVE

Perspective is the relationship of objects to each other with regard to their relative positions and distance. If the camera position remains the same, the photographer can change from lens to lens and the relationship of objects to each other will remain the same. This can be seen more easily if you were to photograph a landscape with a wide-angle and then with a telephoto lens. The wide-angle lens would make the foreground appear large, a tree in midfield appear fairly small, and the mountains at the horizon appear quite small. However, the same view shot with the telephoto would eliminate the foreground to a large extent, bring the tree into greater magnification, and make the mountains appear much larger. If you were to take only the central portion of the wide-angle shot and enlarge it so that it encompassed only the exact portion of the landscape as seen in the telephoto shot, you would see that the perspectives were identical. Other factors, such as depth of field or grain apparent in the enlargement, would differ, but perspective would be consistent.

Most photographers are not interested in making textbook examples of perspective relationships. The above relationship holds only when the camera position remains unchanged. In fact, when creative photographers shoot, the camera position usually does change as the photographer changes lenses. Artistic perspective then, encompassing angle of view, magnification, and viewpoint, changes radically with the lens chosen, while control of the perspective influences the successful outcome of any photograph.

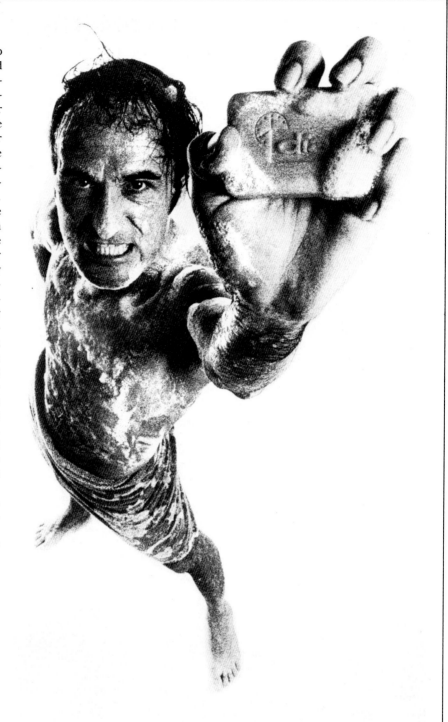

My friend Dominic Barto is an actor who has most often played gangster roles. We wanted to do a photograph of him in character as a tough guy, but with humor in the image. We decided we could achieve both by using deodorant soap, suggesting that even a gangster can care about smelling nice, and that he thinks you ought to use it too—or else! With a 20mm lens, I photographed Dominic against a white background. Two strobe lights were directed toward the white floor, and one umbrella bounced light on him from above. I stood on a ladder and shot, while Dominic growled and threatened me with bodily harm to get himself in the proper mood. I chose the wide-angle lens and this particular angle because I felt they provided strong emphasis on the product, gave good perspective, and added to the humor in the image.

DISTORTION

Distortion, usually seen as a foreshortening or distorted relationship between foreground and background, is inherent in all lenses because no one lens "sees" exactly what the human eye sees. The eyes produce a three-dimensional image and the brain converts the image to fit with past experience in a dimensional world. Distortion is present, but is understood in terms of natural phenomenon and perspective. A tree at the horizon, for example, appears smaller to the eye, but the brain recognizes the fact that the tree is actually as large as the one under which you seek shade.

Distortion may be used for creative emphasis. Unfortunately, it is sometimes used poorly, creating imbalance within the image to an uncomfortable degree. Playing with distortion for its own sake without enhancing the image is acceptable if you are shooting for your own amusement, learning how to manipulate degrees of distortion, or deliberately overemphasizing a photographic point. However, I prefer to let the distortion work for me rather than be a victim of its exaggeration.

Distortion can be seen in a photograph showing objects or lines that seem to lean strongly into or out of the picture. This type of foreshortening is caused by holding a wide-angle or normal lens too close to the subject, or by not keeping the lens parallel to the midpoint of the subject during exposure. When you view the image, ask yourself, "From this angle, using this lens, is the image appearing the way I see it either through my physical eye or in my mind's eye?" If the answer is no, then the exaggeration produced by that particular lens is unacceptable, and you may have to change lenses, alter your position with respect to the subject, or even change the subject if possible.

If your goal is to produce a photograph with a minimum of foreshortening, the usual solution is to move away from the subject and hold the camera parallel to the vertical midpoint of the subject. Sometimes it is physically impossible to move back far enough from the subject or to remain vertically parallel to the subject's midpoint. Sometimes you might not want to move back because the image size would be too reduced by distance. In each of these cases, foreshortening can be greatly modified by the use of PC (perspective control) or TS (tilt and shift) wide-angle lenses. Whether a lens is called PC or TS depends on the manufacturer, and both are essentially the same kind of lens. The lens can be moved up and down or sideways on the camera, thus shifting it on its optical axis. This shift corrects distortion to some degree by positioning the lens parallel to the subject in relation to the film plane. These are very expensive lenses, however, and unnecessary to own unless you plan to use them constantly in your work. I do not own one.

Learning to use distortion is part of the creative use of a lens. One may not want to produce obviously foreshortened images, but distortion can be successfully manipulated to emphasize line, direction, movement, distance, size, or any number of creative factors in the composition of an image. When a commercial photographer is given a layout by an art director, the photographer must attempt to fit a photographic image to the drawing. After some years, it becomes instinctive knowledge, and I find I usually reach for the lens that will give exactly the effect I need. Occasionally I must look through various lenses to achieve the closest possible match. Sometimes one lens does not provide the blending of perspectives or the proper proportions. In that case, I will have to decide how to combine lenses in one image, and which lenses to use.

I wanted to make a very simple set that would nevertheless have strong perspective. I used strips of white electrical wire to make the lines, and a 4′×8′ piece of black plastic for the surface. Because the plastic is slightly reflective, it gave additional dimension to the wire. I wanted the realism of a sunset behind the very graphic perspective, so I used front projection to properly size the sunset over the perspective set. I photographed the set using a 50mm lens and a 40mm front-projection lens. The set took me only 20 minutes to construct, but produced the exact perspective I needed for the image. I later used the transparency of set and sunset as a background for other front-projection images.

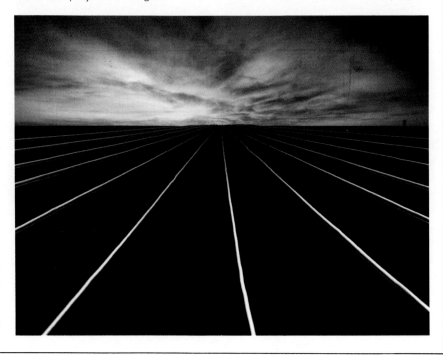

MAKING PERSPECTIVE WORK FOR YOU

Often the photographs I create involve combining elements shot with lenses of various focal lengths into a believable whole. How they are combined depends on the needs and complications of the final desired image, but the fact that different elements are to be combined calls for preplanning when each one is shot.

Angle of View

The angle of view should be the same for each element. When I was originally asked to photograph the image of the microprocessor-chip blueprint with the engineer standing on it and holding the finished chip in his hand, I shot the elements separately. The people at Bell Labs liked one particular shot of the engineer, and another of the microchip, and asked me to combine them. I tried doing this combination various ways, but never was able to create a really believable final image, because each element had been pho-

tographed from a different angle. It was only when I resorted to reshooting the cutout of the engineer that I was able to shoot both him and the chip from the same angle. Had each been shot from the same angle originally, even though different lenses were used, a believable perspective could have been achieved from the start.

The elements in a composite photograph must appear to have been shot from the same camera position. You can, for example, combine a telephoto sunset with a wide-angle shot of a meadow, as long as each seems to be photographed from what would normally be your actual point of view. If you try combining a midday sun with an elevated view of the meadow, the elements will not work, and the combination will be disturbing.

Lighting

The lighting on each element in one photograph should seem natural. Shadows should be placed on the same side, of course, but more than this, the intensity of light

should be believable. Elements positioned near each other should have approximately the same brightness. Elements at an apparent distance from the light source must appear less bright than objects that are closer to the light source.

Spatial Relationships

Spatial relationships between elements must be believable. Distances must be either as they appear in nature, or exaggerated only enough to make the point. A small model spaceship, for example, can be positioned near a human in such a perspective as to make the ship seem huge, but the relationship must be believable. (We've now come to believe in spaceships enough to make this situation work!) If the model is crude enough to show many flaws in its composition, or if the person seems to be gazing slightly past the ship instead of directly at it as desired, the final image will not work, because the spatial relationships have failed to mimic the natural situation sufficiently.

For an annual report, Bell Labs wanted a photograph of a microprocessor chip, demonstrating that its original design had been made on a blueprint 20 feet in diameter, then reduced to a working chip half an inch square. One of the team of design engineers was to be featured in the photograph. The shooting area in my studio is only 18-feet wide, so I was relieved to hear I would not have to deal with the actual blueprint, but a facsimile 20 inches in diameter. However, the facsimile had

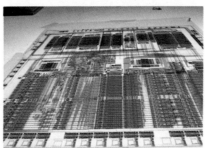

to appear to be as large as the original, with the engineer standing on it and holding the tiny chip.

I shot the blueprint from a few angles, but photographed the engineer as he stood at eye level in front of me. Bell Labs chose an elevated version of the blueprint, but when I attempted to use that image with the one of the eye-level engineer, the perspective looked unreal. After some frustrating attempts to force the combination as a montage, I finally decided to reshoot. I made a print of the engineer and cut him out. I placed his cutout image directly on the 20-inch blueprint and photographed the whole from a slightly elevated angle, just like the angle originally chosen by Bell Labs. Although he had been shot at eye level, the new perspective worked perfectly, appearing as though the engineer stood in person on the blueprint, looking up at me. Art director: Vyto Abraitis.

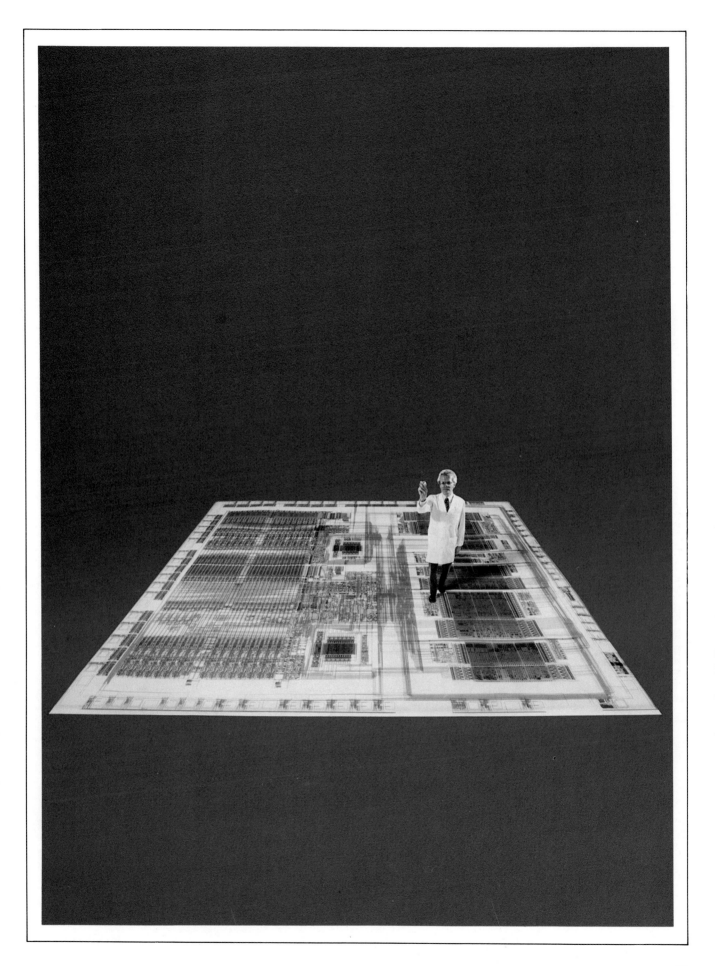

Building a Set in Perspective

Building a set in perspective may be the easiest, fastest, or cheapest solution when you must combine perspectives and find that other techniques do not work as well. Sometimes the layout for a picture may call for a subject or product in the foreground, undistorted by the foreshortening of the lens, while the background recedes in marked perspective to a distant horizon. The background needs to be shot with a wide-angle lens to obtain strong perspective, but the foreground subject calls for a normal, 50mm lens. Other ways of combining perspectives may be time consuming, but a simple set can be constructed in an hour.

MATERIALS

Material for sets should ideally be lightweight, strong, easy to obtain and able to accept paints and texturing. Although I have on occasion needed complex sets for certain assignments, I prefer to keep the set simple and precise. For this reason I like to work with materials such as paper, cardboard, and foam core, a board made of compressed foam with paper on either side. Each of these materials can be cut with a mat knife, put together by tape or glue, and can be stored or disposed of easily when not needed. If a table is needed for a small set, one can be made from two sawhorses and a piece of plywood, all of which can be stored against the studio wall when not in use. I like to have handy a variety of colors in seamless background paper, several sizes of black velvet cloth, several cans of spray paint, including a clear matte spray,

Popular Electronics magazine asked me to photograph, of all things, an electronic sundial! The small set's cardboard wall was cut with one side shorter than the other for additional perspective, and a regular sundial was visible through its arch. I lit one side of the background with blue for night, the other with orange for day, symbolizing time's passage. The 12-inch sundial was lit from above, and photographed with a 20mm lens. I double exposed the moon in later with a slide duplicator. Art director: Ed Buxbaum.

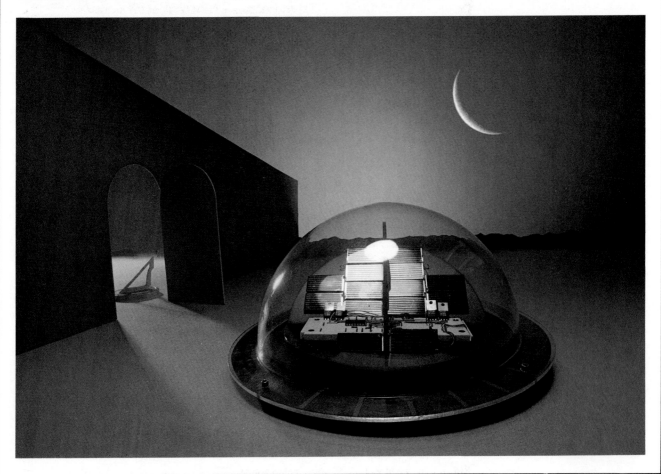

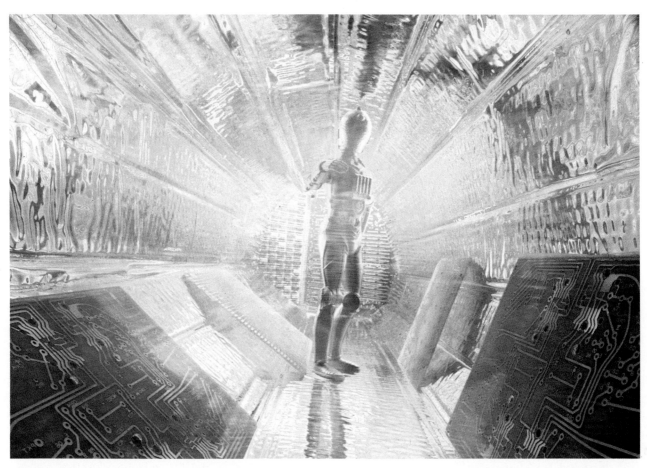

Exaggerating perspective with a wide-angle lens and a perspective set enabled me to create this photograph for *Penthouse* magazine to illustrate an article about robots. I altered a robot model from a kit. The tunnel was a cardboard tube, 3-feet long, rolled like a megaphone so that the small end was 8 inches in diameter; the larger end through which I photographed was 16 inches. I glued silver Mylar to the inside, added a few small electronics boards, and put the robot at the far end. I lit the tunnel with one umbrella so that light bounced from behind and through the tunnel. To further exaggerate perspective, I placed the 18mm lens directly within the tube; the low angle made the robot seem larger.

and assorted mat knives, scissors, pushpins, tape, and some basic carpentry tools. These materials can be purchased at any well-stocked art supply house, and the tools at any hardware store.

THE ILLUSION OF DEPTH

The illusion of depth can be achieved with very small tabletop sets and a wide-angle lens. When the subject in the foreground must be shot with a normal lens for correct and undistorted perspective, a strong illusion of background depth can be built into the set. I once hammered a row of nails at 1-inch intervals along the front of a board, then attached a thick wire to each nail. Each wire was about 3½-feet long, and the other ends of the wires were gathered at the rear of the board and wound around a hidden nail beneath the tabletop. The wires provided instant perspective lines, wide apart near the camera position and receding to meet at what appeared to be a far distant horizon. They gleamed in the light, and the shadows they threw gave further dimension. Several other photographers remarked upon seeing the photograph that the set's perspective was powerful, although the materials and the method were the simplest available. I make mountainous horizons from black paper cut to outline peaks and valleys and have made a cobblestone street from dented foam core. Simplicity is the keynote, because the set must never overwhelm, but always draw attention to, and complement, the subject.

When the set is small, it is a natural tendency for the photographer to want to stand over the set and photograph it from a higher vantage point. The photographer, after all, can see the actual size of the set, and we all tend to look down at miniatures and tabletops, because they are usually placed below head height. To achieve a sense of distance and depth, however, the photographer must shoot from a lower angle. If you bear in mind that the set must appear to be lifesize, imagine the angle that a miniature photographer and camera would take and shoot accordingly. When you do this, remember that a low horizon line, with the subject prominent in the foreground, achieves the greatest sense of distance.

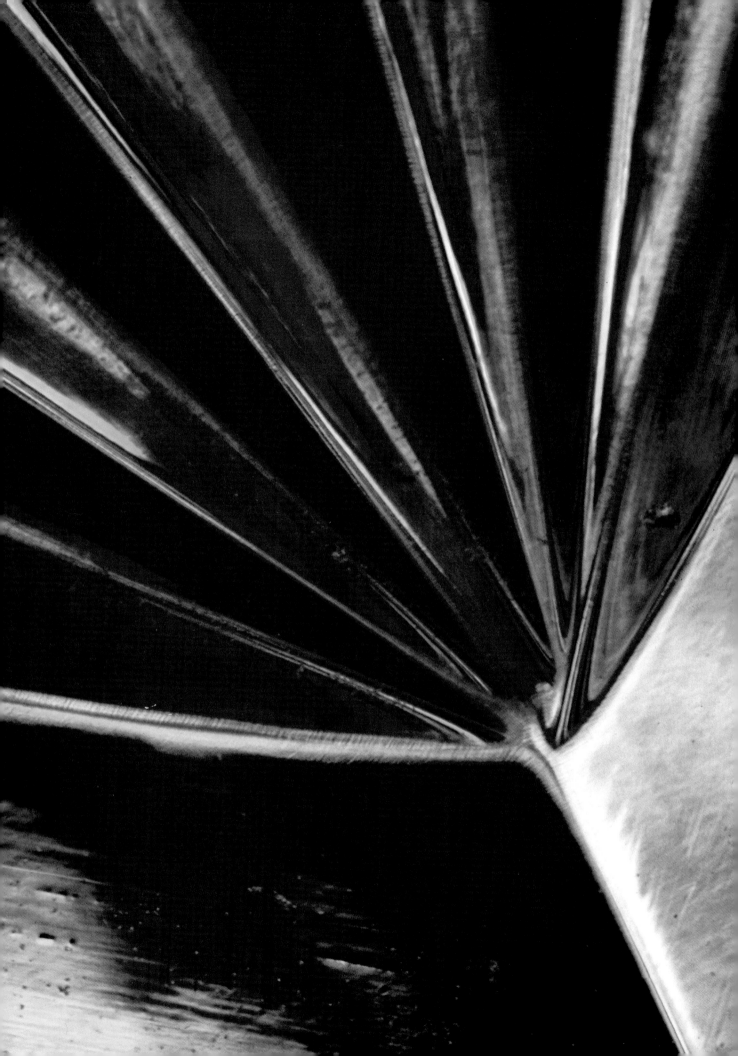

There are times when a relatively inexpensive filter or other lens attachment is needed to provide extra punch to a photograph. Filters are useful, versatile additions to any photographer's equipment, and indispensable for dealing with aspects of light and coloration. At the same time, they are perhaps the most poorly used pieces of equipment available today.

Some photographers prefer to shoot before they think, and filters that provide spectral bursts, multiple images, or other optical effects become "instant special effects" gimcrackery in their hands. When a creative concept exists, any filter use is dictated by the concept. A filter cannot make a dull photograph exciting. It may add sufficient razzle-dazzle to distract the viewer, but a second look at a dull photograph will make its shortcomings apparent. A filter selected only for its effect without concern for an existing need for that effect in your work, will turn your images into a shallow display.

Always buy the highest quality filters that you can afford and select them because their use fills a need in your photographic vocabulary. An inexpensive filter, made of cheap optical glass or plastic, will turn an expensive camera lens of the finest optics into an extension of the poor quality of the filter material. There is no doubt that special effects filters and lens attachments will allow you to expand your creative abilities and express new concepts. I would be the last person to discourage the thoughtful use of spectral bursts, multiple images, and unusual optics. In fact, I have sometimes combined several of these filters on one shot. Any photographer interested in special effects will probably want to own several unusual filters, and should experiment by using each of them in various ways. Just bear in mind that a great filter can't save a bad picture, and overuse of any single effect becomes boring. If you begin your picture with a solid concept and use a filter to enhance the idea, you will get the image you desire.

Filters are used to color light, alter its path, or break it into prismatic elements of color. The *lens attachments* discussed here alter the image by causing segments of the scene to repeat, streak, or reflect and make reverse images. The matte box is a lens attachment that offers possibilities for both filtration and image alteration.

Most of the items discussed here tempt the user to create instant special effects, and must be used with restraint. I rarely use them to photograph the overall image. Instead, I prefer to select a single filter, attachment, or combination to photograph just one element in the picture. The other elements are photographed with different filters or attachments, or without any at all. In this way, I use the effect to emphasize a single aspect or alter a section of the finished image, but the entire picture is not overwhelmed by the effect.

I have a diffraction grating, made of much the same type of material as the transmission grating filter, except that while the transmission grating allows the passage of light through itself, the diffraction grating only reflects and diffracts spectral colors. A small section of a cut glass vase served as the subject, and I photographed it with a 75mm enlarging lens on an 8-inch bellows, using tungsten light and Kodachrome 40. I placed the vase on its side and the diffraction grating material within it, about 2 inches below the surface I planned to photograph. Moving the 500-watt quartz light at different angles to change the colors, I photographed several variations on each small section of vase, and each variation was delightfully different.

Filters

I used a Mist Maker and Rainbow Streaker with a 50mm lens for this version of the flying saucer.

The same saucer, photographed with a Mist Maker on a 35–70mm zoom lens while zooming.

This time I used a 20mm lens with a Mist Maker and a Spectral Burst filter.

THE POLARIZING FILTER

The polarizing filter is probably the single most important filter a photographer can own, and I find it indispensable for producing many special effects.

The polarizing filter is composed of two distinct parts: a front filter section containing a polarizing screen, and a rear retaining ring that is screwed onto the lens threads of the camera lens. The effect of polarization is produced by rotating the filter section until the strongest polarizing effect is achieved, reducing highlight intensity and increasing saturation in those areas.

In my opinion, no photographer should be allowed outdoors without a polarizing filter. I like the deep blue skies and outstanding white clouds the polarizer produces. However, I have often been amused when photographers ask me how I achieve such heavy color saturation in my studio shots, when they have been using a polarizer outdoors for that very purpose all the time. Studio shots, especially those dealing with any reflective subject with highlight areas that are too bright, can be immensely improved in color saturation with the use of this filter. This has the additional advantage of allowing the image to reproduce better when printed or published, since burnt out highlights are avoided and the tone of the whole is more even.

Besides the obvious use of a polarizer on highly reflective subjects like glassware, I find its use beneficial when shooting elements against black velvet. Any sheen on the velvet may produce a faint highlight, and when working with a combination of elements, I can't afford to have a distracting gray area in the background. When I use a polarizing filter, the velvet remains matte black.

I sometimes use a polarizer with the addition of polarizing gels over the lights, as described more fully in the section dealing with front projection. The gels strengthen the polarizing effect, but also reduce light output. Polarization helps in the copying of any piece of flat art, such as a photographic print, a painting, poster, drawing, or map. If the gels are not available, a polarizing filter, at least, should be used.

Polarization should never be used when the highlights, bright or diffused, add to the effect or bring life to the image. Beauty shots, for example, often depend on the placement of highlights on skin to give a luminous quality and glow. Polarization would increase the saturation of color in these areas, bringing skin tone more strongly into play, and perhaps revealing unwanted skin texture that was successfully eliminated by the highlight.

An exposure increase of two stops is required when using a polarizing filter. If your camera has a through-the-lens metering system, no compensation is necessary.

THE DIFFUSION FILTER

A diffusion filter is a clear piece of optical glass etched with concentric circles, which produce overlapping regions of sharpness and nonsharpness that blend to create a softer overall image. The amount of diffusion is variable, depending on the f-stop selected, with a smaller stop giving less diffusion.

Another type of diffusion filter, a mist (or fog) filter, achieves its effect by means of a mildly diffused piece of plastic between two pieces of clear optical glass. The amount of diffusion does not vary with the f-stop selected. Because of its consistency, I prefer this type of diffusion filter and, in fact, it is probably the filter I use most often. The amount of diffusion seems to be just right for my work.

Because diffusion blends highlights and shadows, it can be used with great success for beauty shots, where skin tone should appear smooth and luminous. It cuts contrast on wrinkles and blemishes, and smoothes skin texture, and causes glowing highlights. I used a diffusion filter to photograph the model's face and hands for the cover of this book, to give an ethereal quality to the image.

For the feeling that the subject is lit from within by an inner glow, use the diffusion filter on a light-colored or brightly lit subject against a dark background. This also gives the subject more dimension. However, when this filter is used for an

overall image of light subject on light background, I find the effect disturbingly clichéd. As with most filters and lens attachments, I prefer to use the diffuser on only a single element of the final image. That way, the filter does not appear to be hiding flaws, but emphasizing one facet of the final photograph.

No exposure compensation is necessary when using a diffusion filter. In fact, as highlights blend into shadows, the result may be a slight amount of overexposure since the shadows become more open.

STAR-EFFECT FILTER

A star-effect filter is probably the most overused and misused filter available, and any image photographed with such a filter is in immediate danger of becoming a cliché.

The star effect is made of crosshatched lines etched into optical glass and covered with another piece of optical glass. It diffracts light along the lines so that any bright point of light becomes a brilliant pointed star. It also tends to soften and slightly diffuse the image. A star effect can be achieved by holding a piece of common window screen wire in front of the lens, but the radiating points of the star will not be as extended as with the filter.

Available in versions producing four, six, or eight points, these filters are best at wider f-stops, as the star extension diminishes with smaller diaphragm openings. I prefer the six-point version, because I feel it looks more believable than the others. I have also used more than one in combination for additional points of light. A star-effect filter also diffuses the image, so doubling up can really create a softening of the image.

A color version of the star-effect filter is available that produces prismatic colors in a cross star pattern. This filter is made of a crosshatched grid over a transmission grating, and the image is not only diffused, but slightly yellowed by the use of such a filter.

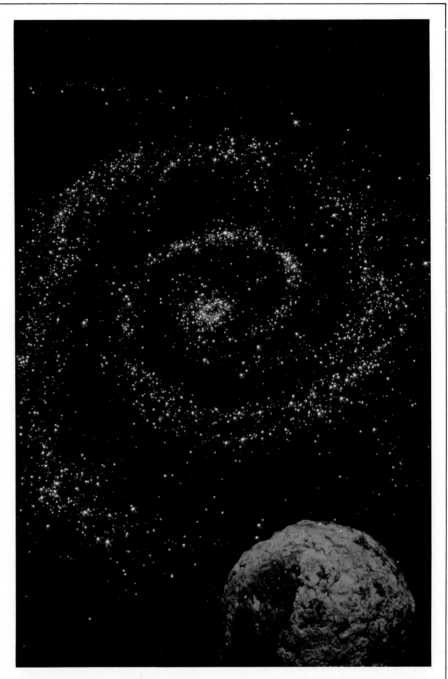

I use metallic glitter, the kind sold for decoration around Christmas time, to make stars. Black velvet is used for the background, and it is important to smooth the velvet to remove wrinkles that might show as slightly grayed ridges in "space." With a six-star filter to produce the star points, I shot the glitter using a 50mm lens. Only selected stars have points, because only those pieces of glitter perfectly caught the light. The asteroid is a geode, double exposed into the image at a later date.

Black backgrounds emphasize the star effect. I like to use a star effect on the "stars" I photograph which are actually pieces of glitter sprinkled on black velvet. If the star effect is allowed to dominate the photograph, I believe it weakens the effect, but used on a single element, and with discretion, it can be unobtrusively enhancing.

TRANSMISSION GRATING

A transmission grating is a filter having as many as 13,000 microscopic grooves per inch. They break any point of light into spectral colors, and variations of transmission gratings break the light in different patterns.

All transmission grating filters are made by sandwiching an acetate sheet of microscopic grooves between two layers of optical glass. Acetate sheets are available by themselves, but are usually optically terrible. They have a heavier yellow cast than the glass enclosed version, scratch easily and reduce image sharpness and contrast further than the glass filter.

When used with black-and-white film, the transmission grating shows the spectral colors as varying tones of gray. The image sharpness is lost without gaining the spectacular color effect of the pure prismatic colors.

I prefer the effect of a transmission grating streaker, a filter that repeats the shape of any point of light, streaking it in a straight line on either side of the source. Rotating the filter in its mount directs the streak. The repeated streak is in bright spectral colors, but any portion of the subject that is bright will also be repeated in a ghost image of prismatic colors. The brightness of the colors depends on the brightness of the source, and the strength of the colors diminishes as they are streaked farther from the source.

Since the effect produced by a transmission grating filter is the last element I consider as I conceive a photograph, I only use it when I need a feeling of some prismatic movement, or to give that extra added kick to the image. If I view the result through the camera and de- cide it seems a little overpowering, I discard it and shoot the element without it. I never want the filter effect to be the most obvious thing in one of my pictures.

Another transmission grating filter produces a spectral burst of teardrop-shaped spectral colors radiating around any point of light. Because this effect looks just the same no matter how the filter is used, I rarely use it. The only variation is the relative nearness of the radiating colors to the light source, with a tighter radiating circle produced by a wide-angle lens and a larger circle by a telephoto.

Any transmission grating filter reduces contrast and adds a yellow cast (amounting to about a 10Y) to the image. No exposure compensation is required.

COLOR COMPENSATING (CC) FILTERS

Color compensating (or CC) filters are used to correct film color. Because I may be combining various elements in a single photograph, I want each element to be consistent in color balance. I usually buy film in large quantities so that the emulsion and storage conditions are the same for all rolls I use on any one assignment. Most 35mm and 2¼"-square film rarely needs color compensation anyway, but when I use 35mm Ektachrome Duplicating Film, each emulsion batch is extremely inconsistent, calling for the use of CC filters to correct the color.

Color compensating filters are available in yellow, magenta, cyan, red, green, and blue, each in densities ranging from .05 to .50. A filter designated CC30M, for example, is a magenta CC filter with a .30 density.

To test for color correctness on any emulsion batch, use a Kodak 18-percent-reflectance neutral gray card. Make the test with electronic flash indoors, because it is a consistent light, while outside light may vary considerably in tone from day to day. To check for flesh tone, photograph a person wearing a white shirt holding the card, preferably while standing before a white or gray wall. Shoot about five exposures, one frame normal, one ½ and a full stop overexposed, one ½ and a full stop underexposed. When the film is developed, the gray in the image should match the gray card. Incidentally, for consistency it is advisable to have the film developed by Kodak, as even the best professional color lab can, occasionally, have color balance problems.

CC filters come in gel form, approximately 3-inches (7.6 cm) square. Gel holders are available to fit the largest lens you own, and adapt to fit smaller lenses through the use of reducing rings. I prefer to tape the gel over the rear element of the lens, cutting it to fit. I use matte finish cellophane tape, making sure the tape does not touch the glass element itself, or interfere with the mechanism of the lens. Used this way, the CC filter is less apt to scratch or become dusty.

Almost no exposure compensation is required unless you use a dense CC filter, and then only a minor compensation of about ½ stop would be needed.

Yellow filters eliminate the blue tones on rainy days, and give a warm feeling to sunset or early morning photographs when the light is low and the shadows long. Orange filters are excellent for sunsets. Brown filters can be used to achieve something of a sepia tone look for a period photograph when using color film. In my opinion, dark green filters are not of much use, although light green can gently tone a forest scene.

An interesting effect can be achieved by using several color filters when making a multiple exposure, resulting in normal color in all stationary subjects, and varicolored effects in those subjects that move. This technique is further discussed in the section on multiple exposure. Primarily, however, I use contrast filters for specific elements that will be added later to an overall normally colored image.

Depending on the density of the color filter, an exposure increase may be needed.

At White Sands, New Mexico, I used an 18mm lens and hand-held a red gel over half the lens to add color to the billowing black clouds that shortly brought torrential rains.

I photographed the original, rather colorless factory without a filter, then used an 80B (blue) filter in duplication to add color. The reflective "water" is actually the polished top of my car.

Lens Attachments

MULTI-IMAGE PRISM

A multi-image prism is made from optical glass that has been ground to make facets or planes on the glass. The number of images produced is the same as the number of facets, ranging usually from two to six. The glass is in a freely rotating mount that can be turned to reposition the images, and the mount attaches to the camera lens with the use of an adapter ring.

One area of the multi-image prism shows the image as it actually appears, while the other images either surround or overlap the principal, usually central, image. As the mount is rotated, the principal image remains stationary, while the secondary images revolve around it.

Because the mount is deep, the multi-image prism causes vignetting when used with a wide-angle lens. At small f-stops, as the depth of field increases, the images can be too sharply divided by the facet line. For these reasons, the prisms are better used with normal- or moderate-telephotos, and at medium f-stops. Wider f-stops can result in a loss of image sharpness and contrast on the outer images (with less color saturation as an additional drawback) but the images blend together without any apparent dividing line. Always check the depth-of-field preview button to view the subject at the f-stop selected.

The only multi-image prism I use with regularity is the one providing for a stepped-off repetition of the principal subject. In this attachment, there is one principal and one secondary image that steps off in repeated portions of the principal. The image is produced by grinding the optical glass so that one half of the glass remains clear, while the other half is ground in parallel planes, each approximately ¼-inch wide.

The repeater can be used successfully to imitate the effect of a repetitive strobe on a stationary subject, and thereby give a feeling of motion. It can also provide layered horizon lines over landscapes. I cut color gels in strips and attach them to the planes of the attachment with clear cellophane tape along the very edge of each strip. That results in an image with normal color on the half of the film frame covered by the clear glass, and stepped off colors on each repeated layer.

I also occasionally use a multi-image prism while zooming during a long exposure. The zoom tends to somewhat disguise the otherwise conspicuous multi-image effect. Consider also the effect possible while rotating the prism during a long exposure.

Unfortunately, most multi-image prism effects are so easy to spot

For this photograph of a single circuit board, I used a six-shooter, multi-image prism while zooming with a 35–70mm zoom lens.

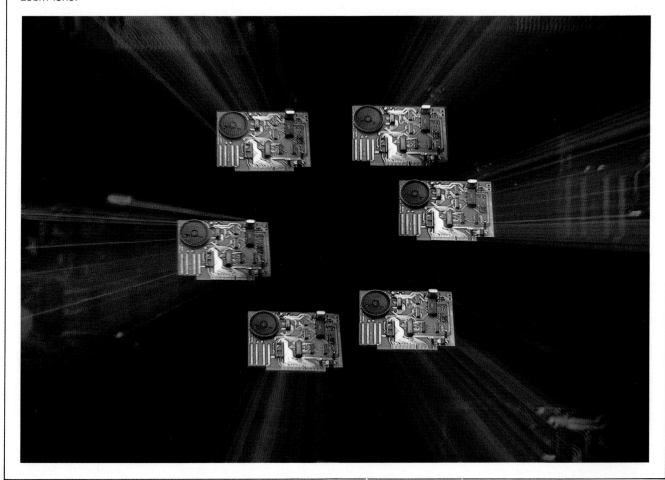

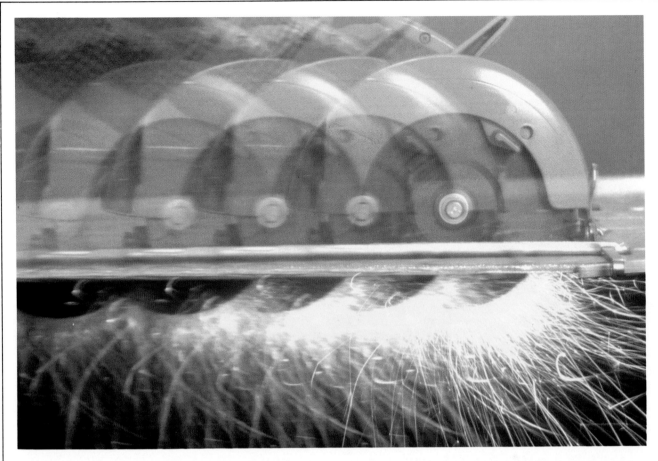

Each of these images of the saw was photographed with a filter to simulate motion. The upper version shows a repeater filter producing multiple images, the lower version shows the use of a Motion Maker to streak the rear part of the saw. In each case, I wanted additional drama and the feeling of power, so a sparkler was placed at the front edge of the saw blade to produce sparks.

in any photograph that they quickly become tiresome when used more than once. Only a specific creative idea justifies their use, and although it is amusing to look at the world through the prism, it is unbelievably boring to look at several photographs shot with the same or similar prisms. Use them with great discretion, or not at all.

THE KALEIDOSCOPE

The kaleidoscope I use was one I made myself in response to the needs of an ad I was assigned to shoot. I have not seen another on the market, so should you want one, you must make it yourself, as I did. Mine is composed of three pieces of front-surfaced mirror to provide an excellent reflected image. It attaches to the camera lens by means of a filter adapter ring.

The ad that inspired the kaleidoscope called for fragmented images of a woman's face. I have used the kaleidoscope only twice since then for assignments, once when the job called for a changed outline of a world map, and once when I had to make a design from a group of brightly colored pills. I have also experimented with the kaleidoscope for shooting flowers, jewelry, and people. It allows more variety in the resulting image than does a multi-image prism, because it is not always instantly recognizable, depending on the designs one can invent with the images. Used in conjunction with other lens attachments and filters, additional effects can be achieved. However, although it is great fun to look at the world through a kaleidoscope, more than one or two such images in a portfolio is too many. I certainly don't begrudge the time I spent making and

experimenting with my kaleidoscope, though. My original $20 investment has earned several thousand dollars, and that is a substantial return!

The kaleidoscope is best used with wide-angle lenses. These provide sufficient size in the central image and in the fragments. They can be focused close enough to make interesting design patterns, and offer

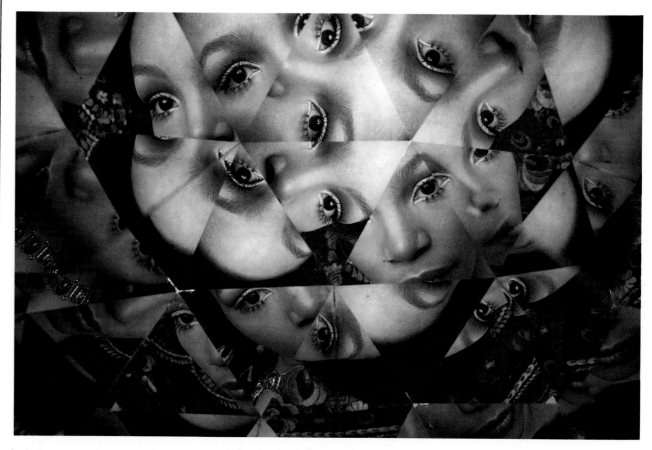

I photographed the woman's eyes through the kaleidoscope with a 28mm lens. The model was lit with a single umbrella above and in front of her, the bounced light aimed toward her face. I wanted bright colors in the background, so I hung a multicolored tapestry behind the model, and it reflected in the kaleidoscope to produce a colorful image.

sufficient depth of field to retain sharpness throughout the fragments. I prefer using a 28 mm lens. Telephoto lenses, for example, do not permit close focus, and the fragmented images will be unsharp. Any filter or lens attachment you want to add should be placed between the lens and the kaleidoscope. Shooting with smaller f-stops does bring the dividing lines of the mirrors into sharper focus, but allows enough depth of field in the image to produce what I feel is a stronger and better image overall.

THE MATTE BOX

The matte box is a cubical black box, 4-inches square. It attaches to the front of the camera lens with an attachment ring. The top of the box has a hinged door, the front is open, and the rear attaches to the lens so that the camera views through the box. Its interior is painted flat black to prevent any stray light from reflecting inside, and there are vertical parallel slots on the sides of the box to hold $4'' \times 4''$ pieces of glass or black matte board.

The glass and matte board squares are used to make masks by cutting a design out of the board with a mat knife. A reverse mask to use for double exposure can be made by spraying flat black paint through the board's cutout and onto the glass. The first exposure can be made with one of the masks, and the black section will prevent that portion of the film from exposing, allowing a second exposure to be placed within the area when the other mask is in place. The sharpness of the edge between combined images depends on three factors.

The closer the camera to the subject, the sharper the edge, because the necessary depth of field required by a close subject brings the edge of the mask within the area of focus. For a soft edge, increase the subject to camera distance.

The smaller the f-stop, the sharper the edge, because of the increased depth of field provided by the smaller f-stop. A wide f-stop yields a softer edge. When masking for double exposure, never change f-stops between shooting the two exposures. If a change in exposure is needed, change shutter speeds, but retain the same degree of edge sharpness, whether soft or hard, between exposures. Otherwise, the two edges will not blend properly.

The closer the mask is placed to the camera lens within the matte box, the softer the edge will be. As it moves farther from the lens it comes more within the area of depth of field and thus becomes sharper.

When attaching the matte box to the camera lens, always tape the

connection of lens barrel and matte box retaining ring. The tape helps secure the matte box and keep it more stable, so that it will not easily be jarred out of alignment while changing masks.

Vignetting Effects

Photographing a single exposure through a cutout mask creates simple vignetting effects, so that the edges of the image seem to fade softly into black. The shape of the cutout determines the shape of the vignetted edge. More creatively, the matte box is used with two masks, one of board and one of glass, made into a reverse mask as described above. A double exposure allows you to position the subject so that it appears to be floating within another background.

You can double expose a single subject twice against the same background and make it appear as though the subject has an identical twin. Children love this effect—even older children like myself. In fact, one of the first photographs I shot with my matte box was a twin photo of me talking with myself. The method of shooting twins is the same as above, using reverse masks so that one mask completely blocks half of the frame, allowing the other half to expose normally, and then reversing the mask. The effect necessitates placing the camera on a tripod. Have the subject stand on one side of the frame for exposure, then move to the other side after you have reversed the mask for the second exposure. Be very careful not to bump the tripod or change the camera position between exposures. The background looks perfectly normal and undisturbed. Films showing an actor with an identical twin are shot with a matte box on the movie camera as the scene is played twice, once for each twin.

Soft-Focus Effects

Soft-focus effects can be achieved by using one of the clear glass masks and smearing it very lightly with a tiny bit of petroleum jelly. No matter what effect you plan, always check the depth-of-field preview button before shooting to see the image at your selected f-stop.

Coat the entire glass with a very thin film of jelly for a dream-like effect to the entire image.

A swirl effect can be made by smearing the jelly in straight streaks from the center to the edges of the glass in a starburst pattern. You may want to leave the center clear for the subject.

A zoom or starburst effect can be created by smearing the jelly from the center in concentric circles to the edges. Leave the center area open for the subject, and the result will be a zoom effect in which the subject remains undistorted by the streaking, and only the background zooms.

Montage Effects

Interesting montage effects can be made by obtaining a beam splitter (or two-way mirror) sized to fit diagonally within the box, so that its rear edge rests across the box beneath the camera lens opening, and its front edge rests above the front opening of the box. The silvered edge of the mirror should be up, facing the hinged lid. When the lid is opened, the lens views as usual out the front open end of the box, through the nonreflective side of the mirror, but it also views the reflected image available from the other side of the mirror. Thus one photograph can be made that shows a subject positioned in front of the box, but makes the subject appear to also be seen within the clouds reflected from above the open lid. When the front subject is standing against an uncluttered background, the effect is much more striking.

To control the relative brightness of each image, purchase two sheets of polarizing gels. Hold them sandwiched together up to a light, and turn one until together they darken and block the light as completely as possible. They are then cross polarized. Place one gel over the front and one over the top opening of the box. Place a regular polarizing filter on the camera lens before attaching it to the matte box. When the lens filter is rotated within its mounting, it will darken first one view and then the other, allowing you to dial the degree of brightness desired in each of the two available images.

In the Darkroom

All the above matte box techniques, with the exception of the beam splitter, can be used successfully in the darkroom, if desired, by placing the matte box on the enlarger. However, I prefer to use the matte box only on the camera, and use the darkroom for other special effects.

With the camera on a tripod, I used the matte box and twin effect matte, shooting with a 50mm lens at f/5.6. The entire roll of register-marked film was shot, then rewound and re-exposed without changing the f/stop, with the mask and model's positions reversed to produce the second "twin."

How to Make a Kaleidoscope

MATERIALS

Gather together the following:

1. Three pieces of mirror, 5-inches wide, 10-inches long, and ⅛-inch thick. It is best to purchase them already cut from a glazier. Although regular mirror is acceptable, the more expensive front surface mirror reflects the image at the surface of the glass, rather than from the rear of the silvered glass. If you touch your finger to the surface of regular mirror, there is an apparent gap between the tip of the finger and its reflection. Front surface mirror eliminates the gap, but must be treated with care as it scratches very easily.
2. Epoxy glue is available at any hardware store. It is packaged in two tubes that, when mixed, form an excellent bonding glue. Choose the rapid drying type if available.
3. A filter adapter ring should fit the widest angle lens you own. Step down rings can be used to fit successively smaller lenses.
4. Hard illustration board, about ¼-inch thick, preferably black, can be purchased from an art supply store. You will need only enough to make an equilateral triangle, 5 inches on each side.
5. Black plastic or black photo tape, about 1 inch in width, is used to help hold the mirror sections together, especially while the epoxy dries.
6. Flat black paint, preferably in a spray can for easy application, may be necessary if the hard illustration board is any other color but flat black.

ASSEMBLY

To make the kaleidoscope, proceed as follows:

1. Cut the hard illustration board into an equilateral triangle, 5 inches on each side.
2. Lay the filter adapter ring in the exact center of the triangle, and pencil a thin line completely around the ring as a cutting guide.
3. With a mat knife and sharp blade, cut out the circle.
4. Line the cut hole with epoxy glue and place the filter adapter ring inside. Use extreme care not to get epoxy on the filter adapter's threads, or it will not screw into the lens. Allow the glue to dry thoroughly before proceeding.
5. When the glue is dry, if the hard illustration board triangle is not black, paint the side that faces away from the adapter ring threads.
6. Put epoxy on the long edges of each of the three mirrors, but use caution not to get the epoxy on the mirror surface.
7. Form a triangular tube from the mirrors with their reflective surfaces to the inside. Wrap tape around the mirrors to hold them securely until the epoxy dries.
8. When the paint is dry on the hard illustration board triangle, put epoxy on its edges and place it over one end of the mirror tube. It should fit perfectly, and will help to hold the mirrors in exact alignment. Keep the triangle flush with the outside edge of the mirrors.
9. Coat the entire area where the illustration board triangle and mirrors are in contact with a heavy coat of epoxy, and let it dry thoroughly.
10. Cover the mirror seams with black tape to prevent any stray light from entering the kaleidoscope.

When you are ready to use the kaleidoscope, screw the filter adapter ring into the filter threads on the lens. It is necessary to use one hand to support the kaleidoscope at all times when shooting, even when the camera is on a tripod, because the mirrors are quite heavy. Fortunately, the camera is rarely on a tripod when using a kaleidoscope, as the goal is versatility, and that requires free movement for inventive composition.

For a pharmaceutical client, I wanted a photograph of pills that was not the usual static array of pills and bottles. The pills were so beautiful that I decided to use the kaleidoscope to produce an abstract design. That way, the client could lay type over the picture without interfering with the continuity of the image. I chose a 28mm lens because it provides maximum depth-of-field along the interior of the kaleidoscope while retaining good subject size. A longer focal length lens would not provide sufficient depth-of-field, while a wider angle lens would yield too small a subject image. A kaleidoscope with different length might be best used with another choice of lens, but for the kaleidoscope I use, a 28mm lens is ideal.

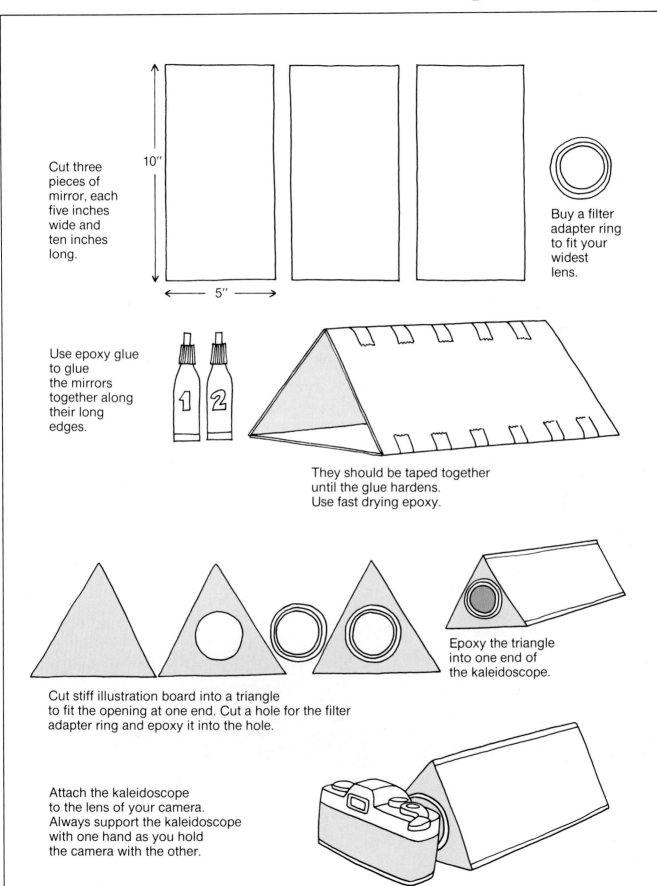

Cut three pieces of mirror, each five inches wide and ten inches long.

10"

5"

Buy a filter adapter ring to fit your widest lens.

Use epoxy glue to glue the mirrors together along their long edges.

They should be taped together until the glue hardens. Use fast drying epoxy.

Cut stiff illustration board into a triangle to fit the opening at one end. Cut a hole for the filter adapter ring and epoxy it into the hole.

Epoxy the triangle into one end of the kaleidoscope.

Attach the kaleidoscope to the lens of your camera. Always support the kaleidoscope with one hand as you hold the camera with the other.

How to Make a Matte Box

Many of the so-called matte boxes available from photo suppliers are in actuality not much more than glorified lens shades. When in the form of collapsible bellows, they are unsteady, and may allow the matte mask to shift slightly when changing masks, causing misalignment of the masked image. The matte box you build yourself should be more rigid.

MATERIALS

Gather together the following:

1. A box, preferably cubical. You may be able to find a ready-made box of lightweight wood. Even a cigar box is adequate, although you can easily assemble a cubical box from hard illustration board or heavy cardboard. The box must have a hinged top and an open front.
2. A filter adapter ring should be selected to fit your normal (50mm) lens. Step down rings can be used to fit successively smaller diameter lenses.
3. Matte board or illustration board, ¼-inch thick, can be purchased at an art supply store. You will need enough to make about ten mattes that fit snugly vertical into the diameter of the box interior. If the box is cubical, the mattes offer more versatility, as they can be used so that any side is up, and the mattes will fit equally well in any position. You must also have enough to make twenty strips approximately ¼-inch wide by the interior height of the box, to serve as slots for the masks.
4. Epoxy glue forms an excellent bond, but any good glue can be used for positioning the matte slots along the bottom of the box. The epoxy is best for gluing the filter adapter ring to the box.
5. Flat black paint, preferably in a spray can for easy application.
6. Clear window glass, enough to make approximately ten masks to fit the vertical interior of the box. These can be cut to size by a glazier. If you choose to cut them

yourself, you should allow extra glass for breakage, and will need a glass cutting tool.
7. A straight-edge, ruler, and sharp mat knife.

ASSEMBLY

To make the matte box, proceed as follows:

1. Be sure the boxtop is hinged, and remove the front of the box.
2. Cut a hole to fit the filter adapter ring, placing the hole in the exact center of the box wall opposite its open front.
3. Line the hole with epoxy glue and place the retaining ring inside, so that the threads protrude outside the box. Be careful not to get any epoxy on the threads themselves, or they will not screw into the lens.
4. Measure and cut the matte board into 20 narrow strips, approximately ¼-inch wide and the height of the box interior. These form the slots within which the masks are placed.
5. Glue the slots vertically to both sides of the box interior, making sure that they remain absolutely parallel to each other. Place ten on each side, ¼-inch apart.
6. When the glue is dry, spray the interior of the box with flat black paint to prevent stray light from reflecting inside.
7. Measure and cut the matte board into ten masks that fit snugly into the slots. The fit should be tight enough to prohibit shifting, but loose enough that they may be easily inserted and easily removed.
8. Have the window glass cut into masks the same size as the matte masks.

You can make positive and negative masks by sketching and then cutting out a design on a matte mask, then taping the matte to one of the glass mattes and spray painting the whole with flat black paint. Wait until the paint is fully dry before removing the tape and separating the glass and matte masks. The mask for the twin effect is made by using one piece of glass and spraying exactly half of it flat black.

The matte box with positive and negative glass masks, black mat board masks, and spray paint.

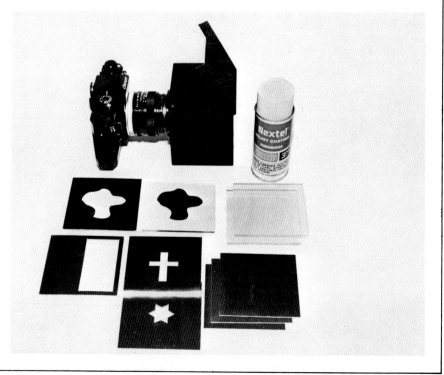

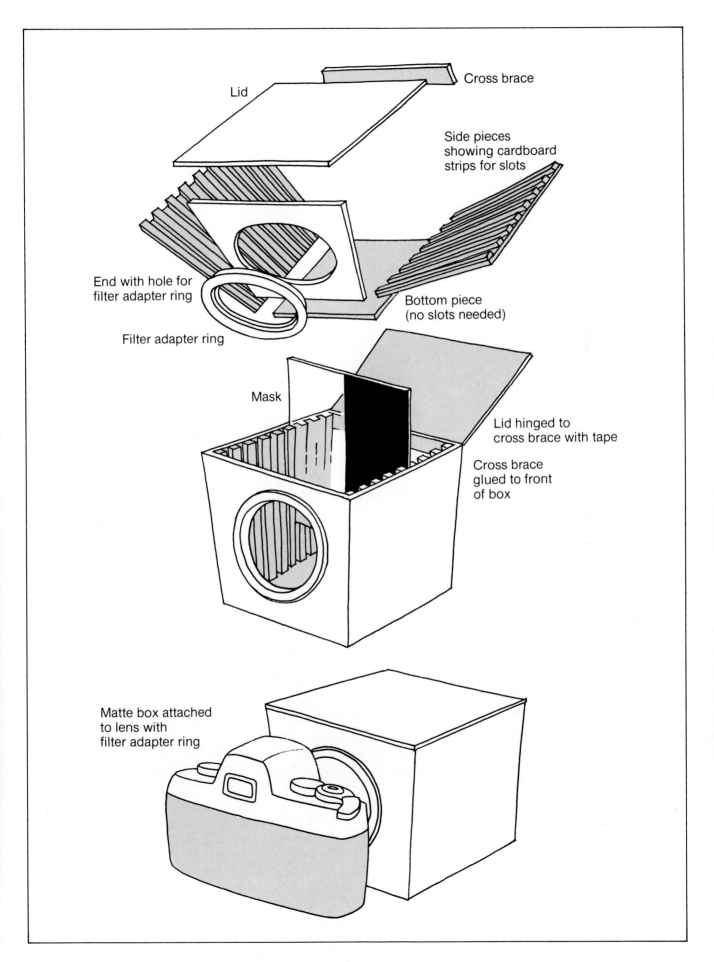

Cross brace

Lid

Side pieces
showing cardboard
strips for slots

End with hole for
filter adapter ring

Bottom piece
(no slots needed)

Filter adapter ring

Mask

Lid hinged to
cross brace with tape

Cross brace
glued to front
of box

Matte box attached
to lens with
filter adapter ring

CONVEYING A SENSE OF MOTION

For the image of the weight lifter, we wanted multiple images suggesting movement, but not as many as repetitive strobe might supply. For selective control, the strobe would have to be fired manually. I used a 90mm lens on a 2¼-square format camera, setting the exposure on "B," but turning the strobe's modeling light off to prevent any blur effect from the tungsten light between flash exposures. The model, actor Gordon Press, was positioned against a black velvet background. I placed two strobes with umbrellas, one on either side of the camera, for front light, and one umbrella on a boom above and to the rear of the model for additional back light. As he began lifting the weights, I manually fired the front strobes. When the weights were held overhead, I fired the front and rear strobes together. This produced a softer edge around the model for the three lower exposures, and a well defined edge for the final image. Since we used real weights and reshot quite a few times, this was a good workout for Gordon! Art director: Fred Sklenar

When I was teaching the Focus 2000 workshops, I met a photographer who had returned from Europe after making special travel arrangements in his vacation so that he could spend time photographing the LeMans automobile race. The weather had been perfect, he told me, and the race as exciting as he'd hoped, but he was vastly disappointed in his pictures. He had reasonably assumed that a high-speed moving object like a racecar should be photographed with a high shutter speed, and he had chosen 1/1000 sec. Instead of capturing the thrill of the wildly racing automobiles, the shutter speed had effectively frozen the action, and the cars looked as though they were neatly parked on the roadway! He had neglected to previsualize the image in his mind. A controlled amount of blur will show that the subject is in motion.

There are times, of course, when you may want to absolutely freeze the action. Some of the most delightful and fascinating photographs I have ever seen were those showing insects and hummingbirds in frozen flight. The photographer had gone to a great deal of trouble to eliminate any blurring in the motion. However, in cases such as this, when a photographer wants to totally freeze action, the subject's movement is usually taken for granted. The bird needs only its position to suggest movement, much like a ballerina at the height of her leap or a diver suspended momentarily above the placid water. The car needs a certain degree of blur, the visual key that says *wizz* in our minds as we see the photograph.

That feeling of *wizz* adds excitement to the image. Because I want my photographs to be exciting, I often incorporate movement within the photographic concept, whether actual, impending, or implied. The movement does not always have to be of enormous speed. Sometimes floating is more exciting an idea than falling, for example. Whatever my aim, previsualization and a preliminary sketch allow me to gain as much control of the image as possible before I pick up the camera.

Timing is essential to control, and practice produces more professional timing. You must learn how to coordinate what the eye sees with what the mind knows the camera will see, and at what instant the action will occur. This effort can be complex, but many worthwhile photographic techniques are. With practice it will come easier, and the guesses you make will be educated guesses. Practice, however, involves shooting film, and many inexperienced photographers complain that after shooting two whole rolls they still were unable to capture the desired action shot.

Fortunately, the type of motion I shoot is usually planned and structured, relying less on the chance appearance of wildlife or the unexpected play of the sports arena, and more on the excitement of the idea I create and generate in the studio. Still, I don't hesitate to use up film and Polaroids in search of that minor nuance that makes movement, once captured, memorable. In photographing motion, you must also be willing to experiment and use film, since the results are always more varied than in any other aspect of photography.

To gain further control, I don't hesitate to simulate motion when that simulation may be the simplest and quickest method of achieving the effect.

The Basics of Photographing Action

CONTROLLING EXPOSURE FOR EFFECTS ON MOVEMENT

Shutter speed and f-stop adjustments control exposure, but depending on whether your intent is to freeze motion, show blur, or combine the two, the subject's speed, the equipment used, and the light conditions will influence your decisions on manipulating that exposure.

Film

Film should be selected according to the way you want to photograph the moving subject. Slow film, like Kodachrome 25, is excellent for producing a blurred image. An increase in film speed allows an increase in the shutter speed. Ektachrome 400, for example, provides a 4-stop increase from Kodachrome 25, allowing the shutter speed at any given f-stop to increase by four stops. Faster film freezes motion well, requiring less light for exposure, but producing more grain in the film quality.

Incidentally, Ektachrome 400 can be push processed by a professional color lab three full stops, allowing you to shoot as though it were ASA 3200. The trade-off is an extreme amount of grain and a much more yellow cast to the film, with fairly poor resolution and contrast, versus photographing a moving subject under relatively low light conditions. For each stop you plan to push, add a 5CC blue filter to compensate for the increasingly yellow tone.

Subject Speed and Direction

Subject speed and direction determine the shutter speed to select for freezing or blurring the action. A fast subject moving parallel to the film plane requires a faster shutter speed than would the same subject moving toward or away from the camera position. The closer any subject comes to the camera, the faster its apparent speed.

If you are planning a blur, remember that the longer the shutter is open on the moving subject, the less detail recorded on the film. A very long exposure leaves only a ghost image where the subject passed, or even records nothing but the background. Any section of the subject that moves slower than another, or that pauses in the movement, will record more sharply.

Available Light

The light available outdoors may be too bright to allow a slow enough shutter speed for a controlled blur. If changing to a slower film is impossible or inconvenient, neutral density filters can be placed over the lens to reduce the light. ND filters range in density from .1, requiring a ⅓-stop exposure increase, to 4.0, calling for a 13⅓-stop increase. Each .3 increase in density requires a full stop more exposure. Filters are available that allow you to dial variations of density within a selected range. A polarizing filter is the equivalent of a 2-stop, ND .6 filter.

If you must use a high-density filter, it may be difficult to see through the filter in order to focus. Any filter shifts focus by slightly interfering with the path of light, so don't try to add the filter after focusing without it. Rather, focus through a low density filter, then remove it and add the heavier density filter without changing the focus.

Interestingly, using extremely dense ND filters to produce very long exposures causes only the stationary objects to record on film. Moving objects are not recorded, because they appear in the frame too briefly to imprint their image. This is how disaster movies are photographed to depict deserted superhighways and city streets empty of pedestrians and traffic.

In the studio, the amount of light can be changed with ease by decreasing or increasing the amount of power used, the number of lights, or their distance from the subject. Outdoors, too little light may be corrected by using fill-in flash if the flash can be positioned close enough to the subject to make it worthwhile. I am always amused to see people leap up to pop their flash when they are sitting in the last row of the stadium. They will get a fine exposure of all the bald heads for several rows in front of them.

LENSES

The best lens for shooting any motion depends on the subject's speed and the distance from the camera.

A fixed focal length, wide angle to medium, is better for shooting blur because it provides a smaller image size of the subject and allows the photographer more freedom of composition. More area can be retained in front of the subject so that motion seems to have room to proceed, and more area is available behind the subject for the blur. You can always tighten the composition later by enlarging it in duplication, but it is impossible to add additional space when the whole film frame has been used. A fast subject will create a greater area of blur on the film frame, and space must be allotted for it.

For following action, a zoom lens should have a single control for adjusting both focus and zoom, or you will need a third arm to hold the camera as you try to follow action. Even with the camera secure on a tripod, the process of adjusting with one hand on zoom and the other on focus is awkward. A single-control zoom is preferable for action that moves toward and away from the camera.

A telephoto lens is the natural choice for distant action, but remember that the reciprocal of the focal length of the lens in millimeters is the minimum speed at which the lens can be handheld for sharp images. In other words, a 500mm lens requires a minimum shutter speed of 1/500 sec., and preferably faster.

BACKGROUND—FOREGROUND TONE RELATIONSHIPS

Background-foreground tone relationships can be used to make the moving image appear sharper to the eye. An illusion of image sharpness is produced when the tonal differences between subject and background are extreme, with one very light and one very dark. When shooting motion, however, the back-

ground must be darker than the subject. Dark subjects record badly (or not at all) against light backgrounds when the motion is blurred, because the light background will have pre-exposed the area where you want to place the darker blur. This leaves the emulsion unable to record the darker image. The ideal relationship would be a white subject against a black background.

When shooting blurred motion, the color of the subject will be carried into the blur. Therefore, consider the color that will result when the subject color streaks over and combines with the background color.

PLANNING FOR ACTION SHOTS

Research and planning involves sketching the idea on paper and looking before you shoot. If you are attempting to capture spontaneous motion that cannot be controlled, take the time to select a good vantage point from which to shoot, and observe how that particular motion usually proceeds. That way you are ready to capture it at the best moment possible. If the motion shot can be pre-planned, review the effect you want to achieve beforehand, and study the sketch to find any difficulties or trouble spots ahead of time. This process is as important as the shooting itself, so do not disregard its value.

I photographed the model in the studio against a black background, using a repetitive strobe and 50mm lens. I rewound and realigned the film, then made a double exposure outdoors, panning the background so it would blur. I made sure the background area of the second exposure was dark in the section where the runner's body had been positioned in the first exposure, as I wanted only selective streaking.

The Moving Subject

When the subject is in motion, you must decide if you want to capture frozen movement, allow a certain amount of blur, or combine the two. Surprises are part of the interest in shooting motion, and even the most experienced professional cannot always predict the exact outcome. The camera records a moment that is too brief for the eye and mind to separate from total subject movement. Because you want the surprises to provide a happy variety, any guess you make should be an educated one, coming from a strong base of previous testing and note keeping.

FREEZING MOTION

The freezing of subject motion, assuming enough light can be provided, is easy enough to achieve by selecting a fast enough shutter speed, and then balancing the *f*-stop accordingly for good exposure. Any frozen image should imply that continued movement is expected, and the interest should be in seeing the motion momentarily stopped.

A brief moment of suspended motion is apparent in many sports, and often provides the ultimate excitement of the action. The peak action that occurs when a basketball player hangs momentarily suspended at the height of a leap to the basket, can be frozen successfully with a shutter speed half as fast as that needed during the player's frantic drive to the basket, or the return of the player to the floor.

Remember that you can't afford to wait until you see the peak action in the viewfinder, but must learn to anticipate that moment. The camera's mirror flips up to block your view at the moment of exposure, so if you have seen the action through the viewfinder, you have missed capturing it on film.

I set the camera for a one second exposure with a 50mm lens. The image began with the robot-held stone hammer resting on its apparent final position, on the spike. The flash was fired for the sharp final image, and the robot hand and the hammer immediately raised in an arc. The tungsten modeling light on the strobe supplied the light for a blurred trail during the one second exposure. Art director: Ann Sjogren.

BLURRING

Blur gives a strong feeling of movement and speed. The length of the blur is controlled by subject's speed and the length of time the shutter remains open during exposure. If the camera is panned, that too will influence the blur's length.

Intensity of the blur is controlled by the *f*-stop selected and the amount of light on the subject. The blur should always be brighter in intensity than the background. Always check the background across which the subject will be traveling, as any bright light, white area, or color lighter than the subject, will overexpose the film emulsion and no blur will record in that area.

Familiarize yourself with the amount of blur different shutter speeds produce on varying subjects. An excellent test can be made by using a slow film like Kodachrome 25 or Panatomic X (ASA 32). To provide a source of movement, find a blacktop roadway that you can view from a high vantage point, having a steady stream of automobiles traveling at a regular rate. The blacktop is an ideal dark background. Fire several frames at each of various speeds, from 1/30 sec. to a full second. This test can be made with the camera stationary or panned, taking into consideration that the speed of the pan will influence blur as will the shutter and subject speeds. Keeping notes is essential. For a more reliable panning speed, try to keep the front wheel of the car centered in the viewfinder.

Keeping the Camera Stationary

Keeping the camera stationary, preferably on a tripod, as the moving subject passes results in a sharply focused background and blur of only the subject. If the background is not particularly interesting, it can detract from the total effect. However, if the background provides an exciting setting for the speeding subject, be sure you have allowed sufficient depth of field to keep both in sharp focus. Even though the subject will be blurred, it must not be out of focus. The farther any image deviates from sharp focus, the more globular and undefined it becomes. The whole purpose of shooting blurred motion is to capture the idea of that particular subject's speed, and you must be able to define its shape to retain the excitement.

Panning

Panning the moving subject provides a better control of the blur. A slow pan provides more blur, while a faster pan that remains even with the subject provides less blur. You may even choose to pan in the direction opposite to the subject's movement, increasing the blur substantially. Most panning is done with the moving subject, however.

In panning, the background becomes severely blurred, the subject less so. To allow more leeway in the choice of shutter speeds, choose a medium speed film as you experiment with panning. After some experience, you may decide that another speed film is more suitable for the conditions of the moment, or for your own particular style.

Before shooting any film, practice the motion of panning. Place your feet about 18 inches apart, with knees bent slightly for flexibility. Support the camera with one hand, the end of the lens barrel with the other, and pivot smoothly from the hips, rotating your body to follow the moving subject.

When you pan, the camera's movement should be smooth. Look for the streak from a bright pinpoint of light or color in the background when you examine the developed film. The subject's blur may be uneven from the movement of the subject itself, but the background streaks indicate just how smooth the panning motion was.

COMBINING FREEZE MOTION AND BLUR

Combining freeze motion with blur is done by using both a high speed flash and available light. Outdoors the available light is provided by nature, indoors by a tungsten modeling light. The flash is usually synchronized with the camera in such a way that depressing the exposure button immediately fires the flash and freezes the motion. The duration of the slow shutter speed then allows the subject to blur as it proceeds across the film frame. This results in a sharp image followed immediately by a blur. For example, a person running from left to right will be caught with the flash in mid-frame, and the blur will then continue from mid-frame on as the subject runs off to the right. This makes the subject appear to be running backwards, with the blur in front of the frozen motion. Since the effect you seek is just the opposite, you must manipulate the procedure. For whatever process you choose, you will probably need a helper.

Place the camera on a tripod. Set the shutter on "B." Disconnect the flash sync cord from the camera. You will manually fire the flash. Open the shutter as the moving subject enters the field of view in front of the camera, then fire the flash manually, and quickly close the shutter. This will produce the blur behind the subject. Unfortunately, it requires perfect coordination on the photographer's part, and can be inaccurate. In fact, were I offered an assignment specifying that I had to shoot using this technique (especially outdoors) I would probably decline the job.

A technique that offers better control involves panning faster than the moving subject with the camera on a tripod for smoothness. Select the shutter speed for length of blur, as usual, and leave the sync cord connected between strobe and camera. When the subject is fully centered in the viewfinder, press the exposure button and immediately pan ahead of, and in the same direction as, the subject. Although easier than the previous method, this technique still leaves a good deal of room for error.

The ideal solution is to simply move the subject backwards! This is probably not a possible solution with runners and automobiles, but it nevertheless works well in the studio where conditions can be controlled precisely, and where you are working with a relatively small object. Photographing the blur of a

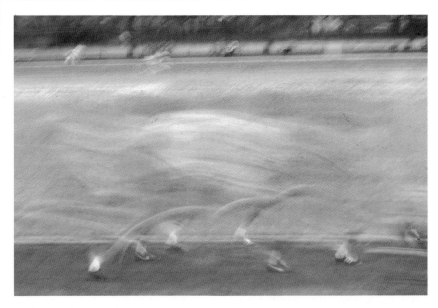

I was shooting some experimental images of motion, and photographed two runners. Because their feet paused for an instant as they touched the ground before taking the next step, that was the only part of their bodies remaining somewhat sharp. I shot with a 35mm lens, hand-held at an exposure of ½ sec.

hammer as it drives down to strike a nail can be done by starting the motion with the hammer on the nail, firing the flash, and immediately raising the hammer. This results in a sharp image of hammer on nail, and the blur of the hammer's trail as it drives, apparently, toward the nail.

Combining frozen action with blur presents a great many considerations to the photographer. Most of my work is done in the studio, where I can control conditions. However, if you are highly adventurous, you may consider combining freeze and blur when shooting outdoors. Should a client ask me to do it, I would agree only if all conditions are ideal, and prefer it if the shot could be done at night with the darkness providing the black background! Otherwise there would be too many variables. The shot may be fully set and ready to go, but I would probably spend so much time testing with Polaroids to perfect the effect that the sun would shift by the time I was ready to shoot. This would invalidate my tests, and require another set of tests! If, miraculously, all conditions were ideal—the background dark, the subject light—an outdoor exposure would proceed as follows:

1. Select the shutter speed for the amount of blur wanted. Let's assume you choose a full second exposure.

2. Take a meter reading of the subject to find the proper f-stop. If you use the camera's built-in meter, read only an important area of the subject—a runner's bright yellow T-shirt, for example. I prefer to then open up an additional full f-stop. An incident light meter gives a better reading, as it reads only the light falling on the subject. In any case, let's assume the incident meter read $f/8$, and the camera meter reading was $f/11$, so you open a stop to $f/8$.

3. A one second exposure at $f/8$ produces a balanced image, if the shot is simply a long exposure. However, it is not, but rather a long exposure combined with flash. The flash unit must be able to provide enough power to sufficiently brighten the subject in order to instantaneously expose the subject perfectly for $f/8$. If the strobe is not powerful enough to provide sufficient light, it may have to be moved closer to the subject, or additional strobes will have to be used.

4. All calculations can be tested with a Polaroid. The trailing blur should not be as bright as the frozen image. If it is as bright or brighter, there is not enough power coming from the strobe.

Indoors, the studio lights are controllable. I use a large piece of black velvet for a background. Black

paper is acceptable, but spill light will make the black overexpose to gray on film, creating a muddy tone in any blur passing across it. For shooting in the studio, combine freeze and blur as follows:

1. Select the shutter speed for the amount of blur wanted.

2. Balance the shutter speed chosen with the f-stop indicated by the flash meter or flash unit's guide number.

3. Be sure the blur intensity is not brighter than that of the frozen image. Check by shooting a Polaroid. If the blur is too bright, move the modeling light farther from the subject until a reading with an incident light meter shows the same f-stop as that selected for flash.

4. Because the blur is lit by a tungsten modeling light, its color will be yellower than that of the frozen image recorded by the flash. To balance the color, place a heat resistant, light blue (80B) theatrical gel over *only* the modeling light. If the modeling light and flash are in the same strobe head, it will be necessary to use a separate modeling light.

5. To provide a crisp, sharp image, position lights so that they strike only the subject, with little or no spill light contaminating the background. Sidelight, rimlight, or backlight are all good choices.

For many reasons, it may be easier on occasion to simulate movement by a stationary person or object, and there are various ways the photographer can approach this.

PANNING

Panning to simulate motion is easily controlled. The same procedure applies as is used for the moving subject, with the obvious advantage that the amount of pan totally controls the placement of blur and/or the sharp frozen image. The same restrictions also apply, with the use of a dark background and a bright subject recommended. Panning on a stationary subject can be used easily in combination with other motion effects, such as zoom or repetitive strobe, to produce further interesting variations on motion. The photographer has more control over subject direction, and can fully predict results, because there is no unwanted motion; only that supplied by the photographer.

ZOOMING

A zoom lens can simulate movement. When the subject is precisely centered in the viewfinder, zooming makes it appear to move directly at the camera, expanding equally in all directions. For any parts of a subject that are farther from the center, perhaps an outstretched arm, for example, the effect is magnified, and the arm will appear to zoom right off the edge of the film frame. An object placed off center in the viewfinder appears to move in the direction of the nearest edge of the frame. The object will seem to be rushing into the frame when you combine freeze and blur, while zooming from wide-angle to telephoto, because the sharp frozen image will be the actual offcenter position of the subject in the frame, and the streak provided by the zoom will appear to lead from the frame edge to the frozen image.

Unfortunately, most zoom lenses are not particularly sharp when used wide open. I prefer to set the lens at $f/11$ if possible, as this forces light to enter through the cen-

tral part of the lens which is always the best optical section of the lens glass. It also gives me good depth of field on the subject, providing leeway for any slight focusing error while zooming. The smaller f-stop is better too, because it allows me to use a longer exposure time for a longer, more controlled zoom.

The longer the zoom range, the longer the distance the subject can appear to travel. I use several zooms, a Spiratone 35−105mm, a Canon 35−70mm, and a Soligor 35−140mm. These are dual-control zooms, requiring focus with one control, zoom with another. For simulating motion with zoom, I prefer the dual control, since a single control might cause a slight focus error if the lens barrel were rotated at all during the long slow exposure while zooming. Some very inexpensive zoom lenses demand refocusing each time the zoom is used, and therefore cannot be used to simulate motion with zoom, as they are unable to retain focus during the process of zooming. Be sure, if purchasing a zoom lens, you select one with continuing focus ability.

I have developed a style and

technique of using zoom to simulate motion that works well for me, and gives good control of the image.

A black background, usually black velvet, prevents the zoomed image from becoming contaminated with other background colors. Many of my finished photographs appear as though the zooming subject was shot against another background. However, the subject was shot against black, then added to the other background at a later time, either by multiple exposure, or by montage in the darkroom. The advantage, of course, is that the subject appears to rush from, to, or across a stationary background, giving the further appearance of actual motion photographed at the scene.

The zoom subject must be correctly sized and positioned in the film frame. The composition, if it is complicated, should be carefully planned and sketched. Since some of my zooms are multiple exposures of various elements, I take time beforehand to exactly previsualize what I want the effect to be. Unusually large items can be controlled by making a print of the item, cutting it out carefully, placing it on

For *Modern Plastics* magazine, I had a print made of the red car and cut the car from the print. The cutout was placed on black paper and lit with an umbrella above and to the front, then shot with a 35–105mm zoom lens. I popped the strobe while zooming during a one second exposure. Art director: Bob Barravecchia.

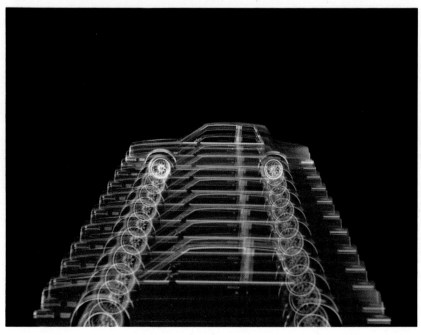

black to isolate it from the background, and then zooming on the manageably sized cutout.

If the subject is to appear to be rushing toward the camera and center of the film frame from a point of origin just off the edge of the frame, place it just off center in the frame, and determine its image size with the zoom at its longest focal length. If the subject must appear to be rushing away from the camera and toward the center of the frame from a point of origin just off the edge of the frame, it must be sized and placed while the zoom is at its shortest focal length.

For uniform control, always position and size the subject with the camera on a tripod. Preview the effect, noting how far the zoom makes the subject appear to travel across the film frame. It is usually better to have the subject appear as though its point of origin were just off the edge of the film, rather than somewhere within the film frame, as this makes the apparent movement seem to be a normal extension of continuous motion.

Focus the zoom lens at its longest focal length, no matter which way you intend to use the zoom. That way you will achieve the sharpest critical focus. With a single-control zoom, be careful not to inadvertently turn the barrel when zooming and throw the subject slightly out of focus.

When I combine a frozen image with zoomed motion, I use strobe lights in the studio, using the flash to freeze the action, and then zooming to provide the blur. The tungsten modeling light is covered, as recommended previously, with an 80B gel for balancing the strobe and tungsten light in the combination image. The only difference when I use zoom for simulating blurred motion, is that the shutter speed is set at "B" for greater control. The entire zoom can be completed before I manually close the shutter.

The same effect of frozen and blurred movement, simulated by zoom, can be achieved with tungsten lights. Balance the lighting for a one-second exposure, preferably at $f/11$ for good depth of field. Then set the shutter at "B." When you fire the shutter, pause for one second. That will yield a balanced exposure of the sharp image. Then zoom as usual. Of course, use tungsten film, preferably Kodachrome 40 or Ektachrome 50, and no blue gel.

With either tungsten or a combination of tungsten and strobe, the intensity of the blur can be controlled by the speed of the zoom. The slower the zoom, the stronger the intensity of the blur.

The advantage of shooting zoom motion using 35mm is that there are a great variety of zoom lenses available for this format. A disadvantage is that to shoot with Polaroid film, the photographer must purchase a special, very expensive Polaroid back for the 35mm camera. I don't own one, and for my simulated zoom motion have managed without one.

USING LENS ATTACHMENTS

The following are some of the lens attachments available for simulating motion with a stationary subject.

The *Motion Maker*

The *motion maker* is a rotating front-lens attachment. Half the optical glass is clear, permitting a normal image to be seen, while the other half curves downward toward the edge of the retaining ring, producing a streaking effect in all objects seen through that portion of the glass.

The streak effect is more pronounced when the subject is photographed against a dark background with the lens wide open. As the diaphragm of the lens closes down, it views through less of the curving glass, minimizing the streak effect, but increasing the depth of field to the extent that the dividing line between clear and curved glass begins to come into focus. With a wide-angle lens, the division becomes even more pronounced. A vignetting effect may be caused because the attachment is a full inch thick, and the field of view of the wide-angle lens may be cut off

Mechanix Illustrated magazine wanted a shot that would show various options a home computer can offer, including menu planning, budgeting, games, and music. I covered the screen with black flocked paper and photographed the computer against a black background. I used a 50mm lens, and lit the computer using an umbrella placed almost directly above and slightly in front of it. Each of the elements was similarly lit, and photographed against black to be self-masking. The tennis racquet, baseball, money, and plate of food were shot separately with a 35–105mm zoom lens which was zoomed during a one second exposure. The musical scale and the chessboard were each shot with a 20mm lens, and I used a Rainbow Repeater filter for color when shooting the scale. I pulled the three other elements: the moon (photographed with a 300mm lens), the stars, and the earth, from my stock file.

When each of the elements had been assembled, I took them into the darkroom. I first drew and sized the computer, since that was the most important element. I then sized, positioned, and sketched each element, and proceeded to enlarge them onto a sheet of 8x10 Ektachrome duplicating film. Since each element was shot against black, each was self-masked, and the main difficulty was in carefully positioning elements so that each would remain clear and visible. Art director: Andy Steigmeier.

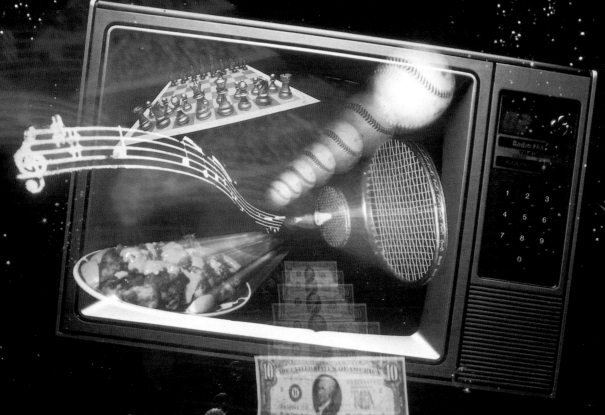

For the zooming "Expanding the Limits," I first had the words typeset, then photographed the type on 35mm Kodalith film with a 50mm macro lens. This produced clear letters against a totally black film background. I then placed the Kodalith slide into a projector, projected it onto a screen, and rephotographed it with a 35–105mm lens. Since the light from the projector is tungsten, I used an 80B corrective filter to convert the color for daylight Kodachrome 25, and also used a dark green filter for the color I wanted for the image. During the one second exposure, I zoomed, panning at the same time to produce a zooming image that moved upward in the final version.

To symbolize space age electronics used in tape recorders, I photographed this multiple exposure. The rounded circuit board was bent into the desired shape and lit from beneath. I shot it against a black velvet background, using a 20mm lens for distortion. Rewinding and realigning the film, I then shot the tape deck, using tungsten light and a 35–105mm lens. The machine was resting on black velvet, and during the one second exposure, I zoomed and panned in a wavy motion for the blur effect. An 80B filter corrected the tungsten light for the daylight balanced Kodachrome 25 film. Later, a cutout photograph of the earth was also exposed onto the same roll of film.

I wanted the record to appear to fly into the picture and hover in place. For the simulated repetitive strobe effect, I used a motion maker attachment on a 50mm lens, photographing the record actually motionless on top of an unseen film box. The feather symbolized a new lightweight turntable arm. The sunset was added to the image by montage.

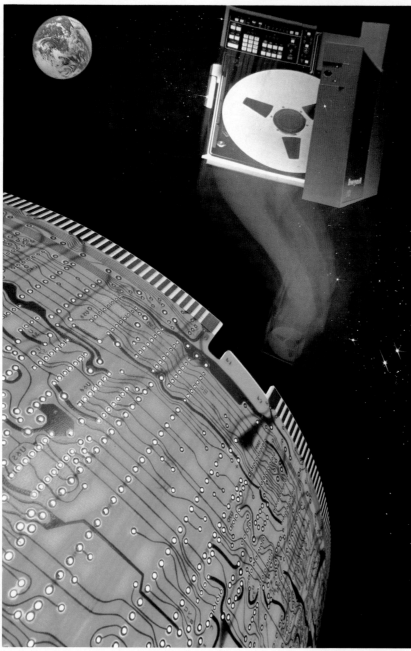

around its edges by the retaining ring of the glass. Therefore, the attachment is better used on a normal or telephoto lens with the diaphragm wide open.

The background influences the believability of the result, too. When a subject is photographed with the motion maker against a light or busy background, the curved glass streaks background and subject alike. Normal motion, which is presumably what you are trying to simulate, would never give this effect. For that reason, I use the motion maker only when I can shoot the subject against a black background that will not show any streaking, and then later place the streaked subject into another background with another technique.

The Repeater

The *repeater* is another rotating lens attachment previously described in the section on filters and lens attachments. It has all the same inherent problems of the motion maker described above, but it can be successfully used to simulate the effect of a repetitive strobe. Its use calls for much selective viewing, and as the *f*-stop is changed, the effect changes too. The maximum effect available occurs when the lens is wide open. Naturally it differs from actual repetitive strobe in that the subject will only be shown in one position with a repeater, and the variety of successive movement is not possible. However, if the aim is to show an object that appears to move in a succession of steps without varying its shape through the movement, the repeater will serve well.

USING PETROLEUM JELLY

A minute amount of petroleum jelly can be used on a plain filter or in the matte box to streak a selected area of the subject without contaminating the background. Never apply the jelly directly onto the front lens element. Only a tiny bit of petroleum jelly is necessary. Were you to shoot a roll of film every day using this technique, a small jar of petroleum jelly should last well over 100 years, so be conservative!

If you are in the midst of a shooting and don't have the availability of petroleum jelly, you can substitute a little of what I call, "nose grease". . . a bit of oil from the pores on the tip of your nose. They provide an ever ready and available source of oil to make a selective streak to simulate motion!

Because this streaking process may be desired only on a very selective section of the image, to exactly place the streak it is better to shoot with the camera on a tripod. Look through the viewfinder as you apply the jelly. When *f*-stops change, the effect will change, so always preview the depth of field. Smaller *f*-stops begin to draw the smear into the picture's depth of field, making it more obvious and less natural looking.

Plan the movement and apply the jelly accordingly. Jelly applied in a vertical streak makes motion appear in a horizontal streak. Applied in concentric circles, it provides a starburst effect. Applied as a starburst, it gives a swirl effect. Clean the filter after use by fogging it with your breath and wiping it with a lens tissue.

By firing a flash unit on a subject in rapid successive bursts, the subject's movement is frozen in multiple images.

EQUIPMENT

Equipment consists of strobe units capable of firing and recycling rapidly. I use Balcar's Monobloc, a powerful unit capable of delivering 600-watt-seconds of light in a single flash and recycling in less than a second when at full power. Used at ⅛ full power, it can deliver six flashes per second. These units are excellent for studio work, but they

Spiralite repeater flash,
5 flashes per second.

are expensive. If you want to experiment with repetitive strobe, small portable flash units are available that attach to the camera, operate on batteries, and can fire up to five flashes per second. The type of strobe lights used in discotheques can be used if their light is directed through the use of grids or barn doors, so that it falls only on the subject. I also have such a unit, and use it for photographing multiple strobe effects. It fires up to twelve flashes per second.

Balcar Monobloc,
6 flashes per second.

The faster the unit is required to flash, the less power is available per flash. To compensate, you must either open to a wider f-stop or use a higher-speed film. When the monobloc is set at ⅛ full power to deliver six flashes, it still provides enough light to shoot from a distance of 10 feet with Kodachrome 64, at f/5.6. For increased directionality and brightness, I flash the light into a silver reflective umbrella and bounce it onto the subject.

BACKGROUND

Background for repetitive flash must be black to obtain the best result, since the process is actually one of multiple exposure and consecutive flashes cause a light buildup on the background. Although each frozen image of the moving subject receives only enough exposure to properly freeze motion, the background receives exposure each time the strobe fires. After sev-

Edmund Scientific's repetitive strobe,
12 flashes per second.

eral exposures, even a black background can wash out to gray, and the gray can contaminate subject color, making it appear muddy.

As with multiple exposure, I use a 16′ × 20′ black velvet background made especially for this process. It can be suspended on a pulley system with the aid of grommets sewn into the fabric, and rolled up and out of the way on the ceiling when not in use. Black seamless paper is acceptable for the background material, but has more tendency to build up a gray tone as it is exposed.

Whatever material is used, the background should be large enough to comfortably allow the subject to complete the motion in the given area. It must also cover the floor in front of the subject.

SUBJECT

Subject tone and color must provide bright contrast against the black background. Models should wear bright garments, preferably white. Dark skin must be highlighted with oil or makeup to pick up reflections, or there will not be enough contrast between background and subject. Exposure cannot be increased to compensate, because that would cause the background to lighten to gray. Models with black or dark brown hair need a separate hair light, or their hair will tend to blend into the background.

REHEARSAL

Movement should be well rehearsed, until both you and the subject know the exact limits of the available area, and the exact duration in seconds that the action requires. The photographer must decide how many frozen images are necessary to achieve the desired result, and plan the number of flashes per second according to the duration of the movement. Sometimes the actual movement proceeds far too fast for the strobe unit to provide enough flashes for the number of frozen images wanted. If this is the case, the subject must slow the nat-

ural movement down, if possible. Unfortunately, one cannot fall slowly, but running can be slowed down, and a golf swing can be done in slow motion. Any motion that is slower than normal must be rehearsed until it feels comfortable to the person moving, and looks natural to the observer. When I wanted to shoot a tennis player hitting a ball, I did not want a high velocity tennis ball ricocheting around the studio. Instead, we crumpled a piece of white paper, and substituted it for the ball. The blurring white ball looked perfectly convincing, and I did not feel vulnerable standing behind the camera.

Movement is inherently somewhat unpredictable. To be certain the effect will be controlled, I have

The tennis player was photographed with a 50mm lens against a black velvet background, using three Balcar MonoBlocs flashing at 6 flashes per second. One strobe was placed on either side of the model, high above and slightly behind him, their silver umbrellas aimed to bounce light at him. The third silver umbrella was in front of the model near the camera position. I wanted separation between the model's dark hair and the dark background, so the front light was set for one stop less power than the back lights. The model swung his racquet at less than normal speed as I shot.

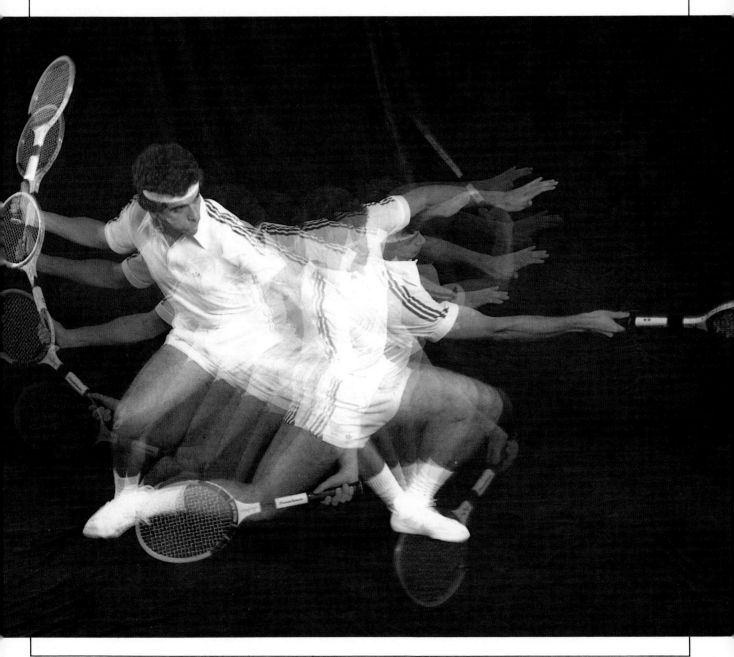

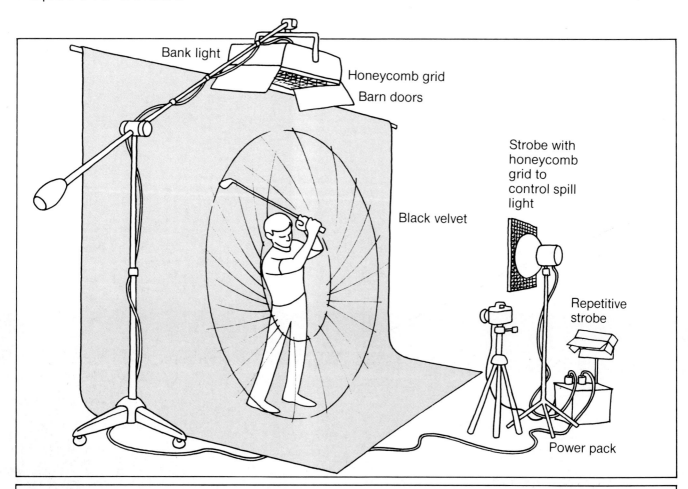

Bank light
Honeycomb grid
Barn doors
Strobe with honeycomb grid to control spill light
Black velvet
Repetitive strobe
Power pack

How the honeycomb grid works

Light rays from a regular diffused light source travel in all directions from the deflector

Light grid controls the direction of the light rays

Closeup of honeycomb grid

When a strobe unit recycles fast enough to produce multiple images, its power output is affected. Even with a unit as powerful as the MonoBloc, light should not be wasted as unwanted spill, but must be conserved for subject lighting. The light-directing honeycomb grid, made of lightweight aluminum painted black, directs all light output where it's needed. Directing the light also prevents the buildup of exposure from spill that can turn even a black velvet background to undesirable gray.

sometimes rehearsed a particular idea the day before the scheduled job, checking with a Polaroid until I was satisfied that the result would be what the client envisioned. It is never advisable to blithely agree to shoot a repetitive strobe assignment until you are absolutely certain you are in control of all the factors involved. I once was given a well-paying job to shoot an advertisement involving motion, not because I had been the first photographer the art director thought of when assigning

the job, but because the first photographer attempted to photograph frozen motion outdoors in unpredictable light, and had been unable to achieve the result the client wanted. Fortunately, I was at least the second photographer the art director had in mind, and I knew immediately how to proceed because I had rehearsed such situations before. The ad went well, and I got subsequent work from the satisfied art director.

POSITIONING THE STROBES

Strobe light placement should be as close to the subject as possible while remaining out of the camera view. Placement of the light affects the shape and exposure of the successive frozen images. Don't position the light in front of the subject, near the camera. The light will expose the subject from that angle, but may also overexpose the background, and will cause excessive light on overlapping images from

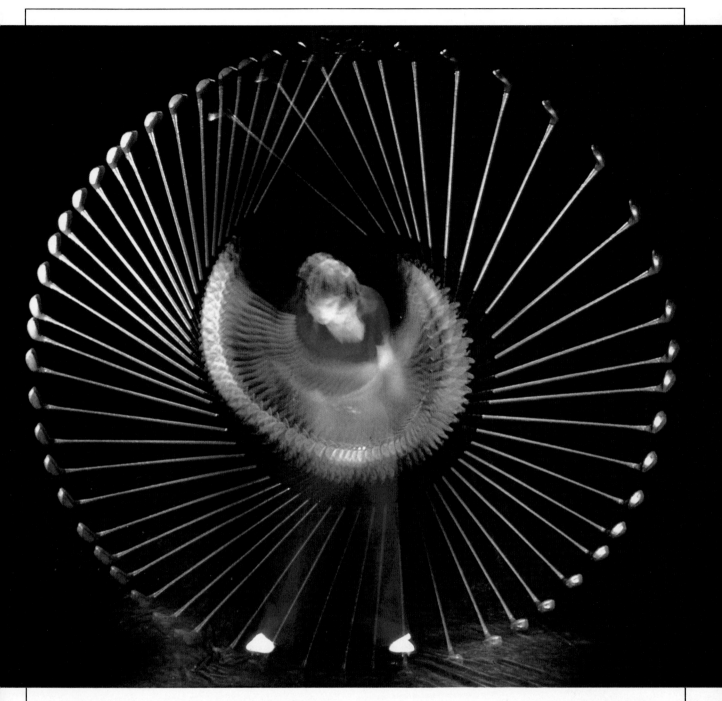

To produce the circular design effect of a golf swing, I had the model perform the action in slow motion. We rehearsed the movement thoroughly before shooting. The model wore dark clothing to prevent overexposure from a buildup of light during the many strobe flashes. Because the golf club's chrome shaft would otherwise have reflected the black background, I covered both head and shaft with white tape to increase reflectance and visibility.

One large bank light with a honeycomb grid was placed above and slightly behind the model's head. A reflector-hooded strobe with honeycomb grid was placed in front of the model near the camera position. The Edmund Scientific repetitive strobe was not powerful enough for lighting, but could be set at a controllable 4-flash-per-second speed. I used this unit as a triggering device, placing it next to my studio strobe. The studio strobe has a built-in slave that fired it each time the repetitive unit flashed. As the slow motion movement began, I held the shutter open for the duration of the golf swing and shot with a 28mm lens.

Imagine trying to photograph a speeding tennis ball in the confines of a studio, and manage it so that the manufacturer's name remained visible on the ball! I did this as a multiple exposure. The tennis ball was threaded onto a long piece of heavy-duty black thread. An assistant held the ends of the thread and slowly rolled the ball along a table, covered with black velvet, toward the estimated position of the racquet as I manually popped the strobe for a simulated repetitive strobe effect. I then closed the shutter, which had been set on "B," and we positioned the ball for its roll away from the racquet, shooting that sequence in the same manner. I hooked the tennis racquet onto the arm of a tripod for control of a smooth, easily repeated motion, and we again used a

slow movement over the black velvet while I popped the strobes. In actuality, of course, the tennis swing would have continued down and across as the ball spun away, but after trying that idea on Polaroid, we rejected it as too messy. The final image of tennis ball on racquet was achieved by piercing the ball with a piece of wire, pulling it to flatten the ball slightly, and then hooking the end of the wire firmly onto the net of the racquet. Ball and racquet were placed in the estimated center of the black velvet, between the areas allotted for the other exposures, and photographed with a single exposure. I shot quite a few variations to allow for imperfect placement, but almost all were successful.

one frozen subject position to the next. The overlapped edges will be overexposed and lose contrast. Instead, place the light to the side of the subject toward which movement proceeds. This setup will record successively brighter images as the subject moves closer to the flash. The side of the subject away from the light will be naturally darker, and overlapping images will retain definition.

As the subject moves closer to the light, it picks up more exposure. Therefore, the *f*-stop should be selected so that maximum detail and best exposure are at the point closest to the light, and the other images are slightly underexposed. If this is unacceptable for the effect wanted, place the light source on a movable boom or a track, and have an assistant move it so that it remains parallel to the moving subject. Should

this prove too complicated, you can still pick up exposure in the darker images by using a reflector card covered with wrinkled aluminum foil to bounce light at the subject from behind or to the side of the subject.

ADDED EFFECTS

Blur

Including blur, or showing the blurring movement between frozen images, sometimes adds to the feeling of movement. If I want to include blur, I simply leave the strobe's tungsten modeling light on while shooting. For correct color, I cover the modeling light with a blue (80B) theatrical gel, so that the tungsten does not make the blur too yellow.

Panning

Panning while shooting with repetitive strobe provides an answer when the shooting area is too small for subject movement, and when the movement should be highly controlled. Begin the pan with the subject located to one side of the viewfinder frame, and pan until the subject reaches the other end or goes out of the frame, depending on the result you intend. Panning also couples camera movement with any actual movement by the subject, so that if the camera is panned in a wavy line, the subject appears to have moved in a wavy line. Interesting design effects can be made by combining the subject's movement and the panned movement.

Zooming

Zoom on the image during repetitive strobe and the subject appears to leap in succeeding steps toward or away from the camera. I prefer to plan the zoom so that the best exposure is on the central image. With this in mind, I calculate the exposure so that the central image has a perfect exposure, perhaps allowing the strobe to flash several times if the subject is inanimate and will remain stationary. After cumulative exposure has built on the subject so that it is perfectly exposed, I begin the zoom. The succeeding steps are somewhat underexposed and draw less attention from the central image. If you pan slightly while zooming, there will not be quite as much image overlap to cause edge overexposure.

Coloring

Multicolored images can be made so that each successive image is a different color. Different color gels can be taped together along their edges into a long strip, then passed in front of the lens during the exposure. Larger gels can be passed across the repetitive flash unit to color the flashing light. You will need an assistant to help in the process. Adjust the motion of the gels according to the number of flashes and the color combinations needed. A color wheel driven by a small, slow-speed motor (about 60rpm) can be placed in front of the flashing strobe light or be positioned so that the camera lens views the subject through the rotating colors. You will probably have to open up at least one or two f-stops to compensate for the density of the gels.

The successive steps of expanding blue from the model's head shown on the cover of this book called for the use of a blue gel over the camera during a zoom on a repetitive strobe shot. I also shot versions in other colors, but felt the red version was too symbolic of anger, while the blue seemed more ideally intellectual. Multicolored versions of red, orange, and yellow were interesting, but again, I preferred the blue.

SIMULATING REPETITIVE STROBE

Simulating repetitive strobe effects is possible without expensive equipment. The results may not be as exact, but should be satisfactory, if properly executed. In much the same way as you taped successive gels together, you can tape a string of black cards together so that there is a clear space between each card. Allow a 2-inch black area, followed by a 2-inch clear area, and so forth. When you pass the string of cards before the camera lens, you will effectively block exposure during that moment. The main problem will be supplying enough light to expose the subject properly during the interval when a clear area passes before the lens. Since no strobe is being used, the available or tungsten light must be powerful enough to freeze the action, while providing enough light to select a small f-stop for depth of field. For large subjects like running people, the power requirements can be high. If you are only using a small moving subject, a hand or an arm for example, the necessary power is not so difficult to provide. Naturally, the pattern of frozen action depends on the relative speed and uniformity of motion involved in passing the cards before the lens. This technique is not exact, and requires much testing and practice.

For the image of the baseball player, the model was placed against a black velvet background and the repetitive strobe aimed so that the light fell primarily on the bat, rather than on the man. That way, the several flashes used to simulate the action of the moving bat did not overlight and wash out the baseball player through exposure buildup. I shot with a 50mm lens.

Backgrounds for Studio Shots of Action

I prefer to shoot motion against a black velvet background. It allows me to double expose the movement at a later date against another background, and causes subject colors to snap with contrast and become more dimensional. Although I have a 16' × 20' piece of velvet, sometimes even that is not wide enough.

The physical limits of the shooting area impose limits on the motion. A runner has to have an area in which to run, without crashing into the wall after three steps. That painful experience inhibits the runner's enthusiasm, and I want models to be as enthusiastic as I am about getting a good shot. One way to solve the problem of area limitation is to create the feeling of movement through space by panning on a runner who runs in place. However, the panning creates another problem, that of bringing the edges of the studio walls into view as the lens pans to fill the film frame and passes the limits of the background. I don't want to see studio walls and light stands at the edges of the picture. My studio shooting area is 18-feet wide, allowing only a foot on either side of the velvet. If your shooting area is smaller, or you don't have a large piece of velvet, your problem will be even more acute.

My solution is to place two black flats just in front and on either side of the camera, positioned so that the lens views the subject through the narrow slit between them. Two black cards on stands or two black velvet curtains would do as well. When I pan to simulate motion, the camera lens views the subject all the way across the film frame as the pan proceeds, but the two flats block out the side view of the studio, thereby artificially stretching the apparent background area.

The usual problem with shooting a color background using repetitive strobe is that the color picks up cumulative exposure with each successive flash, finally becoming vastly overexposed. Additionally, the moving subject may allow the background color to bleed through in the areas of overlapped images, especially where tungsten is combined with strobe for adding blur.

When shooting or panning for blur, background color bleeds through the blurred subject. For these reasons, a black background is always recommended. However, you can experiment with color backgrounds when using the above technique to view and pan on the subject through the slit in the black flats. Begin the photograph with the lens positioned so that the subject is viewed at one end of the viewfinder, and the majority of the lens views the black flat. Only that part of the film exposed to the subject will record, and the emulsion on the area viewing the black will not be used. As you pan, successive areas of the emulsion will be exposed to subject and background, while the predominant area will remain exposed only to the black flats.

Depending on the speed of the pan and/or the number of strobe flashes per second, the color background may record as blocky vertical colors that vary in intensity or overlap. This can be an interesting effect in itself. There are so many variables in shooting this type of technique that you must experiment and keep careful notes each time in order to approach any level of consistency.

I photographed the woman runner for *Self* magazine, using a 28mm lens in the studio. Black panels on either side of the model allowed me to pan while she ran in place, but prevented the pan from encompassing sides of the set as I shot. The MonoBloc strobe with umbrella was placed high and in front of the model, so that she appeared to run toward the light. Her back remained somewhat underexposed, providing a darker area where I could continue to expose the multiple images as I panned. If I had lit her evenly front and back, the overlapping images would have been overexposed. Immediately after the studio shooting, I rewound the register-marked film and walked over to Central Park. I double exposed panned blurred backgrounds of vegetation and bicycle riders onto the film, underexposing by 1½ stops so that she would obviously be the most important element on the film.

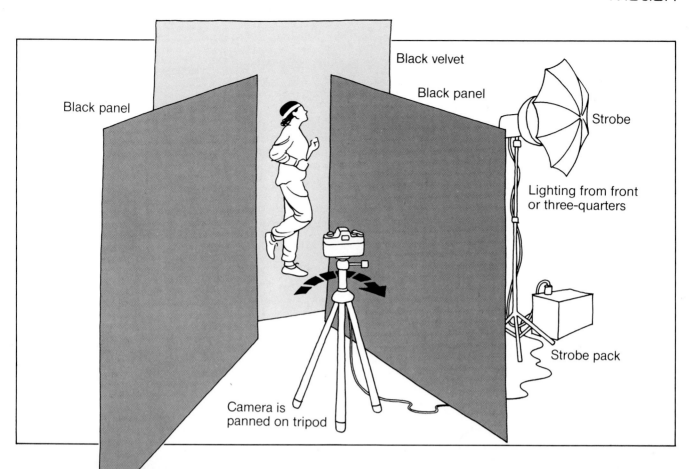

Black panel

Black velvet

Black panel

Strobe

Lighting from front
or three-quarters

Strobe pack

Camera is
panned on tripod

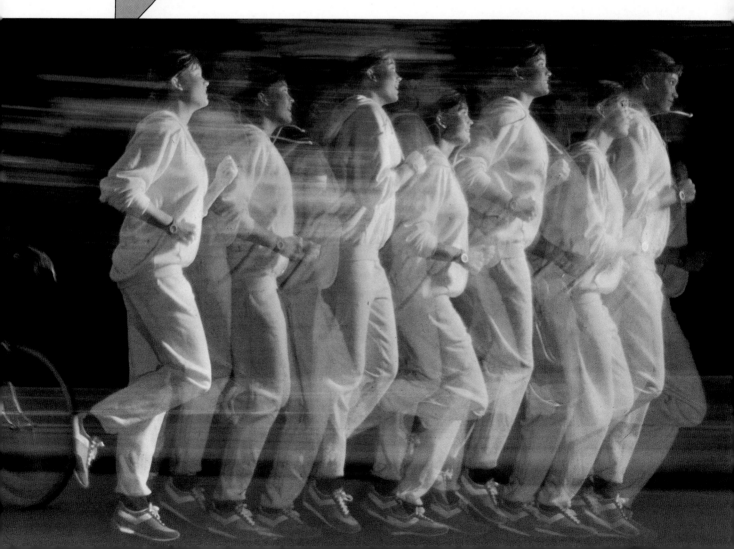

USING PROJECTION SYSTEMS

You probably have seen more front and rear projections than you know. Think of Humphrey Bogart driving a car, talking to whomever was the current leading lady sitting by his side. He could take his attention from the road long enough to stare meaningfully into her eyes because the land racing by beyond the car window was a rear projection in the movie studio. Think of the magnificent living room in an advertisement for a furniture manufacturer. The exotic view from the living room window is supplied by front projection, and the room is a set in some photographer's studio.

Front projection and rear projection provide the photographer with a way to shoot, in the studio, a location that might otherwise be prohibitive to reach. Each system allows the photographer to place a model or a product against a great variety of backgrounds from all over the world, or even out of this world, within a few minutes and with no great difficulty. Used intelligently, each system provides enormous creative freedom.

Unfortunately, few of the photographers who use either system really take full advantage of the creative possibilities each can offer. Even quite creative photographers can bog down in the misinformation about front projection and the difficulty of working with a system that can be temperamental about projector and camera alignment. More often, however, front projection is a tool used by school portrait photographers who rely on a change of background to supply the creativity for their photographs. These systems represent a technique; they cannot and should not be expected to make the creative contribution to the photograph that the photographer's mind should make.

Because of the misuse of front and rear projections in producing uninteresting, unimaginative photographs, most innovative photographers don't take the systems seriously enough to want to experiment with them. If they did, they might be as delighted as I am with the results.

I have used my front projection system to produce ads for such clients as Bell Telephone, Raytheon, Westinghouse, and various magazines. I have used rear projection for clients such as General Motors, Dow Chemical, Hertz, and others. I know that more clients will want to explore the possibilities of these systems in the future, and my front projection system will pay for itself many, many times over.

The main goal in any front projection or rear projection is the simulation of reality. A photographer friend of mine, who is familiar with front projection, paid me a great compliment just the other day. He looked at one of my photographs then asked me how I had done it. I told him it was front projection he exclaimed, "I would have never suspected that was done with front projection! It looks so real!" If a fellow photographer can spot the shot as front or rear projection immediately, you blew it.

Front projection provides a controllable way of making shots that would otherwise be difficult, dangerous, or downright impossible. It is extremely versatile, allowing you to place almost any subject into a background, and blend both into a believable combination through the proper use of lighting and props. It will allow you to shoot scenes out of season or distant locations at your convenience, with no difficulty about weather or travel arrangements. It permits you to photograph a subject in complete safety while making him or her look daring in a dangerous situation. It gives you the freedom to exercise your imagination by placing the subject in the far reaches of space, floating above a distant planet. Finally, it is extremely simple to achieve these

Self magazine asked me to shoot an image featuring running shoes. They assured me I could do whatever I wanted, and specified only that they wanted an unusual point of view on running. I decided to do something in space, symbolizing the future of running. I had the silver jumpsuit, which I had purchased at the Kennedy Space Center at Cape Canaveral, Florida. Shoes with matching silver soles don't exist, so I spraypainted the black soles with silver paint, choosing among several varieties of running shoe to select a style with rugged soles. The background image was a montage of a circuit board, Saturn, and a starfield that I had in my stock file. The screen was made of the newer 7615 material, and I used a 50mm projection lens with a 50mm camera lens for the shot.

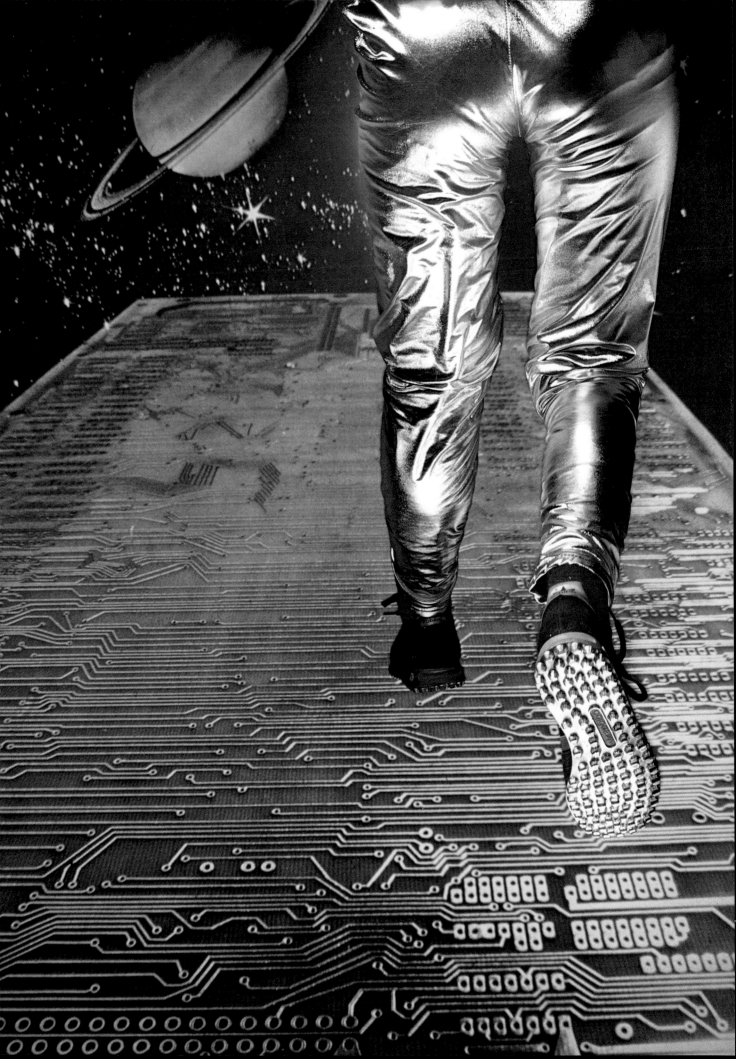

effects without proceeding through a dozen darkroom or other techniques. It is all done in one exposure.

Front projection has disadvantages. The equipment is expensive and specialized. Any optical misalignment causes a black line to appear around the subject, silhouetting the subject's edge sharply against the background. Much misinformation exists about its use, and it can be difficult and time consuming to learn solely by experimentation. It does not work well for photographing a transparent subject, since the subject's shadow may be visible on the screen behind it. Other than the cost of the equipment, however, which can be as much as the cost of a top-of-the-line 35mm camera and several lenses, and twice that amount for the screen itself, the arguments are all in favor of front projection.

Rear projection is inexpensive to do, requires simple, easily obtainable equipment, presents no alignment problems, and is excellent if your subject is small enough to position on a tabletop. It is superior to front projection for photographing any translucent or transparent object, since with front projection you would see through the object to its shadow on the screen. If you are photographing a small room set and want a view behind a small window on the set, rear projection can provide that view easily.

In comparison with front projection, however, rear projection has definite disadvantages. Power and space requirements limit screen size. Even with a wide-angle projection lens, you need at least as much space behind the screen as you do in front of the screen for the image to be both projected and photographed. (With front projection, only half the space is needed, because both projector and camera are on the same side of the screen.) When projecting a large image onto a large screen, you need enormous power that is not available in a normal slide projector. A powerful projector lamp would burn up the slide, so for best results in projecting large images an expensive specialized flash slide projector is needed. A tungsten lighting system in the projector is not powerful enough to allow fast shutter speeds to stop the action of a moving subject. In fact, there can be no subject movement at all, sometimes making rear projection difficult to use when photographing people.

If subject lighting spilling onto the screen can't be avoided, wash-out can only be corrected by shooting a double exposure, one of the subject against black with the correct subject lighting, and one with the subject against the projected background without subject lighting.

Equipment for front projection consists of a projection unit and a screen. A number of manufacturers produce projection units, and some of them also offer screens. If you decide to invest in a front projection system, you will inevitably be sending for catalogs from these manufacturers. Be aware, however, that each manufacturer will try to convince you that his particular system is best, and to that end may make many overenthusiastic statements. I have read brochures which at best are misleading or confusing, and at worst actually give wrong and untrue information. In fact, there are specific features to look for when buying a unit or screen. If these are not available from that manufacturer, a cheaper purchase price will in no way make up for the time you lose in working with awkward adjustments and in reshooting because of unsatisfactory results.

PROJECTION UNITS

Front projection units project an image through a lens, bouncing the image onto a lightly silvered, two-way mirror called a beam splitter, through which the camera lens is also aligned. From there the image is projected onto the screen. Although the concept is simple and workable, many variations are available in unit design that can make a great difference in the final image.

Lamp Housing

The lamp housing contains the projection light and the slide carrier. One of the first decisions to make is whether you want to work with strobe or with tungsten light. The use of strobe for the projected background is natural if your studio is presently equipped with strobes. If you commonly work with tungsten, or intend to use front projection for video or movies, you will need a tungsten unit. I use strobe for all the same reasons I select strobe to light anything in the studio: it is versatile, cool, and allows me to freeze motion, eliminate blur, and use short exposures.

An auxiliary power supply connects to the lamp housing with a power supply cord. This power supply is a small strobe pack; it usually rests on the floor, but for convenience may be taped to the tripod leg so that all controls are at hand. Because it is easier to build, a unit with an auxiliary power supply may cost less than a unit with a built-in power supply.

Some auxiliary power packs are triggered by slave sensors that detect the light from the studio strobes and fire the projector flash simultaneously. However, if the slave sensor is shadowed by any part of the set, or is not positioned close enough to the studio lights, the studio lights may fire without causing the slave to set off the projector light. Because the projector's modeling light allows you to view the projected background image continuously, and since the camera's mirror blocks your view at the moment of exposure, you may not realize the background light has not been working until the roll of film comes back with a smiling subject in front of a blank screen. For this reason, I prefer using sync cords for connecting the lights and projection unit.

Projection Light

Adjustability of the projection light allows you to control the brightness of the projected image.

Some units reduce the power output in half or quarter stops of light, or are continuously variable from 200 watt-seconds down to 25 watt-seconds. Units of this type may offer no f-stop variability on the projection lens, as it is reasoned that the power output sufficiently controls the brightness. However, the lack of variable f-stops eliminates any depth of field control over the projected image, not within the image itself, but across the screen. Therefore, should you have to shoot at a slight angle to the screen because of the demands of a set, you will not be able to select an f-stop that will allow the image to remain in clear focus from one end of the screen to the other. In fact, depth of field falls off rapidly, and you must be absolutely parallel to the screen to prevent any section from going out of focus.

The flash unit lamp housing contains a flash tube, reflector, and a low-wattage tungsten modeling light. Some units are designed so that the modeling light must be turned off in order to be able to shoot, a situation roughly equivalent to shooting flash pictures outside on a dark night. When the modeling light is on, I can compose the subject properly against the background, but I can't shoot. When the modeling light is off, I can shoot, but I can't see the background! It is imperative therefore, to look for a unit that offers a continuous modeling light.

The tungsten unit lamp housing contains a quartz lamp, usually 300 watts, and a built-in reflector. For any tungsten unit, the lamp housing should provide good continuous ventilation to rid the unit of heat buildup, and most units do this by means of a built-in fan. Good ventilation and a fan are also helpful when using a flash unit with the tungsten modeling light on.

Condenser System

The condenser system, as part of the lamp housing, spreads the projected light over the transparency that is to be projected. It is essential that the coverage provided be even. Two types are offered.

A bare single condenser can give a brighter and snappier image, but also may cause vignetting from uneven distribution of light across the transparency. It also will project a better image of any dust and lint that may accumulate on the condenser or on the transparency.

A diffused condenser system uses a material, usually translucent plastic, to diffuse the light. Although the material cuts the light output, it distributes light more evenly over the entire transparency and therefore over the screen, cuts down the visibility of any stray dust or lint, and protects the transparency from heat given off by the tungsten modeling light.

Power Supply

The power supply in electronic flash projection units usually gives 200 watt-seconds of power. Power supplies are either built-in or sepa-

To focus a projector or a camera, you must either move the film while keeping the lens stationary or move the lens while holding the film stationary. The four front-projection systems shown here use these two methods in various combinations for the camera and projector. The H&H Mini-Ultimate front projector (above) is designed to maintain ideal optical alignment, holding both camera and projection lenses stationary.

Optical Systems for Front Projection

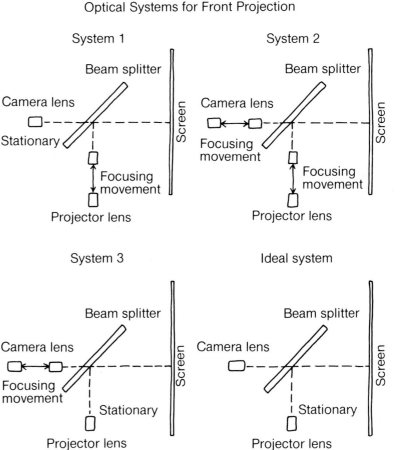

rate. A built-in power supply generally mounts directly on the tripod, beneath the camera track. This arrangement adds bulk to the unit, but places all controls at your fingertips and eliminates additional cords.

Another problem inherent with power reduction is the difficulty of seeing the effect of the reduction with the eye. Often a slight reduction is not apparent either in the modeling light or the flash (or tungsten source if using a tungsten unit). The lighting relationship between the subject and the projected background then becomes difficult to judge by just looking. The photographer must work slowly, testing the balance by shooting Polaroids, until the proper balance is at last achieved. This is a time-consuming method.

Adjustable f-stops on the projection lens provide the best system for controlling the light output. Although the effect of the adjustment is not easily visible, the knowledge that output has been reduced or raised by an exact f-stop is easily understood and controlled.

The Optical Alignment System

The optical alignment system offered on a unit is crucial to its ease of operation and directly affects the quality of the image. Proper alignment occurs when the optical center of the camera lens and the optical center of the projection lens are in perfect alignment through the beam splitter. Because achieving alignment can be an exacting process, any system that does not maintain that alignment is undesirable.

Suppose you want to photograph a model in front of the projected background. The unit has been properly aligned and you have shot a few frames of film. Suddenly you want to exercise a little creative freedom and recompose the picture you see through the camera.

If you choose to move the subject closer to or farther from the camera position, you must naturally refocus the camera lens. However, if the camera lens moves, changing its optical center with regard to the beam splitter, the alignment between camera lens and projection lens no longer exists. The unit must be realigned, then, anytime the camera lens moves to focus on the moving subject. One way to solve this problem is to place the camera on a track, so that refocusing involves moving the camera body, and the lens is held stationary. Some manufacturers use this method, providing a clamping device of some sort to hold the camera lens stationary while the camera body moves to focus.

Suppose, however, that you are perfectly satisfied with the distance from subject to camera, but want to see more of the total projected background without changing the perspective offered by the camera lens you are using. The logical solution is to move the unit and subject farther from the screen to encompass a wider angle of view. Whenever the unit is moved farther from or closer to the screen, the projection lens must be adjusted to bring the background once more into sharp focus. Again the alignment between camera lens and projection lens no longer exists. To eliminate the necessity of realignment, the projector lamp house can be mounted on a track much like the camera body was, and a clamping device utilized to hold the projection lens stationary while focus is made by moving the projector lamp house.

Unfortunately, these very reasonable modifications are ignored by most front-projection unit manufacturers. This is the single most common reason for the discouragement most photographers encounter in working with front projection.

The four available optical alignment systems are:

Camera lens is stationary, projector lens moves. If the subject distance changes, refocusing causes no change in the alignment. If the background distance changes, refocusing destroys the alignment.

Camera lens moves, projector lens moves. If the subject distance changes, refocusing destroys the alignment, and if the background distance changes, refocusing destroys the alignment. This is the most commonly available system.

Camera lens moves, projector lens remains stationary. If the subject distance changes, refocusing destroys the alignment. If the background distance changes, refocusing causes no change in the alignment.

Camera lens remains stationary, projector lens remains stationary. This is the most desirable system. In changing subject or background distance, refocusing causes

no misalignment in either case. This is the least commonly available system.

The Projection Lens

The projection lens should ideally be a flat-field lens. An enlarger lens can be used interchangeably with a projection lens. When making the alignment, the lens should be measured from the point of its optical center, which in most lenses is at its diaphragm. I use projection lenses ranging from a 40mm wide-angle to a 50mm, 75mm, 90mm, or 135mm. At one time I also used a 35–105mm zoom and a 43–86mm zoom, but I no longer use any zoom lens, as it is more difficult to align properly because of its shifting internal optics.

A 50mm or 75mm projection lens is sufficient for most uses. I occasionally need a 40mm lens to project a 35mm image to fill my 12' x 12' screen from a distance of 20 feet.

Many manufacturers offer zoom projection lenses because the zoom can change the projected image size, thereby changing the background composition without moving the unit. This facility does sound inviting, and one is led to believe that because no change has been made in projector distance from the screen, no realignment is necessary. However, in reality, any time you zoom, you change the focal length, and that shifts the alignment slightly. The more drastic the zoom, the greater the departure from the original alignment, and the more apparent the misalignment. Because correcting the alignment is a time-consuming process in the midst of shooting, most manufacturers do not encourage it, and most photographers do not bother doing it. However, this negligence can account for some of the alignment problems that can be seen in many front projection images.

Filters

A filter drawer is rarely available in any unit, but would be a desirable

addition. Filters to change or tint the color of the projected image must in most cases be placed over or under the projection slide itself. Unfortunately, because the unit works with electricity, a static charge can build, and the result is that dust and lint are drawn to any plastic surface. A plastic filter gel can easily become dusty, and the image of the dust is projected with the slide's image onto the screen.

The ideal place for a filter drawer would be between the diffusion material and the condenser, when a diffusion condenser system is used. The next best position would be directly beneath the projection lens. In this position, it might minutely reduce sharpness in the projected image, but the reduction would probably not be discernible to the eye.

Slide Carrier

The slide carrier rests on top of the lamphouse and holds the projection slide.

Movement of the transparency within the slide carrier for changing of the composition on the projected image is desirable. Any system that restricts either horizontal or vertical movement of the transparency limits freedom of composition and is inconvenient.

Magnetic slide carriers attach to the top of the lamp housing by means of magnets. They will not shift inadvertently when the unit is bumped or moved during shooting. They also allow unlimited horizontal and vertical slide movement, and are the most desirable type of carriers.

The size of transparency accepted varies with the unit. Most accept only 35mm, or the square-format *super slides* that have an outside perimeter the same as a 35mm, but an image size of $1\frac{5}{8}'' \times 1\frac{5}{8}''$. Some units also accept $2\frac{1}{4}''$-square slides, but few except those very expensive units built for specialized advertising and commercial use will accept 4×5 or 8×10 slides. Naturally the larger size transparency you can project, the better

the quality of the projected image. Kodachrome 25 provides the highest quality for any 35mm slide, and Ektachrome 64 or Ektachrome 50 the best for any 2¼"-square slide. Creativity and subject matter aside, the super slides commonly available as stock images through manufacturers and photo dealers for use as background slides are generally dupes reduced from 2¼"-square slides. The use of the larger format does allow you to project a larger image from the same distance. However, both creativity and quality will be better served if you project your own backgrounds, from original Kodachrome 25 slides, rather than use someone else's image that has been made into a poor-quality dupe.

The Beam Splitter

The beam splitter is the heart of the front projection unit. It is made from a sheet of optical glass, lightly silvered on one side. This produces, in effect, a two-way mirror, allowing the camera lens to look through the mirror on one side while the projected image thrown by the projection lens is bounced off the silvered surface and onto the screen. The beam splitter is kept mounted at a precise 45-degree angle to each lens, and the lenses are mounted at a 90-degree angle to each other.

It is essential the beam splitter be kept clean. Otherwise, the intensity of the projected image will be reduced, and the clarity of the photographed image will also be impaired. Once it is cleaned and installed, however, it should need no more than an occasional shot of compressed air to blow off dust, or a cleaning with lens tissue and lens cleaning fluid to remove film accumulated from air pollution.

When you install the beam splitter, or replace it after cleaning, be certain the silvered side faces the projection lens. Because the silvering is so light, sometimes it can be difficult to tell which side is silvered. If in doubt, take a sharpened pencil and very lightly touch the glass with the pencil point. If the point and its reflection seem to touch exactly,

that is the silvered side. The unsilvered side will show a tiny gap between the point and its reflection.

Beam Splitter Shroud

The beam splitter shroud covers the area over the beam splitter to prevent extraneous light from bouncing onto the beam splitter from the ceiling, thereby reducing the contrast of both the projected and photographed images. The shroud is usually made of a black flocked material.

Camera Track

The camera track allows the camera body to travel horizontally to and from the beam splitter for alignment. Ideally, the track should offer enough length to accommodate a larger format camera such as a view camera.

Camera Mount

The camera mount attaches the camera body to the camera track. Some manufacturers supply specific mounts according to camera make and model so that the mount becomes an integral part of the camera lens, projector lens alignment. If this is the case, the use of a different format camera will require another camera mount.

FRONT-PROJECTION SCREENS

Front-projection screens are hundreds of times more reflective than any normal material. A subject placed in front of the screen will not reflect the projected image back to the camera because skin, clothing, or any other material is not as reflective as the screen. Therefore there will be no evidence on the subject itself that an image is being projected.

The Screen Material

The screen material is manufactured by the 3M Company. It is a very thin, light gray material composed of minute retro-reflecting glass beads. These work much like

the roadway reflectors that light up when struck by the beam from an automobile's headlights. Each of these reflectors bounces light directly back at the source along the same optical axis from which it has been projected. The image, therefore, is brightest along that exact axis line, and diminishes rapidly as the observer moves farther from the line of projection. When you stand behind the camera to shoot, the projected image is bright and easily seen. Moving off even just a few feet to one side brings you away from the optical axis, and the image dims and disappears as you move away.

Screen material is made in rolls. If you decide to have a front-projection screen made, be sure the maker uses all of the material from the same emulsion run and from the same original roll. A cheap, bargain screen is sometimes made from odds and ends of scrap material the manufacturer has left over from making other screens. Since the material is produced in 2-foot widths, these strips are used in horizontal rows to make a screen. Any one strip that is not of the same emulsion can be slightly less or more reflective than another, so that the projected image will show a definite deviation in the brightness of the background along one strip. The emulsion may also affect the reflected color, so it is essential that a screen be made from a single emulsion run of material.

Older material, designated 7510, was available in the late 1960s, and is still used for front-projection screens. The material is 50 to 75 percent brighter than the newer screen material, but that is its only good feature. Some screen makers emphasize this brightness feature and sell the old screen material which they buy in less expensive quantities. Don't be fooled. I have even seen the 7510 material touted as the most highly desirable for advertising photographers because it demands great lighting control. The 7510 does indeed demand lighting control, making any photographer's job harder, including an advertising photographer's! With the 7510 material, lights positioned to light a

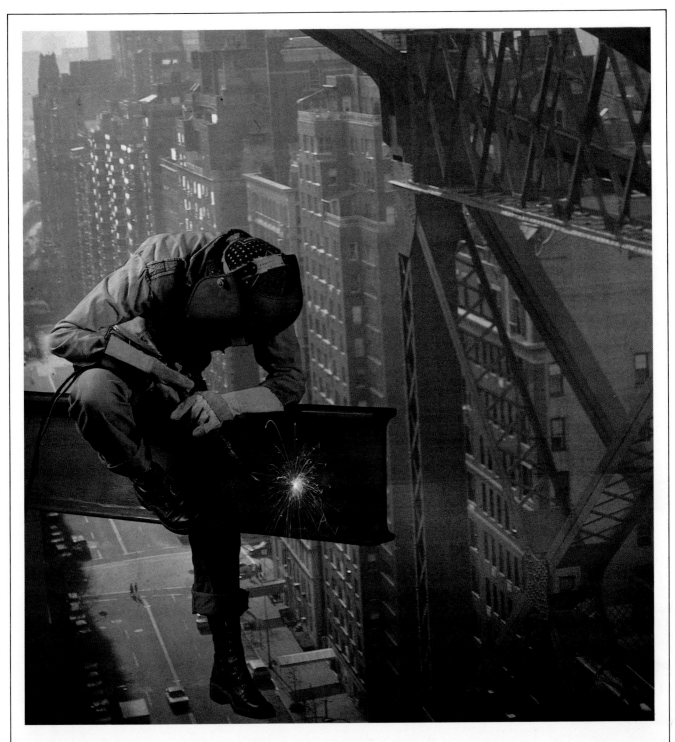

subject in front of the screen must be kept farther from the axis of the projected image than is required by the newer material. If you were to imagine a straight line from the camera position to the center of the background screen, this would be the axis of light projection. Picture this line as the exact dividing line of a wedge of pie, the point of which is at the screen and the wide edge of

which is at the camera position. This wedge-shaped area represents the physical space where subject lights should not be placed. For 7510 material, the wedge is a 40-degree angle on either side of the axis of light projection, a total of 80 degrees, or almost a quarter of a pie! When subject lights are placed within this danger area, spill light falls on the screen and will wash out

that area of the background image. By polarizing the lights and using a directional grid, the danger area can be reduced to 20 degrees on either side, or a total of 40 degrees.

Newer 7615 material is not as bright as the older 7510. Were you to place them side by side, the difference in brightness could easily be seen. However, the flexibility 7615 allows for lighting the subject more

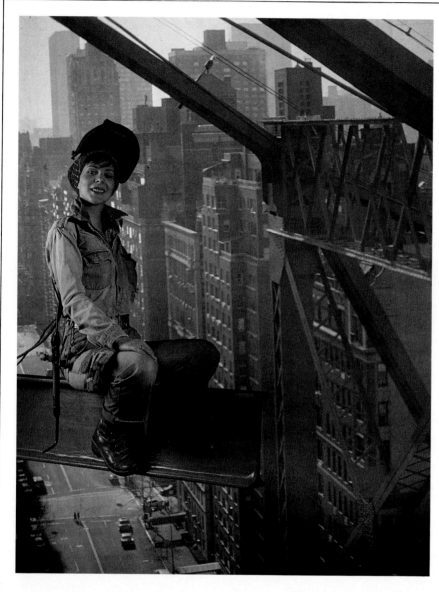

For the concept of women working in construction, I photographed the background with a 50mm lens. In the studio, I built an I-beam from 1′×12′ and 1′×6′ boards, plaster of Paris for the I-beam curves, and wooden dowels for rivets, painting it to match the steel beams of the background. It was supported at one end, and only 4 feet off the ground, or I would never have gotten Marie on it. I used a 40mm projection lens, a 50mm camera lens, and the older 7510 screen material. I carefully positioned one bank light to the right of the camera, and one above and just behind Marie for subject edge definition. We could not use welding equipment on the wooden beam, so the sparks were supplied by inserting a sparkler in the end of the welding tool.

than makes up for this difference. The retro-reflecting beads of the 7615 reflect a projected image more closely along the axis of projection. Subject lights can be placed as close as 20 degrees on either side, and with the use of polarized lighting and a directional grid, the danger area can be reduced to 10 degrees on either side, for a total of 20 degrees. This flexibility much reduces the danger of spill light washing out any area of the background image.

Backing Material

The backing material upon which the front projection screen material is mounted should be made of specially coated seamless material. The backing should never be pieced together, but should be continuous and without texture. Never buy any screen mounted on a textured backing, such as a woven material. I bought a screen with a textured backing, and am exceedingly unhappy with it. Always ask to see a sample of the backing material before ordering the screen if you have the least doubt.

Some manufacturers offer to sell the screen material and say that you can do your own mounting. Don't try it. The retro-reflective material is exceedingly thin, delicate, and difficult to handle. It comes with an adhesive backing, but any tiny crease or fold you may inadvertently make will show up as a glaring fault in the projected image. If a good professional mounts the screen, you can expect a far more precise result.

Mounting the Screen

Mounting can be arranged so that the screen rolls up like a shade for easy handling and storage, permanently installed along the ceiling of a section of the studio. If the screen will be small, or if the studio is large enough, a permanent frame is an alternative. No screen, however, should be mounted permanently on a wall so that it cannot be moved. A permanent mount is vulnerable to spills, falling equipment, and clumsy people. The screen material is delicate, and inevitably anyone who sees it wants to touch it, causing the possibility of fingerprints and dirt that would mar the surface. I prefer a roll-up mounting. The only real problem with a roll-up is that it moves when a fan blows the hair of a subject in front of the screen. In that case the easiest solution is to roll the screen down near a wall and tape the edges of the screen flat against the wall for stability.

Size

The size of the screen you buy will be dictated by your own needs. For location and small portrait work, an 8′×8′ screen should certainly be sufficient. My screen is 12′×12′, and I find this large size gives good versatility for subject movement and lighting composition within the studio.

If you are a photographer who nails your lights in place, forbids your subject to move, and never changes camera position or setup, you can optically align your front-projection system and not worry about getting a black line caused by misalignment of the unit's optics. If you are that rigid in your style, however, the black line probably wouldn't bother you anyway. Unfortunately, many photographers have abandoned the use of their front-projection systems because they had difficulty eliminating or minimizing the black line around the subject. A hard black line around the perimeter of the subject can make it appear as though the subject were badly cut out of one photograph and pasted against another. After testing quite a few front-projection units in connection with writing about them here, I concluded that so much misinformation has been disseminated by the very experts who should know better, it is no wonder photographers are confused.

ALIGNMENT

Absolute alignment prevents the appearance of the black line around the subject. When the background image is projected from the unit, across the subject, and onto the screen, the subject's shadow is cast directly behind him or her. The pure black shadow is called an umbra. Along the edge of the umbra there is a lighter, grayish shadow called a penumbra, unobtrusive and inoffensive when visible. Should the projection unit become misaligned, the umbra becomes visible, and this can be quite disturbing.

Unless you are using a unit where the camera and projection lenses remain stationary in relation to the beam splitter, the optics become misaligned every time you move, reposition, refocus, or zoom. The misalignment may be moderate, depending on the degree of change, but it exists nevertheless, and there is no way to eliminate its consequences except by realigning the unit. Manufacturers sometimes seem to talk their way around this fact, but it is obvious when you examine the optics of each system.

MYTHS AND MISINFORMATION ABOUT FRONT PROJECTION AND THE BLACK LINE

Further myths and misinformation about front projection and the black line abound.

Myth: "You can't use a wide-angle projection lens in conjunction with a telephoto camera lens, because the wide-angle casts a wide shadow, and the telephoto sees a narrow angle of view. This, coupled with the telephoto's stacking effect, makes the subject appear to be closer to the screen, and the camera then views the wider black line caused by the wide-angle's shorter focal length."

Fact: Any wide-angle or short focal length lens can be used in conjunction with any focal length camera lens, including a telephoto. As long as the projection lens is in perfect optical alignment through the beam splitter, it will cast the subject's shadow invisibly behind the subject, unseen from the camera lens. To prove this I did a test using a 40mm wide-angle projection lens, then a 90mm projection lens, and coupled each with a 100mm camera lens. A light stand and reflector served as the subject. I eliminated a background transparency so that the light cast by the projector would make any shadow immediately visible. When the two 35mm transparencies I shot of this setup were removed from their mounts and placed over each other on the light table, it was easy to see that they were in perfect registration. The shadow sizes were identical. The only reason to use a wide-angle projection lens is to increase the image size on the screen. As a matter of fact, I often use wide-angle projection lenses in conjunction with many fixed focal length camera lenses, including medium telephotos, without any difficulty.

Myth: "The subject should always be positioned close to the screen. That way, the shadow size is smaller, and there is no depth of field problem for the camera lens between subject and screen."

Fact: The shadow will indeed be smaller when the subject is close to the screen, but no matter where the subject is placed, the shadow will remain unseen behind the subject as long as the camera and projection lenses are in perfect alignment. You need greater depth of field when the subject is moved away from the screen, but you can remedy this by moving lights closer or increasing their power, so that the subject is more brightly lit. Then you can shoot at a smaller f-stop to increase the available depth of field. The farther the subject is moved from the screen, the more you can do with subject lighting. When the subject is close to the screen, spill light from the subject lighting can wash out the projected background and reduce contrast of the image. This problem is vastly reduced when the subject is farther from the screen. I usually position my subject 8 to 12 feet from the screen.

Myth: "The subject should be sharply in focus, but the projected background should be slightly soft and kept out of focus."

Fact: This may occasionally be true, but any sharply focused subject will appear to have a hard edge when viewed against a soft background focus. This produces a very artificial look, with the subject appearing as a pasted-on image, popping out of the background. The most successful images I have done (and have seen others do) have great depth of field and dimension behind the subject to create a strong realistic effect.

Myth: "The black line is always objectionable."

Fact: Even as dedicated a black line foe as I have occasionally deliberately misaligned the projection unit. I do this in order to simulate the same effect I would get when a subject is shot with raw flash held slightly off the axis of the camera lens. Using flash in this manner produces a black line, not around the entire perimeter, but along one edge of the subject. This effect would normally be visible only when the subject is standing close to the actual background. When simulating the effect with front projection, therefore, the projected background should appear to be close to the subject. Distant mountains, for example, would not pick up the subject's shadow from a hand-held flash!

One of the nicest people I know in photography is Jerry Interval, an excellent portrait photographer who lives and works just outside Pittsburgh. He was instrumental in bringing our Focus 2000 workshop to that city for members of the Professional Photographers of America, and as the workshop ended each day, Jerry and I would spend time talking about the business. He mentioned that he had a front-projection unit and screen material, but had never been satisfied with it. He showed me the unit, an awkward projector that was maneuvered up and down by what amounted to an automobile jack! Jerry is a creative photographer, more concerned with composition and style than with trying to fight with obstinate equipment. "Besides," he added, "every once in a while I have problems with the black line around the subject," and the

unit fought correction. It did not take us long to strike a bargain for my purchase of unit and screen material. After I returned to New York, I spent quite some time making tests and playing with the unit. Finally I placed a call to Jerry. "I think you sold me an incomplete unit," I said. There was a surprised pause at the other end of the line, and I could imagine him worrying about what he might not have included. "It's the black line," I said, "I just can't find it anywhere!" He broke out into a robust laugh and then sighed, "I hope you didn't leave it in Pittsburgh!"

I used that front-projection unit and screen to earn back its purchase price several times over. When I decided to buy a larger screen, I gave the old one to a friend setting up a portrait studio in Connecticut. I also tried to leave out the black line, as Jerry had done for me.

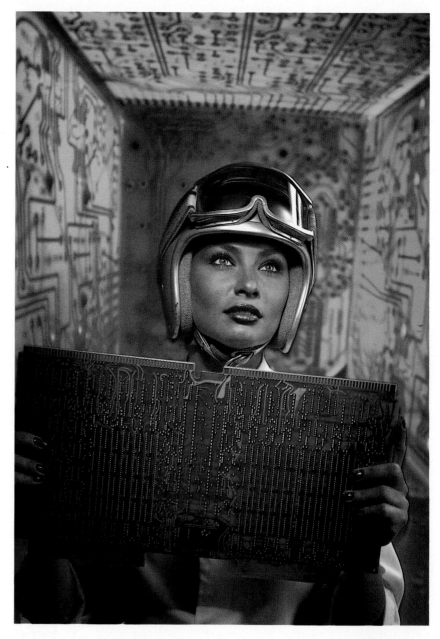

For the background, I taped together five circuit boards with clear cellophane tape, lit them from behind, and shot with a 20mm lens for strong perspective. The model was lit with one large bank overhead and to the right of the camera position. Of course, as with all the other lights used in front projection, the bank was used with a light directing grid. I used a 40mm projection lens and shot the image with a 50mm camera lens. The screen material was 7510.

The whole purpose of front projection is to provide a realistic background for a studio shot. The subject lighting must therefore appear to be identical to the background lighting. Many portrait photographers who use front projection do not experiment enough with their lighting, and their attempts at this technique look artificially lit, ruining the balance. Many standard lighting setups will work with front projection, but thought and time are needed to combine foreground and background well. Once understood and mastered, the appropriate lighting for each situation is easy enough to achieve.

MATCHING THE LIGHT

Matching the background lighting is essential. Observe the direction of shadows falling in the background projection, and be sure you have not inadvertently made it seem as though there are two suns in the sky; one lighting the background, one lighting the foreground, each from a different direction. The density of the shadows on the subject should also match or be only a slight amount lighter than the projected background shadows. Subject and background should match in intensity and saturation of color.

GETTING ENOUGH LIGHT

Depth of field must encompass the distance from subject to background for the final photograph. To achieve this depth, select an *f*-stop that will maintain clear focus on the subject and the screen, then build up the amount of subject light necessary for shooting at that *f*-stop. To get as much available power from the subject lights, move them as close to the subject as possible, so that they are just barely outside the camera's angle of view. The front-projection unit's beam splitter reduces the light reaching the film by one stop, so additional light may be needed, and compensation must be made when taking a reading with a light meter. If you are using all tungsten, the built-in meter in the camera will give the correct reading. When you need more light to achieve the *f*-stop desired, consider adding additional lights, using a higher speed film, or having the film pushed when developed.

BACKGROUND WASHOUT

Background screen washout is always a consideration when using front projection. Any spill light from the subject lighting, or other random sources, can reflect or bounce onto the screen, making the projected image appear overexposed and pale, with blacks becoming gray, and colors losing contrast and saturation. I have even seen this unfortunate effect in brochures produced by projection unit manufacturers, purporting to show that their particular units do no such thing! The first step in avoiding unwanted washout is realizing its cause, which may be unexpected.

If you are having difficulty pinpointing the cause of the washout, turn out every light except for the modeling light on the subject. Turn the front-projection unit off, and stand at the screen position. View the entire area surrounding and to the rear of the camera position looking for any bright source of light or reflective object, and cover the offender with black paper or fabric. That should solve the problem. If it is caused by the subject lighting, you have to make lighting adjustments.

- Some causes of washout are easy to detect, and are fairly typical problems.

- Lighting the subject by placing the lights too close to the camera lens axis for the type of screen used can cause washout from reflected spill light. However, you can minimize washout by the proper use of light directing grids, polarization of light, or both, each of which will be discussed later.

- Any light from behind the camera position always affects screen contrast. You must be sure the area behind the camera is totally dark, and you may have to turn out all lights or drop a black curtain or screen (preferably one about 8'-square) behind the camera position to darken the area.

- When lights are placed behind the subject, either low or high, in order to backlight the subject, the subject itself may reflect some of the light back onto the screen to cause washout. This will be especially true if the subject is wearing a white or light-colored garment, or has shiny blonde hair. You may find it necessary to cover the back of the garment or hair with a black nonreflective fabric or paper that is invisible from the camera position. Another solution is simply to change the lighting.

- When a previously successful lighting setup suddenly seems to be producing washout, look for unexpected culprits. The projector lamp housing may not be well sealed, and any light leaks from it must be masked with black paper. Any reflective surface in the area of the camera may be to blame, such as shiny tripod legs, a chrome light stand, a bright prop or bright portion of the set. Even the glass or chrome of a picture frame hanging on the wall can catch a stray beam of light and kick it back to the screen for a spot of washout. A shiny floor beneath the subject can produce overall washout, and should be covered with black paper or fabric, as should any other offending reflective surface involved.

Avoiding Spill Light

Directional lighting equipment, coupled with careful lighting, can eliminate screen washout caused by spill from the subject lights.

A bank light, because it is a broad source of light, simulates natural light from a wide sky overhead. If you make a bank light from a lightweight carton, it must be well sealed so that no light leaks cause spill. Cover the front with a double layer of tracing paper or a bedsheet to provide diffusion, and for front projection, add a ribbon louver or directional grid to prevent spill from undirected light.

Honeycomb grids range from 10 degree grids having holes about 1/8 inch in diameter, to 40 degree grids having 3/8 inch holes. The smaller the angle and smaller the hole, the more the grid functions like a focus-

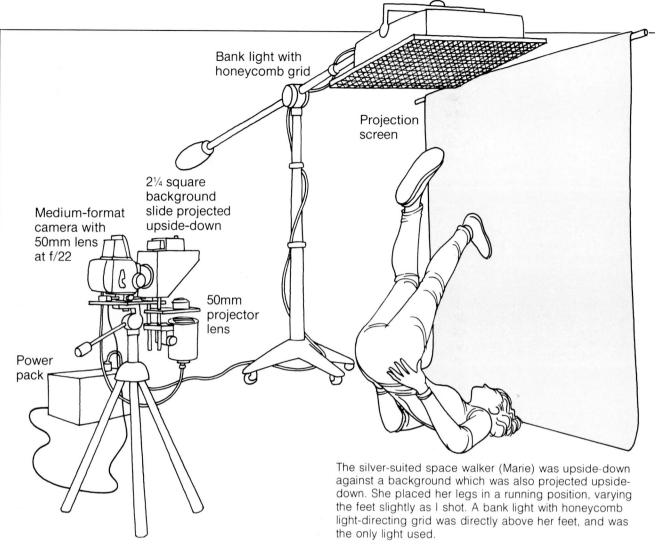

Bank light with honeycomb grid

Projection screen

2¼ square background slide projected upside-down

Medium-format camera with 50mm lens at f/22

50mm projector lens

Power pack

The silver-suited space walker (Marie) was upside-down against a background which was also projected upside-down. She placed her legs in a running position, varying the feet slightly as I shot. A bank light with honeycomb light-directing grid was directly above her feet, and was the only light used.

ing spotlight. The wider the angle and wider the hole, the more the grid functions like a broad source of light. The closer you plan to place the light to the camera axis, the narrower the grid opening you will need. Narrow grids on a large bank light provide an excellent light source for front projection; soft and natural, yet well directed.

Cardboard snoots can direct and narrow the focus of the light, producing a spotlight effect that eliminates spill and simulates the hard shadows of bright sunlight. Strobe spotlights made of metal cost as much as a strobe unit, and I much prefer making a cardboard or black paper snoot to exactly fit the light and subject of the moment.

When the subject light spills over the edge of the subject, a curtain made of black paper can be hung on a light stand and placed between subject and light to effectively block that portion of the light that is causing the spill.

I prefer not to use umbrellas for front-projection lighting, because their shape is awkward, making it difficult to fit a curtain on them to control any spill. However, if you intend to use them, I recommend a silver umbrella because it tends to focus light in a narrower beam, and produces a shadow on the subject resembling that made by bright daylight.

Reflector cards or flats, especially those with a silver surface, must be used with extreme care. Not only does the bounce fill they create reflect back to wash out the screen, but they may also produce shadows dissimilar to those on the projected background. This causes an incongruous, artificial look.

Polarization

Polarization of lights used on the subject coupled with the use of a.

polarizing filter on the camera allow you to position the lights closer to the axis of the camera without causing spill and screen washout.

The 7615 screen material usually requires that you position lights at least 20 degrees off the axis, and the older 7510 material requires a 40-degree angle. When using polarization, each of these requirements is cut in half. If you use more than one light on the subject, you may choose to polarize only the light nearest to the camera axis, or all of the lights, depending on the effect you seek.

Cross polarization will occur if you attempt to polarize both the camera lens and the projection lens. It is only necessary to polarize the camera lens in conjunction with subject lights. If you plan to polarize more than one subject light, the polarizing material must be positioned so that the degree of polarization is the same for each light. Hold the po-

larizing material in front of you and rotate it until the *least* amount of polarization occurs, when the sheet is lightest. Mark the top with a notch or marking pen. When you place the sheets on each light, be sure the notch is at the top. Once the lights are correctly polarized, the rotation of the filter on the camera lens decides the degree of polarization.

Because the degree of polarization increases when you rotate the filter on the camera lens, the light available for exposure decreases. With lights and lens polarized, you can lose up to three full stops of available light. When using a tung-

sten system and through-the-lens meter, the meter will read the correct exposure. If you are using a flash system and flash meter, the meter cannot take the lens filter into account, and the reading will be false. You must shoot Polaroids to check the exposure as you vary polarization. Of course, as the degree of polarization increases, you may need more power to give enough exposure for the *f*-stop you have chosen.

Polarization kills highlights that may be desirable, and gives heavy color saturation and detail. When photographing a woman for a beauty shot, for example, you may

want highlights on the skin to make its texture appear glowing and smooth. You can remove the polarization from one of the lights, usually the main light nearest the subject, but in that case you may have to move the light farther from the camera axis. It is a trade-off decision.

If you use a large bank light, you may need to buy a very large sheet of polarizing material. The 3M Company, which makes the retro-reflecting screen material, also makes sheets of polarizing material. Place the polarizer over the diffusing material and under the light directing grid of the bank light.

The image of the runner on the road was shot for *Self* magazine to accompany an article about jogging. The background road had been photographed with a 20mm lens on a bright day when the sun glared from the roadway. I had stopped the lens down to darken the surrounding countryside. The sunset, also shot with a 20mm lens, was combined with the road as a darkroom montage. The runner sat on a board suspended between two ladders, a bank light with honeycomb grid directly beneath her feet. I wanted the light to appear to emanate from the glowing road, the legs appearing darker in the evening light. A yellow gel was placed in the corner of the bank light to produce the yellow "reflection" of the road's yellow dividing line.

Lighting for Front Projection

For a pharmaceutical booklet dealing with depression, the art director wanted something very dramatic. I suggested the image of a man contemplating suicide, and showed the art director a sketch, which he approved with enthusiasm. I photographed the background from the 14th floor of a nearby building, using a 20mm lens for strong perspective and converging lines. The window and ledge were built in the studio, angled so that the model could lean somewhat forward without losing his balance and falling . . . not 14 stories, but 3 feet down onto the front-projection screen. I could not get the height I wanted by shooting from a ladder, so had to open the skylight above the set, and photograph from the roof just above the shooting area! I used a 40mm projection lens, a 50mm camera lens, and 7510 screen material. The model was lit with two 12-inch reflectors, each having a grid, and positioned on either side of the model. There was another light behind the set to provide additional light from behind the window. The pigeons were stuffed, the flying bird suspended with a clear nylon line. The model has his shoes off because statistics informed us that people who jump from buildings often neatly remove their shoes before they leap. Art director: Jim Horne.

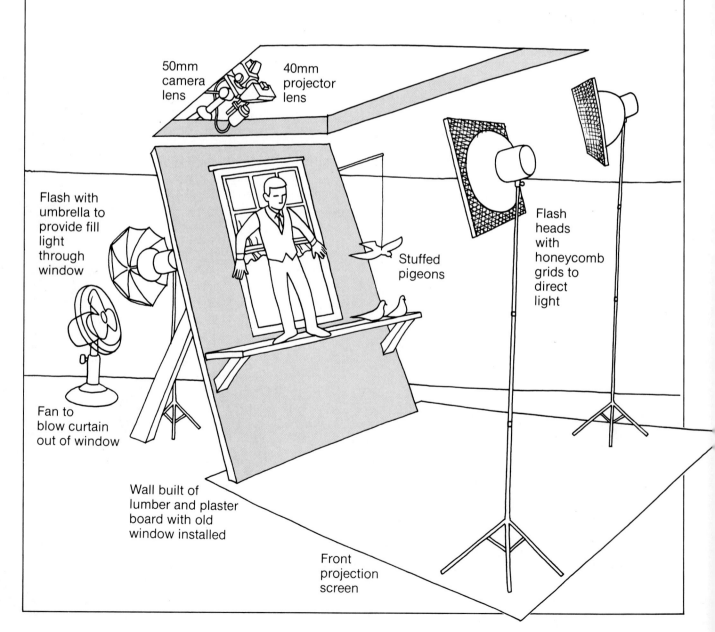

50mm camera lens

40mm projector lens

Flash with umbrella to provide fill light through window

Stuffed pigeons

Flash heads with honeycomb grids to direct light

Fan to blow curtain out of window

Wall built of lumber and plaster board with old window installed

Front projection screen

Backgrounds for Front Projection

One of the most important elements in successful front projection is a good background. Readily available stock background slides sold just for front projection are usually soft-focused, poor quality dupes of trite subject matter. The beginning photographer who sees these stock backgrounds assumes that, since they were specifically designed by experts for front projection, all projected backgrounds should be soft-focus. Even if these were all magnificent images, I would have a great reluctance to use them. I don't believe in using another photographer's image as any part of my own work. I feel it would compromise my integrity to proudly claim as mine any photograph in which a portion of the image was shot by someone else.

Photographing your own backgrounds is an ideal solution. Even when I select images from my own stock, they are not always right for the projection I have in mind. I may change them by duping to crop for image size or composition. When I do shoot specifically to create background slides, I keep several things in mind.

• The projector format dictates the film size. If your projector accepts only 35mm, be sure to use Kodachrome 25 for the finest grained image.

• Focus on every slide should be as sharp and dimensional as possible, with the greatest depth of field. Use a tripod if you can.

• Variations, horizontal and vertical, can save the need for duping to recrop the image later. Be sure to shoot from several camera angles, including a very low angle with the camera on or near the ground. Place the horizon at different heights in the frame. Bracket exposures for variation in density.

• Contrast is increased whenever an image is projected or rephotographed. Therefore, shoot the original background with contrast control in mind. Use a polarizing filter when outdoors if possible, as that will deepen saturation and minimize contrast.

The purpose of the background's eventual use can help select the subject matter. I have seen photographs of executives wearing suits against a background of out-of-focus autumn leaves. They should have been standing against an image of their factory, office interior, or any location in which they might normally be found. Interesting effects can be achieved by showing a close image of the technology their company might use, such as a computer chip greatly enlarged, for the background. When shooting backgrounds, look for dimensional lines of composition that will draw the eye to the subject in a future projection.

Testing for background realism can be accomplished if you have a willing subject. Take the subject along when you go out to shoot backgrounds. Choose a sunny day, and bring a portable flash unit. Photograph the subject against a likely background, using flash fill off the camera axis as you might do normally. Then rephotograph the background without the subject, using the same camera position, depth of field, etc. When the transparencies are developed, bring the same subject into the studio and attempt to duplicate the exact results you obtained in the actual situation. Keep careful notes regarding the camera to subject distance, the camera height from the ground, the f-stop used, any any other pertinent data. Done several times with various backgrounds, this test can teach you to create realistic subject-to-background relationships in the studio.

The color balance of any reflected light is slightly deficient along the red end of the spectrum. This is particularly true with front projection and the use of the retro-reflective screen. Electronic flash also tends to be blue. To correct and balance the background transparency, especially when using flash, add a CC20 red gel over the top of the projection lens. Because any dust or lint on the gel will be projected along with the image onto the screen, don't place the gel on the transparency. The best solution for dealing with color correction is to tape a small circular gel onto the bottom of each projection lens you own. Be sure not to get the tape on any lens elements. In that position, you can be sure that no defects or dirt in the gel will be projected with the background image.

I bought the silver circuit board for a couple of dollars in an electronics shop, and photographed it against a black velvet background with a 20mm lens to increase the feeling of perspective. I had on hand a stock photo of the star field, actually pieces of metallic glitter shot against black velvet. The image of Saturn was a computer-enhanced 4×5 transparency from NASA. I had been down to Florida photographing the space shuttle, and had asked them to send me a picture of Saturn to use as a background element. They very kindly did. I wanted to reduce the brightness of the planet itself to allow its rings to appear brighter, so I made a contrast mask for the transparency, then copied the masked chrome on a light table onto Kodachrome 25. In the darkroom, I montaged the circuit board, Saturn, and the star field onto a 16×20 Cibachrome print. I then rephotographed the print onto 2¼"-square Ektachrome for projection as a background. The background then, is an original, computer-enhanced, contrast-masked, copied chrome, montaged, printed, copied, projected and rephotographed. It does beat a background of autumn leaves, though, so I think it was worth the effort.

Matching the background image with a studio foreground so that they appear as a continuous environment within which to place the subject is one of the challenges of front projection. Nothing can be more disconcerting than seeing a subject standing on a tiled floor in what otherwise appears to be a beautiful field with mountains in the distance. There are various approaches to creating successful continuity.

Do not try to place the retro-reflecting material directly on the floor to make a continuous background-to-foreground image. Although it is perhaps the first solution that comes to mind, it unfortunately will not work.

The retro-reflective material is delicate. Should the subject step on the material, it would be badly damaged.

Were you able to protect the material, perhaps by placing a large piece of glass or plexiglas over it, the use of subject lighting would probably washout the image contrast in that area of the screen directly below the subject.

If you could light the subject in such a way as to prevent washout of the projected image, the projection lens would not be able to provide enough depth of field to hold the entire projected image in focus from foreground to background.

Some workable solutions are as follows. Although not perfect, they can be quite acceptable when well done.

Crop the subject so that the bottom of the screen is not visible, or elevate the subject in some manner so that the subject's feet are above the bottom line of the screen.

Shoot from a very low angle to minimize the amount of visible foreground, leading the observer's eye upward toward the subject and the projected background, and away from the foreground.

Use scraps of retro-reflecting material and attach them to segments of the set, such as the forward edge of a platform, so that the set appears to be a part of the background projection. This can lead to depth of field problems with the pro-jected image, and I have never seen it done very well.

The best solution is to build a set so that the foreground tones match and blend with the background image. The set need not be complex, and often a few props suffice to set a mood. However, it must be made so that there is no obvious deliniation between background and foreground caused by any difference in color, texture, tone, or perspective.

When using any optical system other than that in which the camera and projector lens remain stationary, there can be difficulty with a black line around any set or props. If there is even a minor change in subject or background distance to the unit, such as might be caused by zooming the projector lens, the misalignment may not be very noticable around the subject, but will be most apparent around any items on the set that are some distance from the subject. Even the subject's arms, if held out from the body, will show a more obvious black line. This effect is amplified the farther the object is from the axis of the subject to camera line. Therefore, when building a set or using props, it is even more essential that the unit be kept in perfect alignment to avoid the black line.

The art director's concept for Westinghouse was to show an environmentally concerned scientist. The glowing test tube was a tubular electric bulb with a green gel and diffusion material around it. The model, Bob Fahey, covered the electrical connection with his hand, and the wire ran up his sleeve. I lit the model with a bank light on either side of the camera, each with a light-directing grid. An unfocused background drew attention to the subject. I used a 90mm lens on a 2¼-square camera, and a 40mm projection lens. Art director: Ann Sjogren.

Rear Projection

Equipment for rear projection consists of a standard slide projector and screen. A piece of black velvet or black shade may also be needed.

PROJECTORS

Almost any normal slide projector can be used for rear projection. It should offer at least 300 watts of power through its tungsten system, and project either 35mm or super slides. I use a Kodak Carousel projector with a standard 102mm projection lens. Occasionally I use a zoom lens for changing the background size conveniently. Since there is no complex alignment system, the zoom lens is no problem to use.

SCREENS

The screen should be some type of translucent material, firmly mounted so that it does not cause focus variation by moving.

Translucent material is easy to obtain. Tracing paper (preferably architect's tracing paper if available) provides a fine grain surface that is quite inexpensive. Also, Kodak makes Kodacel matting, the same frosted material that backs the translucent cover of a 4×5 or 8×10 transparency sleeve, in large rolls convenient for rear projection. Kodak and other manufacturers also make special rear projection material.

Mount the screen material securely on a frame, otherwise any draft can cause the lightweight material to move and the projected image will go in and out of focus. Even the cooling fan from the projector can create enough breeze to stir the screen, and should be blocked by paper to direct the moving air away from the screen area.

When photographing the subject or product on a tabletop, be sure the screen extends at least 1 foot lower than the edge of the table. That way, you can elevate the camera angle for composition, if necessary, and still achieve full coverage of the projected background, without the edge of the screen becoming visible.

A black curtain or shade, preferably made of black velvet, should be the same size as or slightly larger than the projection screen. It should be mounted on the same frame as the screen, directly in front of it, to totally block the screen when necessary for double exposures.

LIGHTING FOR REAR PROJECTION

Any spill from the subject light will totally wash out the projected background in the area touched by the spill, and will reduce contrast over a larger area because of the diffusing quality of the screen.

Double exposure is by far the best method of eliminating the chance of spill from subject lights. It is imperative that the product or subject not be moved at all during the procedure.

Place the camera on a tripod and tape the legs of the tripod in position. A friend of mine asked for directions on doing rear projection, and I duly emphasized this point. He told me later that he decided not to bother with the taping, since he planned to be very careful. Of course, he bumped the camera between shots, and had to begin again. I also advise that you use a cable release, and do not walk around during long exposures, as you may inadvertently bump camera, screen, or product.

Decide on an *f*-stop for depth of field that covers subject and background.

To determine exposure, use your camera's through-the-lens me-

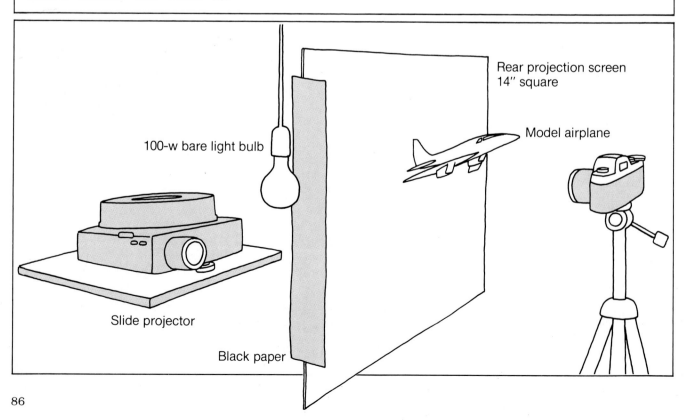

100-w bare light bulb

Rear projection screen 14" square

Model airplane

Slide projector

Black paper

ter, reading only the screen. I prefer to determine exposure by shooting a Polaroid, since that shows instantly the lighting balance between subject and screen.

Make the first exposure of the subject, with the black curtain completely blocking the screen. Turn the projector off during the exposure, and light the subject as you desire.

Make the second exposure after removing the black curtain, turning off the subject lights, and turning on the projector.

Light balance is easy enough if both the projected light and the subject light are tungsten. However, if the subject is lit with strobes, it will be necessary to tape a corrective 80B (blue) filter over the projector lens to balance the color. Put the 80B on the camera lens when shooting Polaroid with tungsten light, as Polaroid is balanced for daylight.

To light the model airplane in front of the rear-projection screen, I used an ordinary lightbulb, and placed a scrim strategically next to the bulb to make sure its light was prevented from spilling onto the screen. Because both the screen image and bulb were tungsten light, I used tungsten film. Had I wanted to use daylight balanced film, I would have had to correct for the tungsten by placing an 80B filter over the camera lens.

In my youth, I learned photography using a Bonnet 3–D camera. It was an unwieldy thing that shot 11×14 film, and made a 1-minute exposure as it traveled along an arched track that allowed it to view the product from all points along the curve.

Enthusiastically, I sold a new client on a rear projection idea for their 3-D point-of-purchase display. I planned a shot showing the client's beer in a foamy cold glass against a background of pristine lakes and cloudless blue sky, symbolizing the purity of the beer's ingredients. The client loved the idea. I did not mention the fact that I had no projector to do the rear projection, because I knew I could borrow one from my friend Ken Marcus, who is now a staff photographer for *Playboy* magazine. He also agreed to help me with the shot.

After a few false starts that used up precious film, we began the long exposure with everything, at last, perfect, including a full foamy head on the golden beer. As the Bonnet camera meandered down the track for the exposure, the head began to fade away, and I was stunned to hear Ken shout, "Stop everything! You're losing your head!" He ran over to the main power switch and threw it, halting the camera in mid-exposure, plunging the studio into total darkness, and me into total despair. I was sure the image was ruined, and knew that was the last of the film I had on hand. Meanwhile Ken found his way to the beer and managed to fill it to make a new head. At his signal, I turned on the power switch, but my heart wasn't in the exposure any more.

When the film was developed, I placed it behind the lenticular screen that brought out dimension, and was pleased to see that there was at least a fine dimensionality, with the beer standing out invitingly against the background. However, as I moved my view slowly from left to right, the beer's head seemed to fall and rise again. In some trepidation I showed it to the client. They loved it! They were so taken with the authenticity of the rear projection that the up-and-down movement of the foam seemed to them a brilliantly conceived personification of the sprightliness of their beer, and I was commended for my additional creative insight!

GATEFOLD

When the possibility of making a gatefold picture for this book was first discussed, I assumed I would use one of the photographs existing already in my stock; one I could simply crop to fit the format. As the idea developed, I realized that size and layout requirements were such that no existing photograph of mine could be satisfactorily cropped to yield such a wide panoramic image without losing something of the integrity of the idea behind the original. There was no doubt I'd have to shoot an original image specifically for the gatefold.

This was one of those times when my ideas seemed to take forever to jell, and I needed the germ of someone else's thought to begin a process of visualization. While I did other work, I kept the gatefold layout size and shape vaguely in the back of my mind, in the hope that it would ferment gently there, maturing at last into a clear, sparkling idea. It didn't. I found the format disconcerting. I was used to thinking in terms of a traditional vertical, horizontal, or square image. Finally I decided that although I could not clearly visualize the image I wanted, I might at least begin by considering what I wanted it to convey to the observer.

I asked myself what the best of my work symbolized to me, and concluded that it reflected my life's ideals. I have always believed that it is essential to retain a sense of childlike wonder, and to be open to the ideas and real magic of life. To me, there is a great sense of joy in discovering a creative idea. Moreover, I believe in a unity of all living creatures, and hope that this unity will someday extend throughout the universe. I believe there is a benevolent power at work in the universe. These overwhelmingly idealistic concepts were heady ones to wrap neatly into a single photograph! I think I was as disconcerted by that realization as I had been by the gatefold format, if not more so.

In addition to all the intangibles I had to somehow make symbolically tangible, I wanted the image to be visually interesting, having strong perspective, well-saturated color, and an entertaining subject matter. I did not want the ideals to weigh the image into a sanctimonious visual lecture, but instead to promote a free and joyous expression of life.

Because I wanted the image to be timeless, I avoided any elements that might date it, such as clothing or computer hardware. An electronic marvel that might be the latest thing when I photographed it was sure to be out of date by the time the book was in print. Knowing these things were to be avoided still did not give me even a vague clue about what I did want to include.

At last, Michael O'Connor, our editor at Amphoto, sent a sketch over to the studio that provided just the impetus I needed. It showed the outline of a man holding a glowing globe at arm's length. Behind him, some figures stood in the background, and the horizon was mountainous. I liked the image, and pinned the sketch to my wall, glancing at it occasionally as I worked. Eventually, the image I wanted began to take a firmer shape in my mind.

I avoided using any element that might not be readily available to any photographer. I selected my elements, techniques, and models accordingly. For example, I did not use front projection, a useful technique, but one to which most photographers would not have access. I rejected using any computer-generated image, or photographs available from NASA. I wanted every aspect of the image to be understandable, uncomplicated, and accessible.

Rather than use an adult in silhouette, as the sketch suggested, I decided to use a child. He would symbolize our human hope for the future, and at the same time represent the child

within each of us who is open to the joyous discovery of the creative idea. Instead of a globe, I would show him reaching toward a bright floating object that for me would symbolize the pure energy of the creative idea. Kenneth Powers, an excellent child actor and model, gave just the right amount of "Wow!" I sought.

The sketch suggested other people in mid-background. I decided instead to use an animal, selecting our own 13-year-old dog, Suzy, for the enthusiastic model. I wanted some type of unifying element to show a unity between human and animal, and decided a glow — an aura — around each of them would symbolize their bond. It seemed right that the glow should originate with the pure white light-energy of the creative idea, and so should be the same bright white as that floating object.

Deprived of NASA's photographs of planets, I substituted common round objects, selecting them for texture and color. I placed many different planets in the sky because I wanted to hint at the untold possibilities of planetary exploration in the future, and gathered them together to symbolize a universal unity.

The grid of light on which the subjects stand symbolizes for me the possibilities offered by digital communications and computers. I sketched the grid, photographically manipulating it to produce the appearance of a computer-generated image. Humankind is linked with computers in a unique relationship, and I wanted to use the perspective of the grid to present a cohesive pull of computer power to the future beyond the horizon.

Rather than use a mountainous horizon, as in Michael's sketch, I wanted the horizon unrimmed and therefore unlimited. Symbols abound, but I had still not found a way to express the idea of a benevolent force at work in this gatefold universe of mine. After some thought, I realized that humankind has always looked to the sky for its gods. Even adults play the child's game of searching for recognizable shapes and faces within the shifting clouds. I played the game too, looking for a subtle face in the sunset clouds of my stock file, and adding star "eyes" to suggest the benevolent awareness I intended. It seemed right that this sunset face should also be the source of all light within the photograph, and that each element appear to be lit by it.

At that point I had the idea of the gatefold image in my mind, but I still had to collect the elements and combine them into a photograph. How did I proceed? How would *you* proceed? Would you make a sketch? How many elements were needed? Which of these might be readily available in your stock file, and which would probably have to be photographed specially for the gatefold picture? Would special props be required? What kind of lighting set-up would be needed for each element? What colors would balance the image, and still provide the variation and impact needed? How would a strong saturation of these colors be best achieved? What would be the easiest method of combining the chosen elements into the final gatefold image?

Even after the idea was clear and the elements assembled, the easiest method was exceedingly tedious. There were so many elements that each final version returned from the color lab with one minor flaw. Trouble was, the flaw differed each time; a tiny dust spot, a slight color inbalance, a hair's breadth misregistration. Three weeks after the rest of the book's text and images had been sent to the printer, I was exhausted! One night, numbly considering filter effects that might be used to eliminate the flaws and unify the image, I stepped wearily into the shower, closed the shower door, and suddenly saw the answer clearly. The answer

was an effect that would make the entire photograph appear to be a computer generated image composed of tiny rectangles.

If you have inferred by this time that I am not going to tell you the exact procedure I used, you are quite right. This is not because I want to be mysterious, or because the image contains any particular secret I am unwilling to reveal. On the contrary, my goal is exactly the opposite. I want to reveal all the secrets to you, but I need your cooperation. You must exercise your own imagination and explore all the possibilities available for producing the image.

When I was at last sure of what the image would be, it still existed for a time only in my mind. I had to learn how to put it all together by trial and error. I might have made fewer trials and stumbled over fewer errors than you would, only because I am constantly working to produce special effects photographs and practice has made me fairly intuitive about how to proceed. Still, there is nothing I did in making this image that you could not do. Every technique is available to you within this book, and requires only that you add the spark of your own imagination. Look for the simplest solution and it will not be difficult to infer how any element was photographed and each combined finally into the whole.

I am always happy to discuss any aspect of my work, and will willingly answer questions regarding other images in this book. I refuse, however, to respond to inquiries regarding this image. Don't bother to write and offer your solutions of how each element was produced, because I will only nod and smile. This is one area where I want to encourage each reader to come to his or her own conclusions. I hope it is not presumptuous of me to say that I do this in the same spirit that a parent encourages a child to walk, knowing a few falls are inevitable. Eventually the child does walk, and some day the child will run faster than the parent. Therefore, as you experiment, explore, and learn by doing, let the child within you reach out in freedom for the joy of — not my — but *your* creative idea.

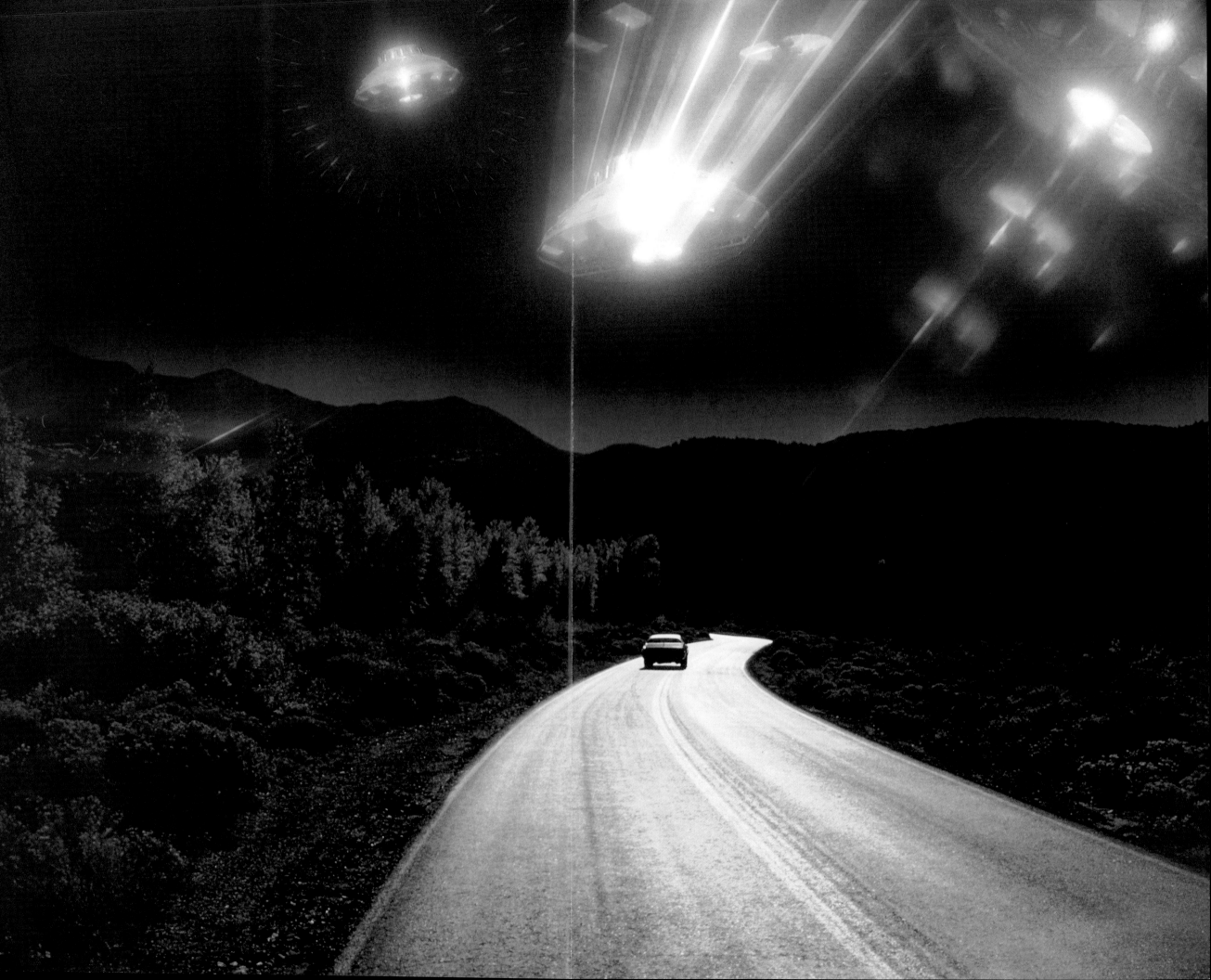

MAKING MULTIPLE EXPOSURES

I seldom, if ever, want to get involved in building props, but I thought it might be fun to build a flying saucer. We had a hanging lamp over our kitchen table that I thought would be ideal as the saucer, so I promised Marie a new lamp as I detached this one. I added plastic toy tank parts, Christmas tree lights, and green plastic Fresnel lenses for windows. I hung the resultant saucer against a black velvet background and lit it with three strobes, each with a modeling light to show the effect of the lighting. The strobes were directed to bounce light from the white ceiling.

Using a 50mm macro lens, a Spiratone Mist Maker and Rainbow Streaker filters, I positioned the largest saucer image and shot 36 exposures on the register-marked roll of Kodachrome 25. The film was rewound and realigned. Using a 35–70mm zoom lens, a Mist Maker filter, and a tripod for stability, I fixed the lens at 35mm, and made a one second exposure. The flash as I tripped the shutter produced the clear image of the medium sized saucer at 35mm, and the zoom to 70mm produced a zoom effect, lit by the modeling lights. The film was again rewound and realigned. Using a Hoya Spectral Burst filter and Mist Maker, I viewed the saucer with a 20mm lens for the smallest image, and found I had a problem.

Although the small saucer was an ideal size for the composition, the 20mm wide-angle lens included a view of the ceiling, strobes, and floor. To remedy this, I cut a 1½ inch hole in a piece of 8×10 black paper, and positioned the hole in front of the lens until only the saucer was in view. The paper masked out the background, and I shot the third set of exposures.

In my stock file, I had the image of the road, photographed with a 20mm lens on an afternoon when the glaring sun silvered the roadway. The image was added to the multiple exposure by slide duplication in my Bowens Illumitran.

The shot was used in *Penthouse* magazine to accompany an article. Art director: Joe Brooks.

Multiple exposure, the process of exposing several elements separately onto a single piece of film, is a versatile technique for solving photographic problems creatively. I would estimate that about 50 percent of the special effects I do involve the use of multiple exposure, with the other 50 percent divided among all other techniques.

Because in multiple exposure the original elements are exposed directly on first-generation film, the images are of better quality than those combined through any other method such as montage or duplication. Any copying or blending used in other techniques brings the image into a second generation that is bound to be somewhat less sharp than an original.

I have sometimes been asked if I do not find it difficult to plan intricate multiple exposures on such a small format as 35mm film. The answer is yes, of course I do sometimes find it difficult, but I much prefer to work with 35mm in most cases. Careful planning for precise element placement is necessary, but exactness is certainly possible. The use of 35mm also provides a flexibility and spontaneity not obtainable through the use of a larger format such as 4×5, even when image placement is tight. There is usually a very slight margin for variation in at least one, possibly two, or more elements, and I like to shoot for variation so that I have a wider range of choices. If I were to use 4×5, for example, I might still have the same options for variation, and certainly would have an easier time with image positioning, but the time consumed in exposing and re-exposing all elements would be highly stifling to my creativity and enthusiasm. I seldom shoot all the elements at once, but may work with a number of elements, objects, or sets, each of which may take time to position or even construct separately from all others. Some sets might have to be taken down to allow room in my studio for others. If I use 35mm, I can shoot several rolls on each element, remove sets or change elements, go out for coffee or home for dinner, and return the next day to shoot another 36 variations on the next element. Several of the images might be slightly off their proper positioning when the film is at last developed. However, with the dozens of choices available to me by using 35mm, I can always find quite a few that are exactly what I am looking for, and may even find something better than I originally expected.

There is almost no limit to the number of images a photographer could conceivably expose onto one piece of film. As you learn to handle multiple exposure, begin with only double or triple exposures. Once you are more confident and able to be precise in image placement, give free rein to your imagination, and experiment by combining as many images as you need for an effect. You will learn a great deal if you are as daring as possible. Be daring, but not reckless; multiple exposure demands great care, precise image placement, total exposure control, and much patience.

Probably the most delightful thing about experimenting with multiple exposure is that sometimes the unplanned blendings result in happy accidents that are so interesting that they take you off on a new creative tangent, and add more than you planned to your original concept.

Select multiple exposure over other special effect methods when the subject is placed, or can be placed, against a black background to allow for the addition of successive elements over that black background, or when the succeeding elements are not so light as to wipe out the film emulsion as they are layered. Use multiple exposure when the overlapping image of one element into or over another is not objectionable, or when you want bleed-through to lighten the overlapping area. Consider that any one element unbalanced with regard to size, intensity, or position, will destroy the total effect, so use multiple exposure either as a precisely planned effect, or with the intention of total experimentation and acceptance of unexpected blendings.

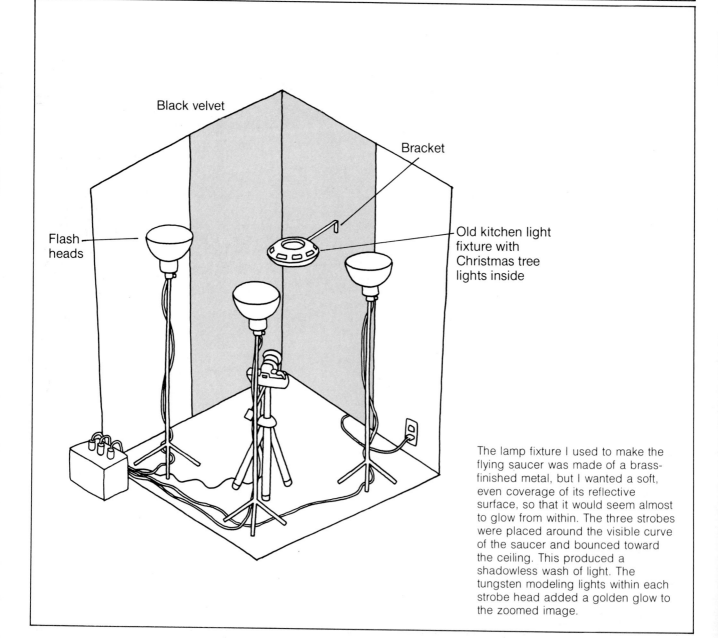

Black velvet

Bracket

Flash heads

Old kitchen light fixture with Christmas tree lights inside

The lamp fixture I used to make the flying saucer was made of a brass-finished metal, but I wanted a soft, even coverage of its reflective surface, so that it would seem almost to glow from within. The three strobes were placed around the visible curve of the saucer and bounced toward the ceiling. This produced a shadowless wash of light. The tungsten modeling lights within each strobe head added a golden glow to the zoomed image.

AVOIDING OVEREXPOSURE

Each time a piece of transparency film is exposed to light and developed, it gets lighter and less dense. So, when you make a multiple exposure, the film can become overexposed. You must compensate by allowing less light to reach the film with each exposure. Do this either by deliberately underexposing, or by deliberately misrating the film speed. Negative film gets darker each time it is exposed to light, and when you make a multiple exposure, the negative becomes too dense. So, when making a multiple exposure, you must compensate by deliberately underexposing or by deliberately misrating the film speed just as you would for transparency film. In each case, the final result should be as near to a normal exposure as possible.

The exception to this rule occurs when you expose elements against black or very dark backgrounds and don't let the elements overlap. Because each element is, in effect, placed on an unexposed area of the film, no exposure adjustment is necessary. For example, when I expose a roll of full moons I give the film normal exposure. The black sky doesn't affect the film, and when I shoot the next image, I can give it normal exposure as well. The same principle applies to the dark areas of any scene.

Underexposure Method

Set your shutter speed at a faster setting, *or* close the aperture to a smaller opening. For making a double exposure (two separate exposures on one frame of film), set the shutter speed one stop faster, *or*

close the aperture one stop smaller. If you plan on making a triple exposure (three separate exposures on one frame of film), set the shutter speed two stops faster *or* close the aperture about two stops smaller.

Film Speed Method

Set the ASA dial of your camera to a higher number, and take a meter reading as if the film had a faster speed. This will have the same effect as underexposing. If you plan to double expose, increase the film speed by doubling it. For example, ASA 25 film would be exposed at ASA 50. If you plan a triple exposure, triple the film speed. Therefore, ASA 25 film would be rated at ASA 75.

The very first multiple exposure I ever made was the result of my being too poor to afford more than a single roll of black-and-white film. Fortunately I had friends with photographic equipment. I lived in Los Angeles at the time, and went to a "Love-in," a gathering of flower people in full regalia, carrying a camera bag of borrowed equipment and the single roll of film. There was so much happening that my single roll was finished all too soon. I walked around resignedly, accepting a few offered flowers, some gentle philosophy, and consoling myself by sampling frequently offered wine. In no time, I was feeling highly in the spirit of the gathering, and decided to throw caution to the smoggy Santa Anna winds. I would reuse my single roll of film. I had shot with one lens the first time, but decided to try another lens for the second set of exposures. I exposed the roll three times in all, using a 28mm, a 50mm and a 100mm lens. Satisfied at last, I returned to my studio to process it and see what I had. As I prepared the developer, I had the suddenly sobering realization that the film was badly overexposed. I knew nothing about exposure compensation in shooting, but reasoned that I might compensate for overexposure by underdevelopment. It was a relief to see the negatives were not too dense to be printed. None of the compositions had been planned, but each print fascinated me by its unexpected blendings. I was hooked on multiple exposure from that moment.

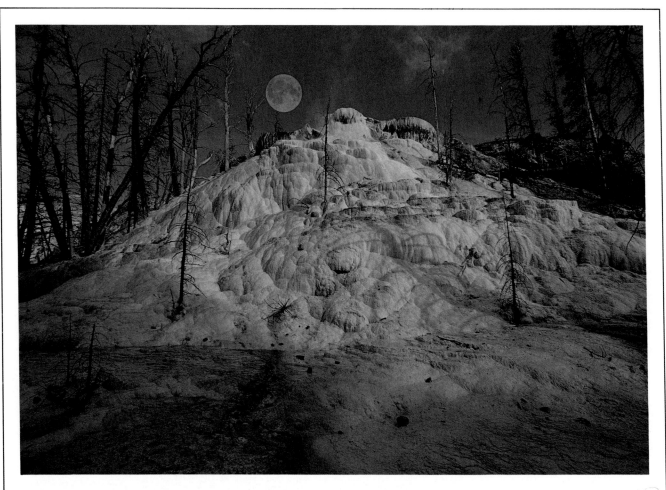

Whenever you intend to shoot a variety of planned multiple exposures on a single roll of film, it is helpful to keep notes on each exposure. In the sketch, shade dark areas on the first exposure so you know where other images can be placed in succeeding exposures. This formation was photographed at Yellowstone National Park, Wyoming, with an 18mm lens and polarizing filter to darken the sky. The moon was photographed in New York City with a 200mm lens.

NOTES AND SKETCHES

Notes and sketches are an essential part of working with multiple exposure. Although it may at first seem like bothersome and unnecessary paperwork, it will soon prove its value as you progress to more complex multiple exposures. I make it a practice to roughly sketch every element of the planned shot, and I spend at least as much time thinking about their placement as I do in shooting them.

When beginning to experiment with multiple exposure, the more detailed the notes you keep, the better. I admit to sometimes making my notes and sketches on the back of napkins or spare envelopes, but although the paper may be haphaz-

ard, the sketch and notes never are. Results of multiple exposure are only predictable when they are planned with great care, so if a particular combination is excellent, I want to know exactly what I did every step of the way that made it so. When the result does not meet my expectations, I should be able to look over my notes to see where corrections must be made, and how the variations were done.

A small notepad, 3½×5 inches, is ideal, since the proportions roughly correspond with a 35mm film frame. When shooting many variations on a single roll of film, you can number each right-hand page to correspond with the frame number. On that page, make a rough sketch of the image, showing the result you expect from the combinations of elements you will multiple expose. Shade in any areas of the subject or scene that are dark. Begin by sketching the first exposure, then the next, and so forth, watching how they fall in the order

of the whole. If you are satisfied that the placement is good, go ahead and shoot. On the facing page, write any information pertinent to each exposure, such as f-stop, shutter speed, film type, and ASA used. As you progress, you may also want to record which lens was used for what exposure, or which filters were used.

If you are shooting variations of a single subject on a roll of film, the notes can show the variations that occurred in each of the 36 exposures on the roll, something that may be difficult to recall by the time the film is developed.

MARKING THE CAMERA'S VIEWING SCREEN

Marking on the camera's viewing screen is an excellent way of planning the positioning of elements in a multiple exposure. I once worked with large format cameras much more than I now do. They

allow the photographer to sketch the planned photograph to size on a grid-lined focusing screen. This seemed to be a logical method of planning for 35mm as well, so I purchased a viewing screen for my camera that has an etched grid of horizontal and vertical lines. Such a grid can be ordered from any camera dealer, but you must have a camera that allows you to remove its pentaprism to reach the screen. Many cameras do indeed have a removable pentaprism, and if your plan is to pursue multiple exposure, consider that as a factor when purchasing a camera body.

To mark the screen, place the camera on a tripod, view the subject, and remove the pentaprism. Use a well-sharpened grease pencil to trace on the screen the outlines of the most important element, or elements, in the primary exposure. It helps to shade the viewing screen with your hand to achieve good viewing contrast while you trace the elements.

After the tracing is complete, replace the pentaprism, and without moving the camera, proceed to shoot the first element. When you are ready to add other elements, watch how they fall into the outline, and position them with regard to that outline. With successive exposures, you may want to again sketch a bare outline of elements for extra control.

If the subject is moving, the outline can still be used, but the exact placement of lines will be somewhat inexact, unless the movement can be repeated exactly without variation each time. However, even a general outline can be helpful for positioning a moving subject against other elements.

Even if you have a camera that does not give you the freedom of pentaprism removal, a grid-line viewing screen can be extremely helpful in positioning multiple exposures, and is well worth the purchase. Without the ease of marking, you will have to watch the grid carefully in positioning elements, and keep exact notes. The more you practice, the better and more critical your ability will become.

Some cameras allow you to remove the pentaprism and mark directly on the viewing screen with a grease pencil. This is very helpful in multiple exposure, because it enables the photographer to place elements with some exactness with regard to each other's positioning in each exposure.

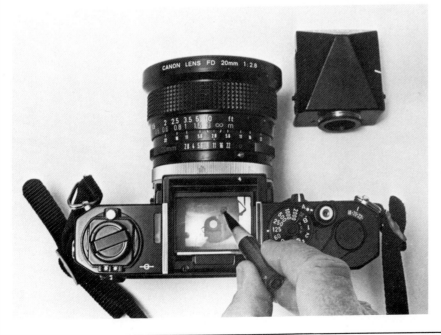

REGISTRATION MARKING CAMERA AND FILM

In order to make a multiple exposure, the film frames must be positioned exactly in the same place with every exposure. Otherwise, the edges of the frames would overlap, and you could never be sure how to correctly line up elements so that they are in proper relationship to each other. Noses that you wanted to touch tip to tip might merge nostrils, and the moon might fall into a lake or be impaled in the trees. To solve the problem, register mark both your 35mm camera and the film. That way, the film frames will fall in exactly the same place each time the film is exposed.

On a trip to the Caribbean, I had taken photographs from the air with a 100mm lens. Later I decided to double expose the SST into this background. I photographed the model SST against a self-masking black velvet background with a 50mm lens. A rainbow repeater filter provided color ghost images of the SST to symbolize its velocity and power. The model was lit with one umbrella above and in front of it. I made the double exposure in a slide duplicating device, exposing the transparency of the SST first, then the Caribbean background slide. The self-masking black background nevertheless allowed the rainbow images to overlap in the double exposure, as I had planned.

Marking the Camera

To register mark the camera, use nail polish, acrylic paint, fast-drying enamel or laquer. Any marking material will do as long as the mark will not rub off, is waterproof, and can be seen easily in dim light. It can be helpful to have a ruler or tape measure. Some cameras need not be marked at all, as they have a screw that can be used as a permanent position marker.

1. Take film out of camera.
2. If the camera has an interchangeable lens, remove it.
3. Place the camera, lens-side down, on a clean dry surface.
4. Open the back of the camera as if to load it, so that the take-up spool is on the right-hand side.
5. Measure approximately ½-inch to the right of the lower right-hand corner of the shutter opening and ¼-inch below this point. Some cameras have a screw at just this place, which will serve perfectly.
6. Place a small dot of marking material at this point, no larger than ⅛-inch diameter.

When the marking material is dry, it is a permanent registration mark against which to align the film each time it is re-exposed.

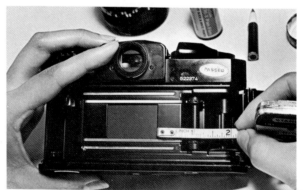

Measuring.

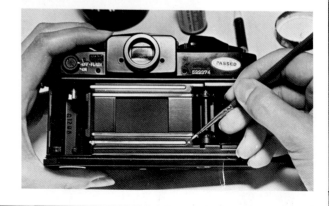

Marking the camera.

Advancing
the film.

Register Marking the Film

To register mark the film you need a sharpened grease pencil. You should carry one whenever you plan to shoot multiple exposures.

1. Again place the camera lens-side down with the back open, and load it with film as you would normally.
2. When film is loaded, cock the shutter by moving the film-advance lever to the right until it stops.
3. Turn the film rewind crank clockwise until the film is stretched snugly between the rewind spool on the left (within the film cassette itself) and the take-up spool on the right.
4. With the grease pencil, make a straight line across the back of the film upwards from the camera registration mark.

Tightening
the rewind.

Realigning the Film

Each successive use of the film must be begun by careful realignment. Should you find it necessary at any time to remove a partially exposed roll, whether you are shooting multiple exposures or not, the film can be correctly replaced if you register marked it the first time you loaded it.

Marking the film.

1. After the first set of exposures has been shot, rewind the film slowly. You will feel it become tight just before it releases from the take-up spool. At this point, stop turning the rewind crank.
2. Open the camera back. The film leader should be hanging out of the film cassette, just as it did the first time you loaded the film.
3. Again load the film onto the take-up spool, and cock the shutter completely, advancing the film until the grease pencil mark is in the area of the camera's registration mark.
4. Manually adjust the film so that the mark on the film lines up exactly with the mark on the camera. Holding the mark in position with a finger firmly over the film, turn the rewind crank until the film feels snug between the rewind and take-up spools.

Realigning
for re-exposure.

Properly aligned,
ready to shoot.

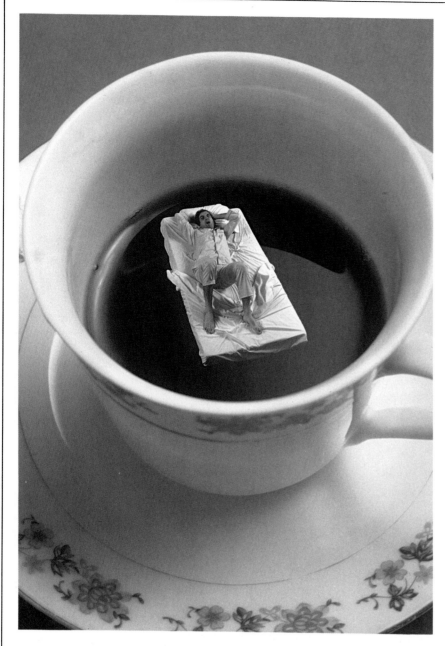

At least something good — the idea for this photograph — came from a sleepless night I spent as a result of my own overindulgence with coffee.

I photographed the coffee cup with a 50mm lens, sizing it and sketching it on the viewing screen of the camera with a grease pencil. I lit the cup from above and to the left with a bank light, making sure the light did not reflect in the coffee. I wanted no light spots in the dark coffee to expose emulsion where I planned to place the subject of the next exposure. To photograph the man, I covered the studio floor with black velvet. The mattress and model rested on the velvet, and I climbed a 10-foot ladder to shoot. Lighting was again supplied by the bank light, which was placed at the same angle I had used for the cup. When I looked through the 20mm lens I found I had a problem. Although perspective was perfect and the subject was sized exactly in the coffee, I could see from the guide sketch on the viewing screen that the 20mm lens allowed me to view beyond the limits of the black velvet background to the studio wall. To solve the problem, I did the same thing I had done to photograph the flying saucer. I cut a hole in a piece of black paper and held it in front of the camera to serve as a mask, shooting through the hole. The black paper masked the entire background, and I was easily able to make the second exposure.

Whenever a roll is removed, you should always mark it with the date, the number of frames exposed, the subject, and the film speed used, if it differs from the normal rating.

If you have more than one camera body, make a note of which camera was used. I number all my 35mm cameras, and write the camera number on the roll of film. That way, I know any camera idiosyncracy will not cause misalignment, as it might should I reload the wrong camera.

One camera, for example, may have slightly more play in the take-up than another.

I always replace any half-used cassette in its plastic film can, and label the can so that I won't have to open several in search of the one I seek.

To continue shooting a partially exposed roll, register it within the camera and then place a lens cap over the lens. Fire off the number of exposures originally made, and re-

move the lens cap. The frames should be lined up without overlap for the continuation of that roll.

Motor drives or power winders occasionally cause misregistration problems, even when you have made every effort to correctly align the film. I suspect that this is because the film is pulled and wound so rapidly that there is some minor slippage in the gearing. When shooting multiple exposures, I always cock the shutter manually.

Subjects and Backgrounds for Multiple Exposure

Before beginning any multiple exposure, consider what elements are to be used. The following basic rules in making multiple exposures govern where and in what order elements must be placed.

- A dark background is the best, the darker the better. I use black velvet for most multiple exposures, and in fact had a 16×20-foot piece of black velvet made especially for placing elements. The matte surface of the velvet prevents stray light from reflecting along the background and overexposing it to gray, which usually happens when you use black paper for the background. The velvet background does not significantly reflect light. Therefore, the film is exposed only where the image of the subject is positioned. Other elements can subsequently be placed in the unexposed areas of the frame.
- A light background should not be used, because it will expose the entire film emulsion. Once the emulsion is exposed, no more elements can be successfully recorded on that film. Any additional attempts at exposure will result in overexposure without subject definition. If one of the elements is a light area, plan to expose that area last. Always expose any dark subject or area first, and successively lighter subjects later.
- The number of elements that can be successfully placed on a frame of film is limited only by the amount of dark area still left where emulsion remains on the film for exposure. That is why you should shade the sketches you make, recording for your information the areas still available on the film. If all the elements are generally the same density or brightness, and your aim is to have them blend one over the other, rather than being more sharply divided, I would suggest that you limit yourself to three exposures on a single frame.

PHOTOGRAPHING ELEMENTS WITH DIFFERENT LENSES

Most of my multiple exposures are done with more than one lens. This allows me to control perspective and combine images as the eye might see them. An expansive meadow with a big yellow moon rising in the late afternoon sky is seen by the eye, but what lens could capture the image? A wide-angle lens will show the meadow, but the moon will shrink to a tiny yellow dot above the distant horizon. A telephoto can capture the size of the rising moon, but the meadow becomes narrowed and compressed, without the benefit of depth of field offered by the wide-angle. What is needed is a combination of the two perspectives, and this is easily achieved by using two lenses in a double exposure. When I wanted to place the man on a mattress floating in the coffee cup, my first thought was not how to shrink the model or how to build a huge cup, but which lenses I could use to give the proper size and perspective I needed in a multiple exposure. Because I sketch and plan the placement and size of elements beforehand, it is easier for me to decide which lens to select for which element.

As I was leaving on a motorcycle trip to Mexico, a client friend of mine asked if I would photograph a geode for his company, which sold crystals and minerals. He wanted, he said, a unique look. I did not have a clear idea of what to shoot until I was at last in the desert. Since a geode is a volcanic product, coming from the earth, I wanted to symbolize it as Earth's offering. I mixed desert dirt with water for a thick mud pack, and applied it to the arm of a friend. He reclined on the ground, stretching his arm above him. With rocks, I blocked his upper arm from view. By that time, the hot desert sun had baked the mud, and it began to crack as I'd hoped. I had him turn the geode to face and reflect the late afternoon sun, as I lay down and shot with a 20mm lens. Later I double exposed the crescent moon onto the register-marked film, using a 300mm lens.

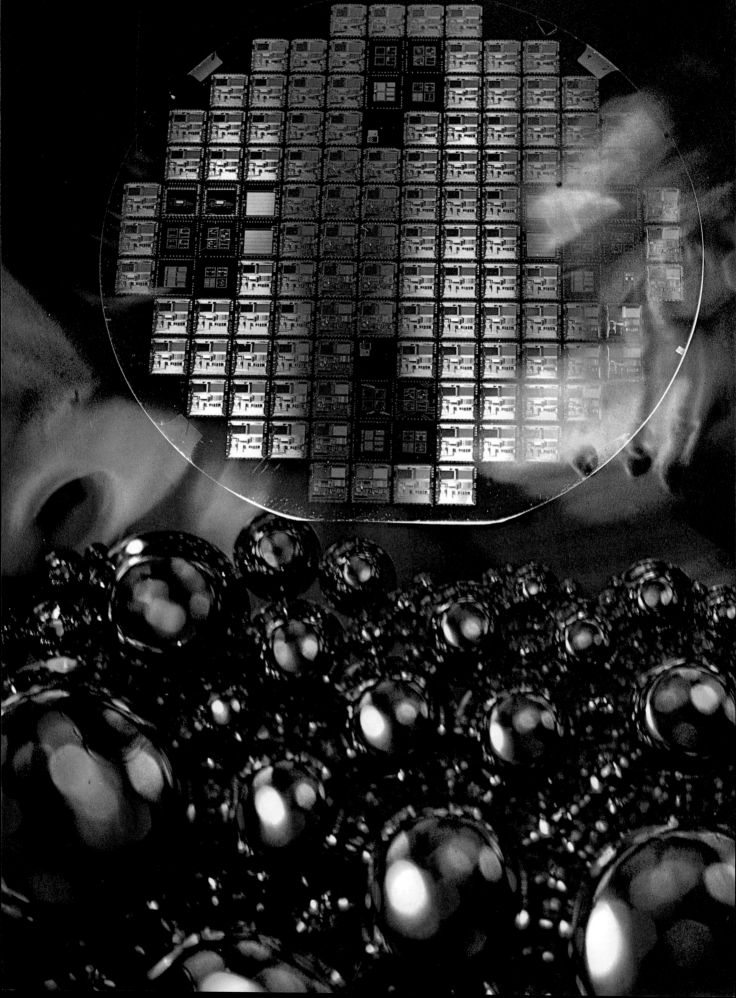

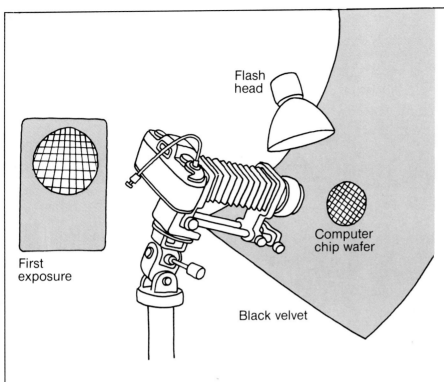

First exposure

Flash head

Computer chip wafer

Black velvet

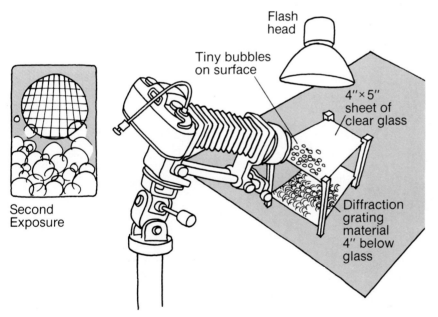

Second Exposure

Flash head

Tiny bubbles on surface

4"×5" sheet of clear glass

Diffraction grating material 4" below glass

PROCEDURE FOR EXPOSING ELEMENTS TOGETHER

1. Register mark film and camera.
2. Select the subject elements, bearing in mind the light to dark relationships.
3. Decide on the number of exposures and set the shutter speed faster, the *f*-stop smaller, or change the film speed to compensate for overexposure.
4. Sketch the idea in the note pad, watching where the elements will fall.
5. If necessary and convenient, mark the outlines of the elements on the camera's viewing screen.
6. Expose the first element, and make note of all pertinent information. I always shoot the entire roll on the first element before proceeding to the next. You may wish to expose the next element immediately. Some cameras have a multi-exposure button that allows the shutter to be cocked for the next exposure without advancing the film. If your camera has no such button, you can try to achieve the same result by turning the rewind crank clockwise until it is tight, holding it in position so that it is unable to move, while simultaneously depressing the rewind button. Then with one smooth stroke, cock the shutter. This method usually works, and the film remains in the same position, ready for the next exposure.
7. Rewind the exposed film carefully, and realign it for the second exposure, assuming you prefer to shoot the entire roll on one element at a time.

For a *Popular Electronics* magazine spread dealing with new technology, I was asked to photograph a gold-plated bubble memory wafer that diffracts light in rainbow colors. I wanted to symbolize the bubble aspect of the wafer.

I photographed the 3-inch wafer on a black velvet background with a 50mm macro lens. I moved the light overhead until the maximum spectral diffraction showed on the wafer. I drew the position of the wafer on the camera's viewing screen.

I next placed a sheet of glass several inches above a sheet of diffraction grating material. Photo-flo and water

provided tiny bubbles that I put onto the glass with an eyedropper. I used a 75mm enlarging lens on a bellows to provide high magnification and a short depth-of-field that would hold only the bubbles in focus without showing the diffraction grating material. I again lit for maximum spectral diffraction, visible as reflections in the bubbles. With the sketch on the viewing screen as a guide, I used a small brush to remove bubbles from the area where I intended to place the wafer so they would not overlap in the double exposure.

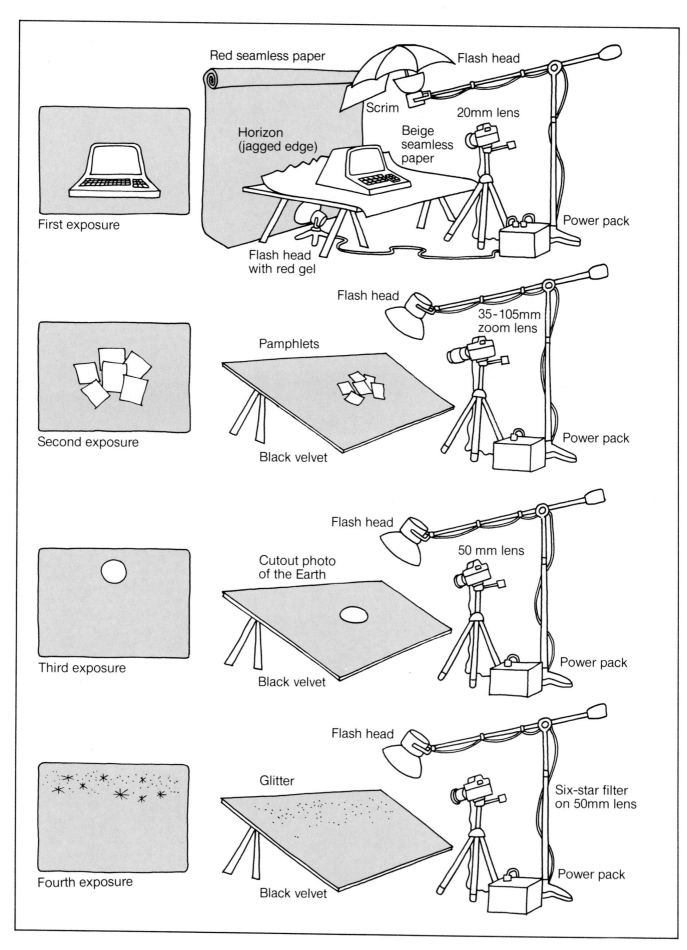

First exposure

Red seamless paper

Horizon (jagged edge)

Scrim

Flash head

Beige seamless paper

20mm lens

Power pack

Flash head with red gel

Second exposure

Pamphlets

Flash head

35-105mm zoom lens

Power pack

Black velvet

Third exposure

Cutout photo of the Earth

Flash head

50 mm lens

Power pack

Black velvet

Fourth exposure

Glitter

Flash head

Six-star filter on 50mm lens

Power pack

Black velvet

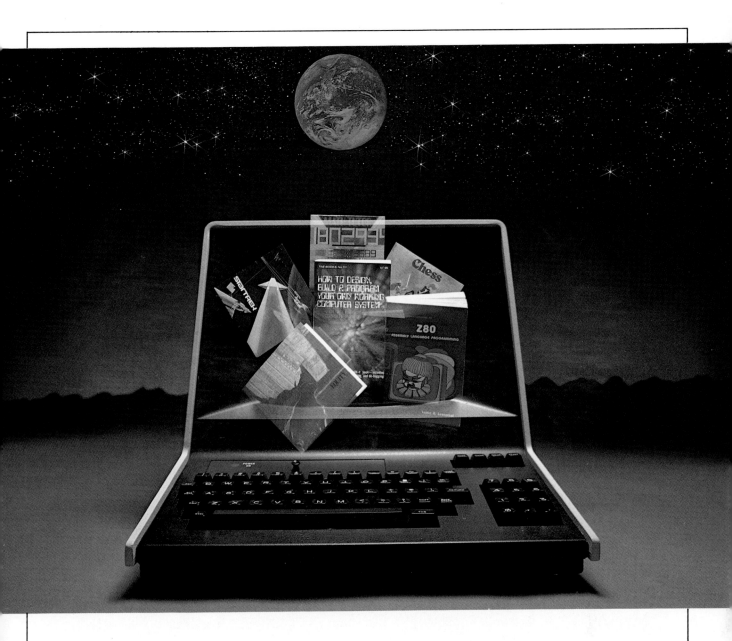

Popular Electronics magazine wanted a photograph of a computer with software packages. I made some sketches showing the computer as I saw it, and the art director approved.

In the studio, I made a plywood and sawhorse table, and covered it with brown seamless paper. I curved the paper upward at the rear of the table, cutting it to resemble a mountainous horizon. The background was red seamless paper, lit from beneath the table with a strobe covered with a red gel for additional color intensity. I covered the computer screen with a black flocked paper to prevent reflections and provide a black surface for the double exposure. On the camera's viewing screen, I marked the outline of the computer and its screen. The computer was lit from directly overhead with an umbrella

on a boom, a scrim on the umbrella to prevent spill light from reaching the background above the computer rim. I shot with a 20mm lens from a low angle to increase perspective.

The software packages were placed on black velvet, composed so they fit within the computer screen as marked on the camera's viewing screen. I lit them from above with an umbrella, and zoomed with a 35–105mm lens during a one second exposure so that they appeared to zoom outward. A cutout of the earth was then put on black velvet, and shot with a 50mm macro after I marked its location in the camera's viewing screen. I used that mark as a guide to sprinkle the metallic glitter stars on the black velvet, and photographed them with the 50mm macro lens. Art director: Ed Buxbaum.

I bought circuit boards from an electronics supply store, and taped four together with cellophane tape. I lit this translucent box with strobes from three sides, and a silver reflector card beneath the fourth side, photographing it with a 20mm lens to emphasize foreshortening. The background was black velvet. I marked the opening of the box onto the viewing screen for a guide to position the earth in the double exposure. With a cutout of the earth in place on black velvet and lit with a single strobe above it, I sized the cutout according to the viewing screen guide and photographed it with a 50mm macro lens.

Discover magazine asked me to conceptualize a shot of something no one has ever seen. Neutrinos, thought to be the smallest particle, can penetrate even the densest matter as they emanate from the sun. I thought it might be interesting to show streaks of light pouring from the sun, penetrating a crescent earth and moon.

I placed a 12-inch aluminum reflector on a strobe, covered it with tracing paper for diffusion, and put it against a black velvet background. That light would be my sun, and I marked its position onto the camera's viewing screen as a guide for exposures of other elements onto the same register-marked film roll. I aimed the light directly at the 20mm camera lens, stopping the lens all the way down. A Mist Maker filter provided additional diffusion.

I had no image of a crescent earth, but did have a round cutout of earth that I put on black velvet. A black cardboard circle blocked part of the light from a spotlight, casting a rounded shadow. I shot with a 50mm macro lens, using an 80B filter to correct the tungsten light for the daylight balanced film. I marked the placement of the earth on the camera's viewing screen.

The image of the crescent moon existed in my stock file, and I exposed it into the photograph with an Illumitran slide duplicating device, marking its position on the viewing screen.

The stationary stars were pieces of metallic glitter on black velvet. The single gleaming star was glitter angled to catch the light for the effect of a six-star filter on the 50mm lens. Tungsten light with no corrective filter added golden color.

The neutrinos, also pieces of metallic glitter, were sprinkled within a 12-inch circle on black velvet. I used a 35–105mm zoom lens, and practiced zooming so that streaks moved from the center of the film frame, where I had positioned the sun, off to the edges. Tungsten light without a corrective filter again added golden color. Art director: Suzanne Ritchie.

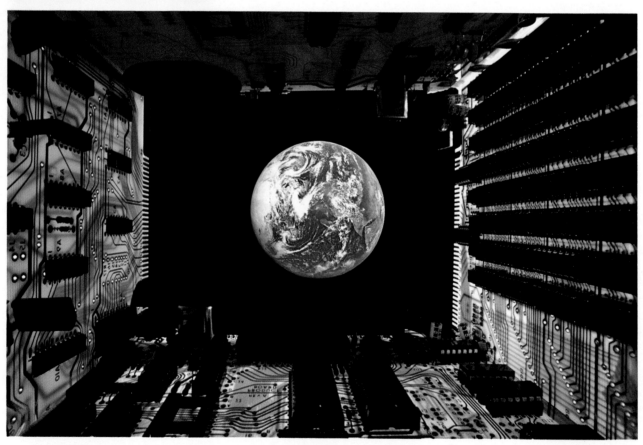

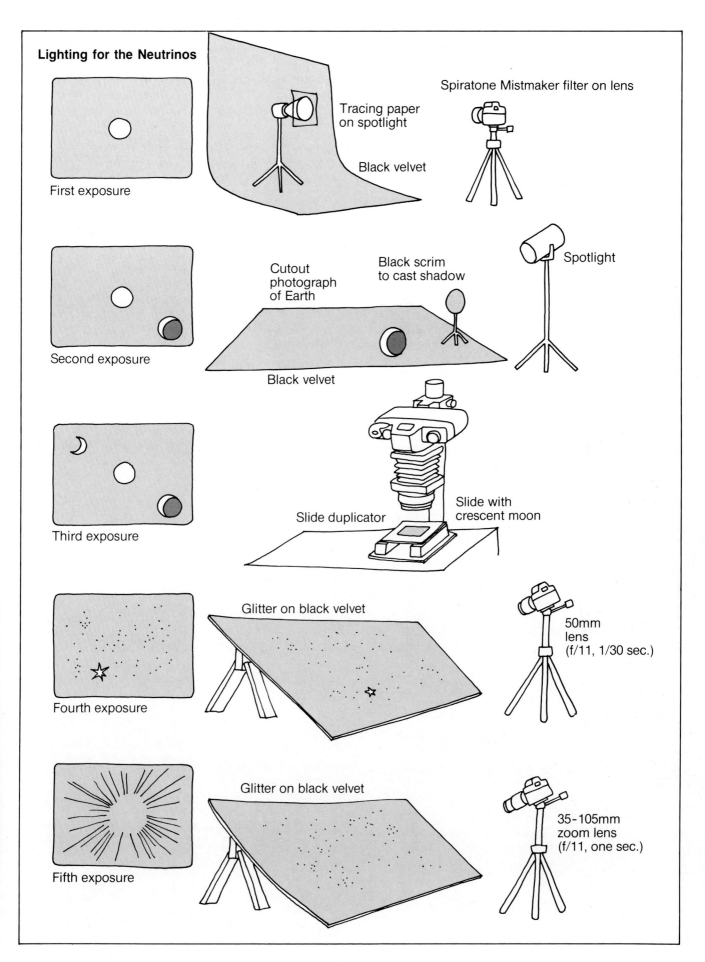

Lighting for the Neutrinos

First exposure

Tracing paper on spotlight

Black velvet

Spiratone Mistmaker filter on lens

Second exposure

Cutout photograph of Earth

Black scrim to cast shadow

Spotlight

Black velvet

Third exposure

Slide duplicator

Slide with crescent moon

Fourth exposure

Glitter on black velvet

50mm lens (f/11, 1/30 sec.)

Fifth exposure

Glitter on black velvet

35-105mm zoom lens (f/11, one sec.)

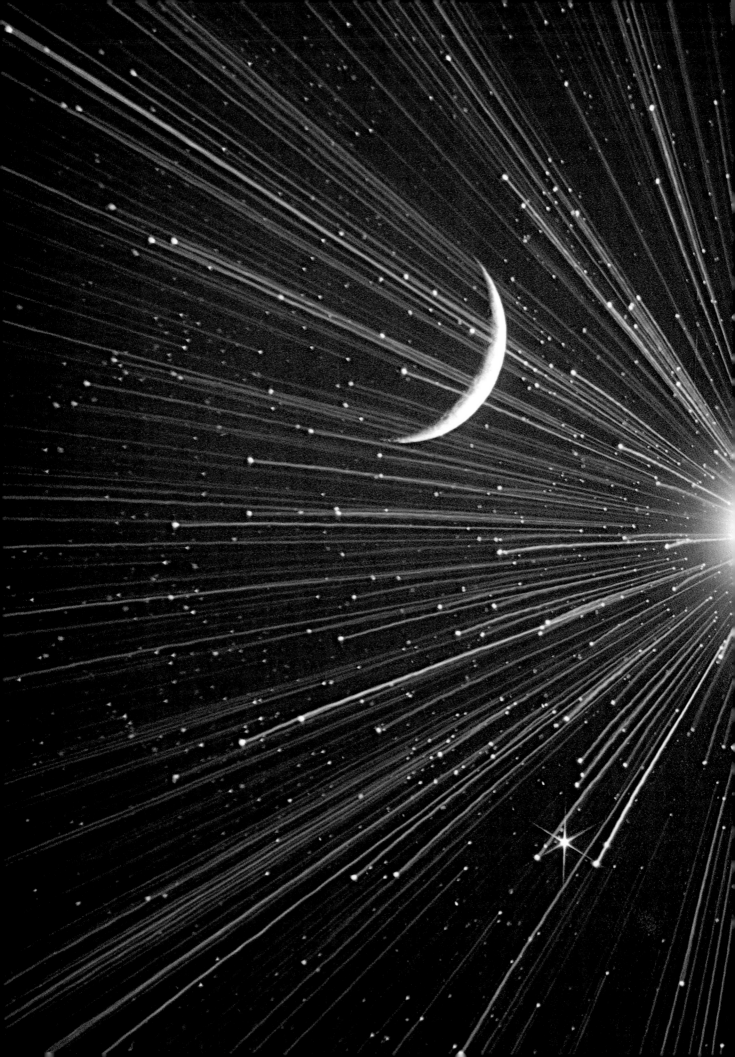

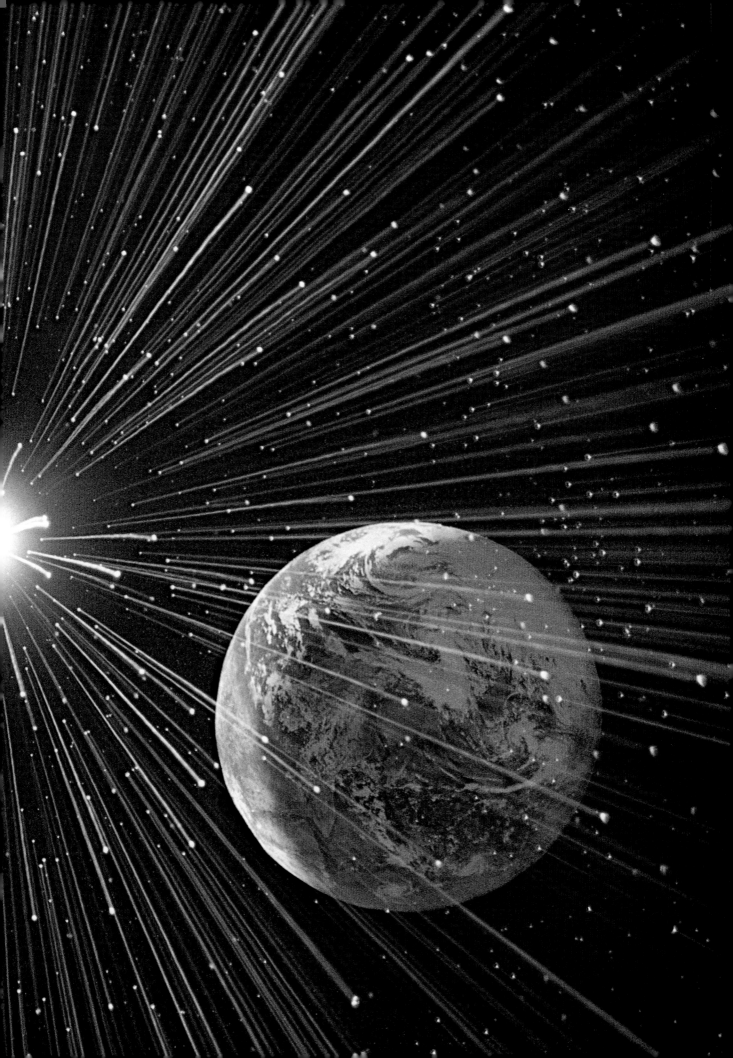

Shooting the Moon

Photographs showing landscapes with a beautiful white or golden moon above them have always been fast selling stock photos, and we have a large print of the moon over the field of yellow flowers hanging in our living room. No matter how many times we see it, we still get the feeling of peaceful beauty it captured.

Calculating Exposure

Metering an exposure for the moon is next to impossible. The moon is only one bright spot, surrounded by black sky, and meters unthinkingly average these opposites in trying to render the whole a neutral gray. The correct exposure time for the moon is available to you on the information sheet packaged with film, listed not under "moon," but rather "bright or hazy sun with distinct shadows." For Kodachrome 25, the exposure is $f/8$ at 1/125 sec., for Kodachrome or Ektachrome 64, $f/8$ at 1/250 sec., for Ektachrome 200, $f/11$ at 1/500 sec. These are perfect moon exposures, with good gray tone and detail. I prefer a brighter moon that appears more luminous and glowing, so I usually open up ½ or 1 stop.

When to Shoot the Moon

For multiple exposure, the moon should always be photographed on a clear night when atmospheric haze and pollution are not apparent. The black sky all around the moon provides a perfect mask for multiple exposure, as it does not use any film emulsion, leaving the emulsion available for future images. Always place the camera on a tripod to shoot.

We once saw a truly incredible moonrise over a field while driving through Nebraska. The huge misshapen moon glowed bright orange, wobbling up from the flat horizon through layers of atmosphere. I leaped out of the automobile to take a photograph, but by the time my camera was ready, the moon had undulated up through the horizon haze, lost some of its color, and was not quite as gigantic as it had originally appeared. Because the moon actually moves an eighth of its diameter every 15 seconds, I had missed the image I wanted to shoot. Later, I realized that it was no loss at all. The landscape had been dull and uninteresting, a bare-tree winter flatness of dusky blue, and the sky had been too bright in the late afternoon moonrise for me to have used the moon as a double exposure. The experience had been one that held wonder only for the observer of the moment, and was meant to be watched in admiration, not photographed. I never would have combined those elements of landscape, sky, and moon with any satisfaction in a photograph were I making it up. So although the moon may look temptingly huge and orange as it rises at the horizon in the late afternoon sky, my advice is to relax and marvel, but put away the camera. You can achieve better results photographically by using a telephoto lens with an orange filter, and double exposing a sharply defined night-time moon over a spectacular landscape. Then you've got it all!

Moon Size

The size of the moon dictates the sense of reality in the photograph. I prefer to use a 200mm lens when I intend to double expose the moon over a landscape, since that provides a moon size corresponding approximately to normal vision. If the moon is to be positioned very low on the horizon to simulate a rising moon, it might be shot with a 300mm lens. Unless I'm aiming for a specific unusual effect, I object to moons shot with lenses any longer than that. To me, a longer lens would make the moon unrealistically large and destroy the illusion I want to create: that of a natural landscape with a moon above.

Positioning

Position the moon in the film frame when you photograph the moon in a night sky. Since you plan to re-expose the roll, you will want to know where the moon has been placed so that you can keep it from falling into trees or merging with a mountain in the double exposure. Whenever I am not quite sure how I might be eventually using that roll of moons, I always position the moon in the upper right corner of a horizontal frame, which simultaneously positions it in upper left when I use the camera in the vertical position. In this way, I am assured of knowing that six months later when I decide to shoot that roll of moons, no matter what the landscape may be the moon can be placed with confidence in the upper right corner of the horizontal frame, or the upper left of the vertical.

Setting the Moon in its New Location

Landscapes to be double exposed with the moon will not be photographed at night, but in the daytime, when the sky is blue and bright. Because the moon will appear in the sky, the pictures should have the feeling of approaching evening. Darken the sky and landscape by underexposing one stop. Because the moon itself is masked by surrounding black night sky, there is no need to compensate for double exposure by changing shutter speed, f-stop, or ASA. I usually add a polarizing filter when shooting the landscape, deepening the sky to a darker blue, a perfect backdrop for the glowing moon.

Any white area in the sky that overlaps the image of the moon will cause the moon to become overexposed and washed out. So when the moon must fit between afternoon clouds actually floating above the chosen landscape, position it carefully. Cloudy or hazy days when the sky is mostly white are totally unacceptable for double exposing with the moon.

I prefer to shoot landscapes with an 18mm or 20mm lens, giving an expansive feeling to the image, but if the foreground is sparse and uninteresting, I may choose a telephoto to compact the landscape.

A year after we were married, we decided to take the money we expected from one of my first major New York advertising jobs and go on a month's car trip across the United States. Because we also had continuing studio and home expenses, the money allotted for the trip was going to be tight, and the money allotted for film to be shot on the trip was tighter still. (Marie has this crazy idea that food is more important than film!) I decided I would have to shoot each frame of 35mm film as carefully as I would shoot a sheet of 8×10 film. There was no budget allowance for snapshooting. We planned our route to cover as many scenic places as possible, and I decided I wanted to photograph a double-exposed full moon over some of them. Before we left, I took advantage of a full moon and a clear night to expose one entire roll, shooting from the roof of our apartment building in New York. I

placed the moon in the upper right-hand corner of the horizontal frame, because that way I would always know the exact positioning of the moon with regard to the landscapes I hoped to photograph. The roll of moons was kept in a separate camera body, ready for exposure whenever the landscape moved me. As we traveled, we sometimes got strange looks from fellow sightseers when we asked each other, "Is this place worth a moon?" If we both agreed it was, I exposed one frame. This photograph of the moon over the field of yellow mustard flowers, for example, was made with an 18mm lens and was the only exposure I shot of that field. When we returned at last to New York, 34 of the 36 shots were excellent. That single roll of film, carefully and thoughtfully shot, paid for our month's trip many times over.

SANDWICHING

A photographic sandwich is made by placing two or more transparencies or negatives directly over each other. The resulting combination of images can be shown in a slide projector, duplicated for convenience onto a single piece of film, or printed as a single image on photographic paper. Probably the easiest and fastest of all creative techniques, sandwiching can be done by anyone who has appropriate transparencies.

When we taught the Focus 2000 photo workshops, one of our favorite sections of the workshop was the one dealing with sandwiching. We handed out plastic sleeves containing 20 unmounted transparencies. Most were chosen because they were appropriate elements for sandwiching, but a couple in each sleeve were put there exactly because they would not work well, and we wanted everyone to understand the limitations as well as the possibilities of the technique. Each person also received a plastic slide mount and a small battery operated viewer to use as a light source against which to compose. From the twenty unmounted chromes, each person was to make only one sandwich. At the end of the allotted time, we collected the sandwiches.

When we came back from a coffee break, they were ready to view in the slide projector. I was constantly surprised and delighted at the finished images. Even in the larger groups, where some participants had received many of the same elements with which to work, there was hardly ever a case where two people made the same selection and composition of slides. Moreover, they combined elements that I had shot and used for my own combinations, but in ways I found completely fresh and exciting. By and large they chose to avoid the easier and more obvious combinations, and created veritable Dagwood sandwiches full of wonderful surprises.

If you sit once at a light table and begin to combine elements, you will be hooked. You will be limited only by your own imagination and by the number of slides you have on hand to combine. Soon neither will limit you, because your imagination will take flight, your creativity will seize new combinations, and you will take every opportunity to photograph elements that you can play with on a rainy day.

Select sandwiching over other special effect methods when there are large areas of light colors or white surrounding the major elements, or when you want to combine a silhouetted dark subject with a light or colorful background. Although some sharpness is lost with successive layering, sandwiching has the advantage of allowing you to select the very best elements culled from your entire stock file, combine them immediately and see results as you work. Use this method when image bleed-through caused by overlap is not objectionable, or when you want to darken overlapping areas or combine their colors.

Repetitive strobe images are usually shot against black, but I wanted a repetitive image against white. I chose a meditating man to symbolize the expansion of awareness meditation brings. I placed the model against white seamless paper, aiming strobes with reflectors at the background so that there was an even backlight across the paper, with no gray tones. I then shot successively sized images, using a 43–86mm zoom. When the images were developed, I selected the sizes I wanted, sandwiched them, and achieved the multiple image against a white background.

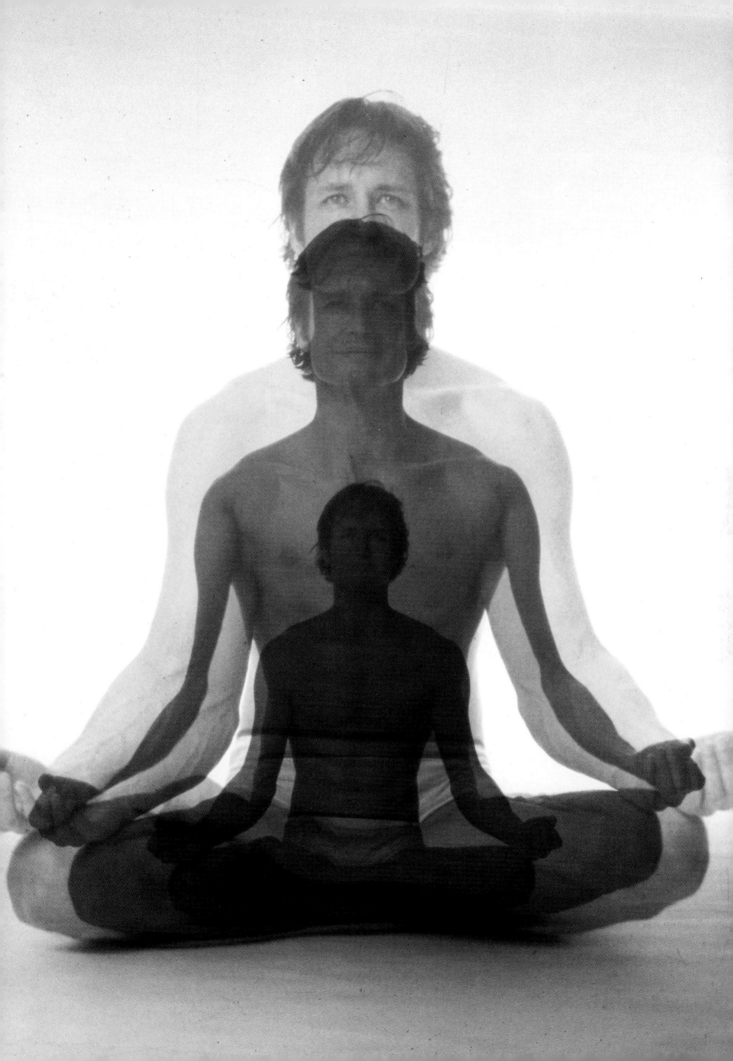

How to Make Great Sandwiches

WHAT WORKS

Any clear or transparent areas of a chrome will transmit the image of another sandwiched over it. If you hold a transparency up to a newspaper and can clearly see the type through any area, that is the portion that will be most suitable for combining with another color or image element. Graphic silhouettes or strong graphic designs in a white or pale background make excellent elements for combining with other slides having strong color. Slides having little color, but strong in texture, can be combined with dark elements and with color. The almost colorless fluid texture of moving water, or the pale and subtle variations in density of a wave washing against white sand can be sandwiched with a sunset to give the sky an additional pattern and flowing texture.

What works best may not always be what you might expect. One of the participants in the Focus 2000 workshops combined a macro shot of strongly colored, crystallized paint with a second shot of an airplane and a third of the Empire State Building, producing a terrifying glimpse of a cataclysmic crash. It certainly was not pleasant, but the image made us all gasp, and riveted our attention to the projection screen. The interesting sidelight was that the crystallized paint slide had been included precisely because it seemed to be a poor choice for a sandwich. It was an image that seemingly had no relationship to any of the others, and was so strongly colored that we thought it impossible as an element in sandwiching. Only by allowing your imagination to combine all kinds of images will you test the limits of what works in superimposition.

WHAT DOES NOT WORK

Any dark or opaque slide will be too dense to transmit enough light to be successful for a sandwich. Heavily saturated color may be too intense when combined with another slide having a definite color cast of its own. Combining colors definitely will not work if the colors are opposite each other on the color wheel, as they produce a dingy, muddy gray. A combination of too many transparencies can become too dense, and there may be confusion with overlapping images, diluting the effect of important elements. Some combinations of elements, like birds and a sunset, are so obvious they almost become a cliché, but they work because they are still powerfully evocative romantic images. However, generally predictable combinations should usually be avoided, if only as an exercise in imagination. Just because a combination of elements is logical and orderly does not mean they are restricted to that use, and a new and unexpected reality can be made from images and elements that are not logically related. Remember that no one is looking over your shoulder as you combine images (unless you have an interested spouse or friend), and no one should tell you that some combination is impossible.

Marie had always wanted to see the wild ponies at Assateague National Seashore along the Atlantic coast, and we were delighted to wake up in the campground there, snug in our tent, hearing the horses call to each other at dawn. When we looked outside, however, we were greeted with a drizzling, chilly morning that soon turned into a downpour. Weather reports promised no end in sight for a few days, so we returned to New York. The shots I took were all of the ponies against the gray sky, gray dunes, gray sea. In fact, the most pleasant memory was that of the horses calling at dawn. With this in mind, I looked for a suitable dawn image, and found one I'd shot some years before when we were in Maine. I combined the 50mm shot of the horses with the 18mm sunrise, for an image that is part reality, part nostalgia, and one of Marie's favorite pictures.

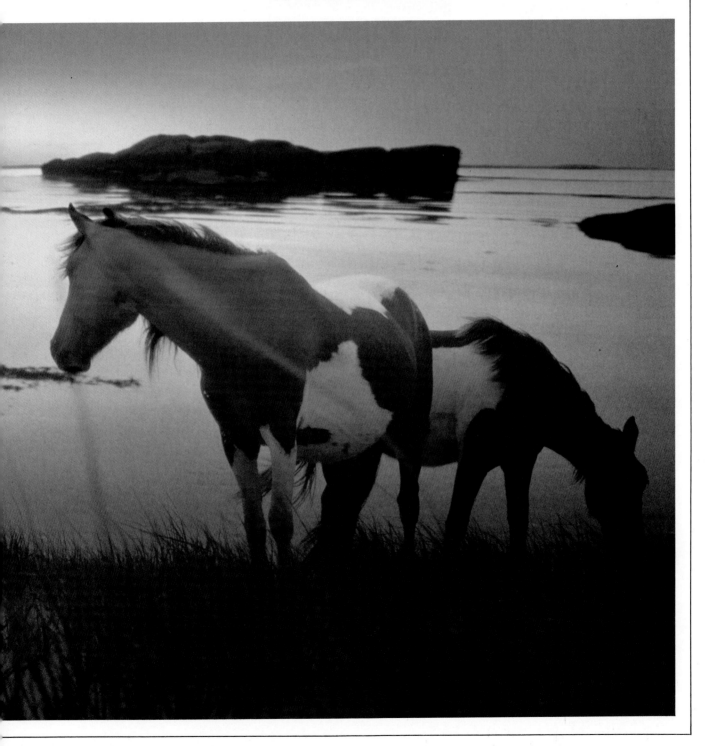

Considerations in Sandwiching Transparencies

COLOR

Dark or heavily saturated colors cancel the effect of sandwiched lighter colors, although some tinting from the lighter color may remain. Colors opposite on the color wheel cancel each other's power, and the result is gray. Any light colored, white, or clear area will transmit and assume the color of another slide sandwiched with it. One person who attended the Focus 2000 workshop combined a shot that was basically yellow in tone, showing a group of reeds against a white sky, with another slide of blue water, producing a glowing green bunch of reeds against blue and blue-green dancing water. The combination gave a fresh and vital aspect to the image that was not present in either original.

NUMBER

If you want to superimpose more than three transparencies, it is helpful to make a duplicate slide of the three primary layers of the sandwich, then use this new image of the combined elements to begin again and add additional elements in a further sandwich. Combining three or more slides causes an inevitable buildup of density. The density can be partially eliminated by making a duplicate that is slightly overexposed, providing a lighter base to begin building upon again. It is also difficult to hold a consistent focus on all the elements in a sandwich of three or more slides. Only one element may actually be in sharp focus. This is important when you view the slide sandwich, or when you attempt to make a duplicate or a print. The more layers a sandwich has, the more surfaces are provided for the buildup of dirt and dust, and this can be a real problem.

DENSITY

Combining images accumulate density, reducing the amount of light transmittable through the sandwich. If you plan to make a print from the sandwich, the light in the enlarger must be doubled to compensate for each additional normally dense layer. Thus, for a sandwich of two normally dense slides, a 100 percent exposure increase is necessitated, for a sandwich of three normally dense slides, a 200 percent increase, and so on. Therefore, images that are slightly overexposed, or made of a single saturated or dark element in an otherwise washed-out background, are ideal. These require less light transmission in reproduction, and a combination of several such slides can produce a normally dense final image. If you are combining negatives instead of chromes, it is well to remember that two dark negative areas cannot successfully be sandwiched. Together they would produce a degree of opacity that prevents the transmission of any enlarger light, and the resulting section of the print would be totally washed out. If you want to combine dark negative areas, they can be blended more successfully through the use of montage.

SHARPNESS

Each time another layer is added to the sandwich, the sharpness of the underlying layer is slightly reduced when the whole is projected, printed, or duplicated. The top image provides the easiest element for focus, and so the most important of the elements should be placed on top. For example, in a sandwich of a bird flying against a sunset, it is usually more important to have the fine feathers of the bird in sharp focus and allow the sunset to be a tiny bit soft. If possible for the composition you intend, it is better to place chromes emulsion to emulsion for the best possible focus.

CLEANLINESS

Unfortunately cleanliness is often next to impossible when making a photographic sandwich. Each slide or negative has two sides to collect dirt, dust, lint, fingerprints, and scratches. Multiply those two surfaces by the number of slides in a sandwich, and you can easily see that special care must be taken to

Assigned to shoot for Mobil Oil, I was faced with a colorless and overcast day. I photographed the tugboat anyway, later sandwiching it with a stock shot from my file, showing a sharp blue sky with white clouds. The cloud area provided a place to position the tugboat without causing a color change in the sandwich. The tugboat was shot with a 20mm lens, the clouds with a 50mm lens.

from the mount. Clean the glass mount thoroughly with a good glass cleaner.

POSITIONING

The object of sandwiching is to further your own creative freedom. Don't allow yourself to be hampered because you hesitate to match a horizontal with a vertical chrome. That will simply produce a square image with a visible film edge from one of the transparencies, but that edge can be masked by covering it with black photographic tape. The image can also be duplicated in such a way that the edge is eliminated and the resulting duplicate is horizontal, vertical, or square, depending on the demands of the image and your decisions about the final result. Often it is difficult to hold a group of transparencies in place, especially in an off-axis sandwich. They may then be removed from the mount and carefully taped together with photographic tape, preferably along their edges. Do not put tape on the emulsion side of a transparency or negative.

SIZING

Sometimes one of the elements is too large or too small to fit properly within the area where you want to place it in the sandwich. It is helpful to plan ahead when you shoot elements for your stock file, and shoot various sizes, horizontal and vertical, of each element. However, if you have not done so, you can simply make a duplicate of that element, sizing it properly to fit.

CONTRAST

The more layers a sandwich has, the less contrast it has, even though individual layers may be normal or high in contrast. It is obvious enough that one layer of strong saturation or density will reduce the contrast of the sandwich, but even a sandwich made of chromes that are predominantly clear will be reduced in contrast as a whole compared with any one of its layers. Therefore, expect colors to lose some of their snap when you sandwich. You can get it back through careful duplication, if you do it carefully.

keep all surfaces clean. To eliminate dust as much as possible, view and select the combinations of slides on a light table, but once selected, remove them entirely from the area of the light table and clean and assemble them elsewhere. Because a light table is made with fluorescent lights and covered with plastic, it becomes a magnet for dust and lint that can statically cling to film surfaces.

To clean the layers of film in a sandwich, remove them from their mounts and blow the surfaces clean with compressed air. An anti-static cloth or brush is helpful to prevent the attraction of any additional airborne particles. If the chrome is dirty, clean it further with liquid film cleaner. When each layer of the sandwich is as clean as possible, assemble and mount the sandwich in a plastic and glass mount to protect it from damage and dirt until you are ready to duplicate or print it. At that time it will have to be removed

Photographing Elements for Sandwiches

Much of my work depends on combining various elements to make a new image. Therefore, I am always aware when I go out to shoot that I must make many variations of elements intended for my stock file. I shoot both horizontal and vertical versions of each shot, and sometimes use different lenses for sizing. I am aware of color saturation, and when there is a specific element I know I will use for a sandwich, I overexpose the film. Overcast days soften color, and are ideal for shooting elements for sandwiching. Birds flying against a white and overcast sky, or a sky made mostly of big puffy clouds against bright blue may look like subjects that are of only mild interest, but I know the overcast white sky can be sandwiched with a striking sunset. One such photograph of a bird was sold once for use as the cover of a product package, and again as a poster, because the dark silhouette of the bird, shot with a long telephoto lens, looked dramatic when sandwiched against an orange-gold sunset. White walls or any light surface can be used as element backgrounds. If I suspect that I may need variations of density or saturation, I bracket the film exposures. If you train yourself in the needs and possibilities of using your pictures as elements in sandwiches, as unfinished possibilities rather than strictly literal images, hundreds of creative opportunities will arise when you go out to shoot.

I had often driven by the Gothic style towers of Fordham University and promised myself to shoot them one evening as they were silhouetted against the sunset. Instead, I photographed them one overcast afternoon, as an afterthought on the 37th frame of a 36 exposure film roll, shooting with a 100mm lens. In my stock file I had the image of a horizon that had been photographed with a 50mm lens and a repeater lens attachment, each facet of the attachment having a color gel taped on it to provide the layers of color. I chose this as the sunset sky I had originally envisioned behind the towers. I also added a stock shot of seagulls, photographed against an overcast sky with a 50mm lens. The triple sandwich provided exactly the mood I wanted, and one I might have waited many sunsets in vain to capture had I tried to shoot such an image as one shot.

Sandwiching

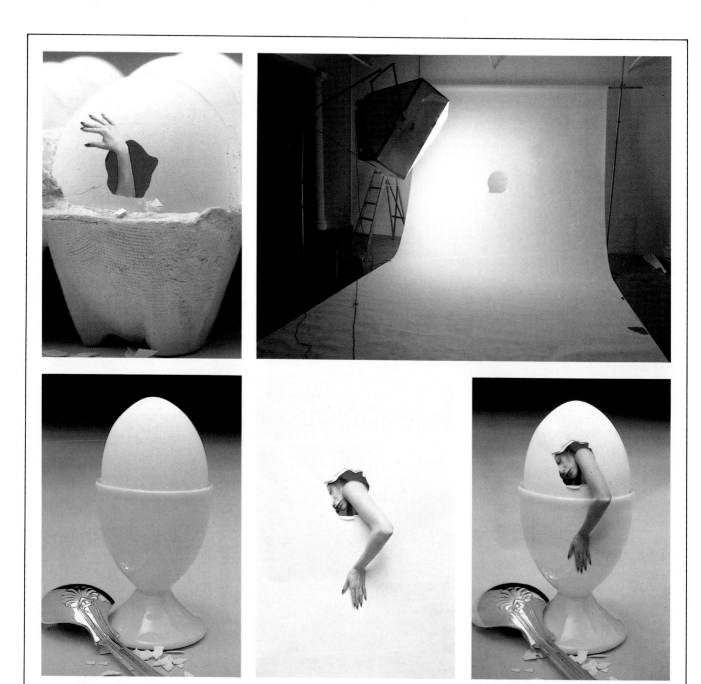

This shot was used as a kind of logo for the Focus 2000 workshops I taught, and caused more comment than any other image. There were hundreds of guesses of how it was done, but although it was incredibly simple, few people ever guessed it was a sandwich.

The egg in the cup, the spoon, and the extra shards of eggshell comprised the first shot, because I could then refer to the finished egg transparency to size the image of the woman. I prepared the set for the second shot by cutting a hole in a piece of white seamless paper. An egg has membrane, so I used a piece of tracing paper to make the membrane around the hole. The model was lit

with a large bank light placed to the upper left of the camera position. I wanted only a delicate shadow.

When the two images were sandwiched, the rim of the egg cup was lightly visible beneath the arm of the model, and needed to be removed by retouching. I regretted not using a yellow light behind the model to symbolize the life-giving yolk, so I had the yellow color retouched there. When we decided to use the shot for Focus 2000, we decided the original shot, with its gray background, was not colorful enough, so we also had a blue background added, and in so doing, the retoucher added a few additional shards of eggshell.

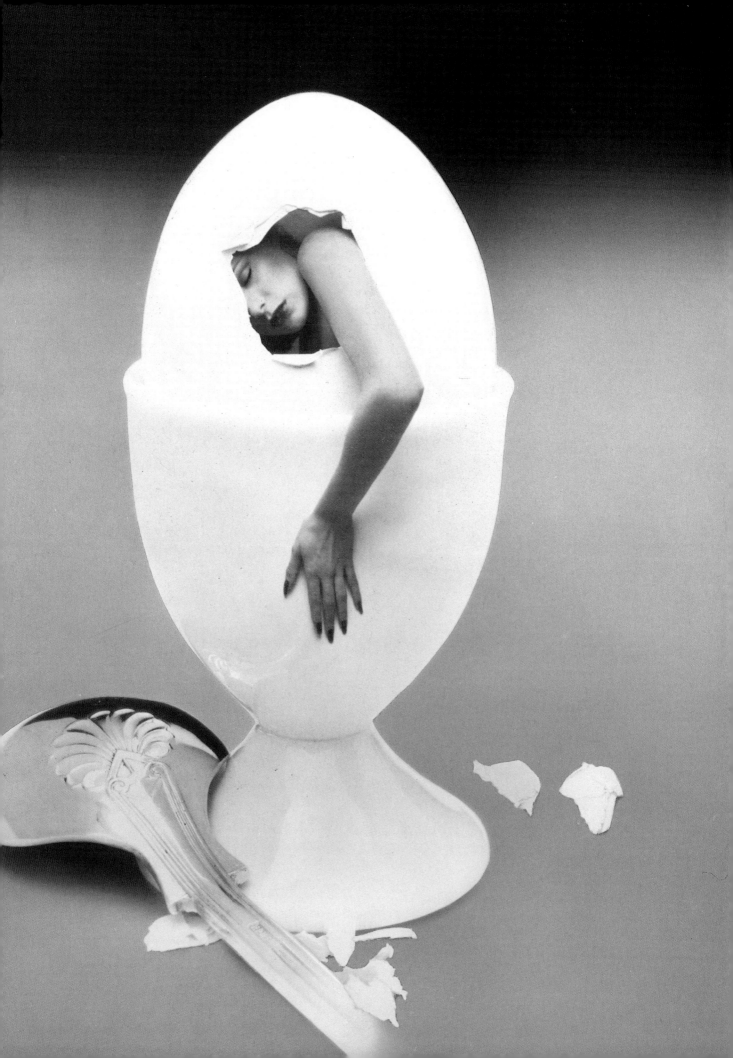

Organizing Your Transparencies

Most of my work is 35mm color, and I have enormous numbers of transparencies to deal with. I file most of the slides in the wastebasket, give a cross-section of the best to my stock house, and keep only those I know I can use as elements in montages or as backgrounds for other shots. Even with all the editing I do, there are still quite a few slides for me to file. These I put in vinyl sheets that hold twenty 35mm transparencies per sheet. I prefer top-loading, rather than side-loading pages because they are not as uncomfortably tight fitting as some other sleeves. For my own stock, I file the slides in sheets with frosted backing that diffuses the light and makes it easier to view the slides. If you must send quantities to a client, it is wise to file them in clear sheets and have a color photocopy made of each sheet. That way you can keep a ready reference of exactly what was sent out.

Each vinyl sheet has prepunched holes to fit into a three-ring binder, providing a very convenient method of filing your slides. Label the binders as to subject matter and be sure to keep the binders up-to-date by filing transparencies promptly. You must decide what is the most convenient and logical filing system for your own work. I divide transparencies into categories for separate binders, such as sunsets, space shots, people, couples, and so forth. Caption at least one transparency in a sheet of similar transparencies. That way you will not have to hold every sheet up to the light in order to know what images are there.

An otherwise mundane shot of a crane was sandwiched with a stock shot of clouds for a warmer, more dramatic image. Crane and clouds were both shot with a 50mm lens.

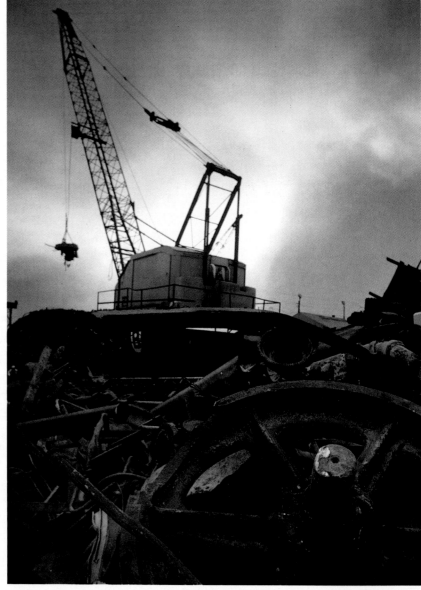

Making a Light Box

Every serious photographer needs a light box on which to view transparencies or negatives. A light box is particularly useful for sandwiching. It need not be huge or terribly elaborate, but can be as simple as the one I made for traveling when teaching Focus 2000 workshops. This was made out of a cardboard box.

WHAT YOU NEED

1. A cardboard box.
2. Enough wrinkled aluminum foil to cover the inside of the box. The foil is wrinkled so that no hot spots result from the foil reflecting the light unevenly.
3. Fixture for lightbulb, including electric wire and plug.
4. A 50- or 100-watt, soft-white lightbulb or a 75-watt enlarging bulb.
5. Glue to adhere the aluminum foil to the inside of the box.
6. A piece of translucent plastic or glass, or clear glass with tracing paper attached. This should be cut to fit over the open top of the box, and acts to diffuse the light.
7. Masking tape to attach the plastic or glass to the box.
8. Contact paper to finish the outside of the box if you wish.

MAKING THE LIGHT BOX

1. Glue the wrinkled aluminum foil to all inside surfaces of the box to form a lining.
2. Cut a small hole in the side of the box near the bottom, about one inch in diameter.
3. Cut another larger hole in the top of the box approximately one inch smaller than the size of the glass or plastic. This will allow the glass or plastic a lip on which to rest more securely.
4. Screw the lightbulb into its fixture and place it inside the box, pulling the wire out through the small hole.
5. If using clear glass, tape the tracing paper to the underside.

6. Set the plastic or glass over the hole and tape it in place. You may want to tape only one edge very securely, and allow the other three sides to be more easily untaped for the eventual replacement of the light bulb.
7. I made the original version without thinking of adding vents, because I did not intend to be using it for great lengths of time. If you plan to use your light box for a long enough period that it will get too warm from the heat of the lightbulb, then it would be advisable to make vents. Do this by cutting a slot near the top for the hot air to escape, and one near the bottom for cool air to enter.

Light boxes are invaluable for more than just viewing transparencies and negatives. Many beautiful still-life shots are done on a light box, and some fashion photographers use large light boxes as a platform for models. The light box I use to view my transparencies is 2'×4', equipped with six fluorescent warm white tubes. These are the closest to correct color for viewing. You can purchase special color-correct tubes, but these are more expensive. On top of the ¼-inch thick translucent plastic of the light box, I have a ¼-inch thick sheet of clear glass. The glass provides a hard surface so that I can cut negatives and masks with a utility knife without scratching the soft plastic.

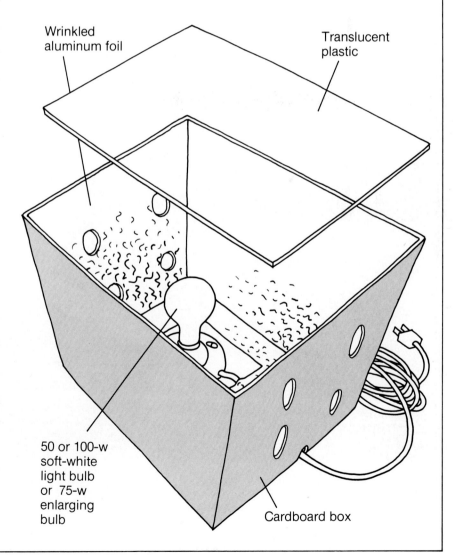

Wrinkled aluminum foil

Translucent plastic

50 or 100-w soft-white light bulb or 75-w enlarging bulb

Cardboard box

DUPLICATING TRANSPARENCIES

Duplication is a process of rephotographing an original transparency in order to produce a copy. Usually you will want the copy the same size as the original, but sometimes you might want to enlarge or reduce the size of the copy. You may, for example, want to make an 8×10 transparency from a 35mm. Faithful reproductions having the same contrast, cropping, color tone, and size certainly can be achieved, if this is desired. When I make duplications, however, I'm looking for a better chrome than the original.

If the original is an excellent image, the duplicate can be a knockout. I often consider duplication as a step in a shooting, when I intend from the start to improve the image by copying it. It is also an equally convenient method of reworking existing images in my stock, when I may want to rethink, recrop, or redesign the idea. It provides the opportunity of adding additional images to one finished photograph by enlarging only a section; changing or intensifying specific colors in either highlights, shadows, or both; increasing or reducing contrast; adding grain or texture; improving exposure; lightening or darkening the image; or using a combination of several of these possibilities.

Duplication can be a time-consuming process. I have heard photographers comment that they would prefer to be out shooting new images, rather than working to duplicate existing ones. I want my images to be as terrific as I can make them, and I am certainly willing to invest the extra time to enrich the quality of an already good image. Besides, I believe the possibilities offered by duplication save me the time of attempting innumerable or impossible variations on an original shooting, and give me further manipulative control over the results.

Ordinarily, duplicates that are faithful replicas of originals may be sent to potential clients in lieu of the more valuable originals. In this case, the understanding is that originals will be supplied for reproduction, if necessary. However, duplicates that I make are generally markedly different from the originals. In some cases, since an original may be only one of several used as an element in sandwiching or multiple exposure while duplicating, the duplicate is actually the original.

Duplication systems and devices can be simple and inexpensive, or complex and capable of incredible slide manipulation. There is a duplicator for any budget. You may even decide to make your own system, and directions are included in this book for doing so.

Once you begin to explore the possibilities of duplication, you may become as enthusiastic as I was when I first had a duplicating system. I often worked late into the night. When Marie would ask when I planned to call it quits, my answer of "Pretty soon . . . " would be punctuated with the reassuring "ka-thunng!" of the duplicator. She would smile and sigh, and go off to read a good book. I suppose we both became more educated in the process!

Using a 500mm lens, I photographed a child playing on a foggy monochromatic gray beach. I sandwiched that image with one of a deeply saturated red sunset in a dark evening sky that had been shot with an 18mm lens. Duplication allowed me to create variations of mood by altering the color.

Equipment and Film

Duplication can be done using simple equipment, if you are on a tight budget, or with the use of special duplication illuminators that provide a better and more consistent source of light. Whatever you choose for duplication, you will need a good camera and a copy lens.

CAMERA

The camera selected for duplication can be any single-lens-reflex (SLR) camera with the availability of interchangeable lenses. Surprisingly, however, most SLR cameras have viewfinders that show less than 100 percent of the image actually recorded on the film. When making a dupe, bear this in mind, and crop the image a slight bit tighter to compensate. (As far as I know, the Nikon F is the only SLR camera that has a viewfinder showing all of the image that will be recorded in the film frame.)

Rangefinder and twin-lens-reflex cameras do not permit the photographer to compose exactly, because the viewfinder is at such close range that it views one area of the subject while the camera lens views another. Additionally, neither system usually allows the photographer to focus close enough to the subject to use such magnification, so even if you were able to estimate what the camera lens views, the camera system would not be satisfactory for duplication.

THE COPY LENS

The copy lens used for making duplicates must be a flat-field lens. A normal camera lens is a curved-field lens, which is unsuitable for duplication because when it is focused close enough to provide 1:1 magnification, it is sharply focused only at its center, and slightly out of focus at its edges. The ideal duplicating lens is a macro lens, because it is a flat-field lens that gives a sharp image over the whole film frame when focused at 1:1. I believe that a 50mm or 55mm macro lens is probably the most versatile lens a photographer can own, permitting focus from 1:1 (life size) to infinity. If greater than 1:1 magnification is desired (as it sometimes is in duplicating when cropping a section of the original for copying) the macro lens can be used with bellows or extension tubes. A macro-zoom lens does not usually focus as close as 1:1, so it is seldom useful for duplication.

Enlarging lenses are also flat-field lenses, and can be used for duplication when coupled with bellows or extension tubes. I use a 60mm Rodenstock Rodagon $f/5.6$ enlarging lens on the bellows of my Illumitran for duplication. If you plan to use an enlarging lens, remember that the quality of the dupes is only as good as the optical system used, and select only a top of the line, high-quality enlarging lens. If the enlarging lens is fast ($f2.8$) it usually lacks contrast and sharpness to a noticeable degree when used wide open. If used for duplication, such a lens should be set at about $f/11$.

In duplication, sharpness is critical. Any lens, except for specially designed aspherical lenses, when used wide open is not as sharp as when used at a medium aperture. A wide-open lens provides virtually no depth of field and only one flat plane of actual focus, so that any attempt to duplicate a sandwich of two or more slides will result in accurate focus on only one layer of the sandwich.

Photography magazines occasionally have articles that encourage the use of a normal lens mounted in reverse on a bellows in order to achieve high magnification. Used backwards, a lens will magnify, but cannot provide edge-to-edge sharpness. If you are not particular about the quality of duplicates you make, this arrangement may satisfy you, but I make duplicates primarily for reproduction in magazines and on book covers. I want my dupes to be of the best quality possible. The extra expenditure you make to purchase a better lens for duplication is worthwhile, if you are a photographer serious about making sharp duplicates.

BELLOWS AND EXTENSION TUBES

Bellows and extension tubes can be mounted between camera and lens, offering the photographer a means to extend the powers of lens magnification. Either can be used with a macro or an enlarging lens for duplication. If you choose to use a macro lens, set the lens at infinity, and focus by adjusting the focusing knobs on the bellows. A well-made bellows has both front and back knobs. The front knobs are used to select magnification size by compressing or extending the bellows, causing the lens to move closer to or farther from the subject. The back knobs are used to focus the image by compressing or extending the bellows, causing the camera to move closer to or farther from the lens. Naturally, a copy stand or tripod is needed for stability during the process, and for duplication, a copy stand is easier to use than a tripod.

Some camera manufacturers make an automatic bellows that can operate in conjunction with their system's macro lens, stopping the lens down automatically for metering when a tungsten light source is used for duplication. Most automatic cameras produced today give excellent metering when coupled with a bellows. Some newer systems even provide metering that will automatically stop the camera lens down instantly when flash is used as a light source, requiring only a connection from the flash to the camera's hot shoe when duplicating. Older cameras may or may not yield an exposure reading when a non-automatic bellows is used between camera and lens.

To discover if your camera gives a meter reading with bellows and lens attached, attempt a reading as you would normally, changing f-stops or shutter speeds. If the meter's needle will not budge even when the light should be sufficient for exposure, your camera may be so constructed that removing the lens and replacing it with a bellows and a lens disconnects the automatic camera metering system. To ascertain

the correct exposure reading for duplication, it will be necessary for you to make an exposure test as a guide. That will be explained later in this section.

Extension tubes are used in much the same way as the bellows, placing the tubes between camera and lens. However, they provide none of the convenience of continuous focusing available when using a bellows, but rather must be constantly adjusted to achieve the desired magnification and focus. Adjustments are made by adding or removing various lengths of tube. It is often difficult to combine tubes to achieve the exact magnification you want, and the process of working with the tubes, adding and removing, is exasperatingly slow. As with the bellows, an exposure reading may or may not be available through the camera's built-in meter, and the same quick test can be made to check this. To me, using extension tubes in duplication is the absolute pits.

If you are using an enlarging lens with either the bellows or extension tubes, the lens must be stopped down manually, and will not make an automatic exposure adjustment.

For a complete duplication system, you must have a tungsten or electronic flash light source in addition to either bellows or tubes, a camera, and copy stand or tripod. A cable release is also highly recommended, as any jarring of the camera during exposure will cause a blur and ruin the duplicate.

SLIDE COPYING SYSTEMS

Slide copying systems are available to provide a consistent, reliable light source for duplication. Depending on sophistication and features offered, the cost of these systems can vary widely.

Bowens Illumitran 3C

The Bowens Illumitran 3C is the system I currently use. It offers electronic flash as the light source, but has a built-in tungsten light for use while adjusting focus and magnification. It also provides a built-in exposure meter, as well as a bellows,

Bowens Illumitran 3C with built-in electronic flash and fogging device.

a magnification scale, and a device to fog the film during exposure for contrast control. I have had the Illumitran modified by the addition of register pins at the light stage. These allow me to consistently and exactly position masks I use to control contrast when I dupe. The use of register pins will be discussed later in this section. I also modified the Rodagon lens I use for duplication with the Illumitran, mounting a shutter on the front of the lens so that I can make multiple exposures

without advancing the film, simply by manually closing the shutter between exposures.

Vario-dupliscope

The Vario-dupliscope is a system sold inexpensively through the mail-order catalog of Spiratone, in New York. It connects directly to the SLR camera body like a lens. It consists of a bellows, movable slide holder, built-in $f/11$ lens, small electronic flash, and exposure scale for use with the flash. Because it is difficult to see clearly through the $f/11$ lens, you must add some type of tungsten light to use when composing and focusing on the slide to be duplicated. It is a good unit for a beginning system.

Testrite Kingdon Illuminated Slide Copier

The Testrite Kingdon Illuminated Slide Copier is a unit that includes 22 color filters, two 7-watt tungsten lights for use while composing and focusing, and a 3200 Kelvin bulb for a light source. A small portable strobe may be inserted into the unit as an alternate source. The copier is distributed by Spiratone.

Honeywell Universal Repronar

The Honeywell Universal Repronar is a good unit, but is no longer manufactured. Some of them are still available second-hand, however, and are well worth buying, de-

Spiratone Vario-dupliscope with portable strobe and f/stop scale.

The Kingdon Illuminator sold by Spiratone is similar to the one you can build.

The dichroic head from the Omega 600-B enlarger, used upside down to serve as a duplicating device.

pending of course on the condition of the unit. This is a total duplication system, consisting of camera, flash, bellows, copy stand, and lens.

Chroma Pro

The Chroma Pro is much the same as the above, offering a dichroic color head built into a copy stand for the purpose of making dupes. Unlike the Omega color head,

The Chroma Pro.

however, it cannot be reversed to serve as an enlarger, but offers a copy stand designed to maintain alignment for duplication, and is a more professional duplicating unit.

Several Omega enlarger models, as well as a few other enlargers using the dichroic color head, can be used for duplication by turning the dichroic head upside down. The enlarger column then becomes a copy stand, and the dichroic filters provide easy color filtration at the turn of a dial. Naturally, the light source is tungsten.

FILMS

In duplication, most photographers want to make exact copies of existing slides, perhaps varying them only slightly. Because increases in contrast and grain are not desirable, films made specifically for duplication are slow films, with low contrast and low grain. I usually want to increase contrast when duplicating, but rarely want to increase grain. I choose film for duplication according to the results I want to obtain.

Ektachrome Duplicating Films

Ektachrome SE Duplicating Film (SO-366), for use with electronic flash, and Ektachrome Slide Duplicating Film 5071, for use with tungsten, each have a speed of ASA 8. They are best used to make faithful and accurate copies of the original. Required filtration for either film depends on the emulsion batch, and instructions for filtration are included with each roll or box of film. Some degree of consistency can be achieved by buying the film in 100-foot rolls and bulk loading it when working with 35mm. I often use 8×10 sheets of tungsten duplicating film, and prefer to buy a box of 100 sheets at a time.

The duplicating film meant for use with electronic flash can be used with tungsten, and vice versa, but the filters these changes necessitate, coupled with the filtration dictated by the film's emulsion, make the whole idea of switching more complicated than it is worth. For more technical information on each of these films, read the Kodak information sheet packaged with the film, or write to Kodak.

Kodachrome 25 and 64

Kodachrome 25 is the film I prefer for duplication, and Kodachrome 64 is also good, but granier. Both films increase contrast so that the color becomes more brilliant in the dupe, having blacker blacks,

brighter highlights, and heavy color saturation. Kodachrome adds punch to a slide that is dull in color, or one that is slightly overexposed.

If you decide to use Kodachrome and want to reproduce the original slide faithfully, you must use the techniques of fogging or masking to cut contrast during the duplication process. (Fogging and masking are discussed in detail in this section.)

When using Kodachrome with electronic flash for duplication, an 81A or UV16 filter is suggested to compensate for the slight amount of ultraviolet light from the electronic flash. With the 150-watt enlarging bulb in the homemade illuminator, (usually rated at 3200 Kelvin) use Kodachrome Type A Tungsten film (ASA 40). This film is balanced for 3400 K. In theory, Kodachrome should require no filtration, as long as the daylight film is used with electronic flash, and the tungsten film with tungsten light. However, various emulsion batches may need slight filtration. When exact color balance is required, it can be helpful to run a test using a normal slide with good color as the original. Buying the Kodachrome in batches helps you achieve a consistency, since all the film in a batch has the same emulsion number.

Mask.

Dupe film.

in the dupe. However, in addition to fogging or masking, you may, when using Ektachrome, have a professional lab reduce the development time by ½-stop to reduce the contrast. Have the lab run a *clip test* first, by snipping off a piece of the Ektachrome roll and processing the clip for your approval before processing the roll. The reduction in development time results in less visible grain structure in the duplicate.

Ektachrome 64 should not require any filtration when used with electronic flash. Used with tungsten, it requires an 80B filter. Emulsion variations may, as with Kodachrome, require some slight filtration, and again, buying in quantity can help you achieve some consistency of the filtration with Ektachrome.

Ektachrome 160 and 200

Ektachrome 160 for tungsten light, and Ektachrome 200 for electronic flash can be used for duplication, when the aim is to strongly increase both contrast and grain for effect. Contrast can be reduced by masking, fogging, or preferably having a professional lab reduce development time, but grain will be

Unmasked Kodachrome 25.

Original Kodachrome 25.

Masked Kodachrome 25.

Fogged Kodachrome 25.

Ektachrome 64 and 50

Ektachrome 64 for flash or Ektachrome 50 for tungsten are not as sharp as Kodachrome, have more grain, and increase contrast further

increased even when steps are taken to reduce contrast. If you are using Ektachrome 160 or 200 for duplication, presumably the increase in grain structure is what you specifically plan.

Exposure

The exposure for making duplicates depends on factors influenced by shutter speed, f-stop, magnification desired, filtration needed, and light source used.

SHUTTER SPEED

Shutter speed is usually determined in part by the light source used for duplication. If electronic flash is used, the shutter speed must be the one recommended by the camera manufacturer for synchronization with flash, usually 1/60 sec. or slower. If the duplication system uses tungsten light, set the shutter speed at 1/8 or 1/15 sec., because these shutter speeds allow a greater versatility in choosing f-stop ranges. A slower shutter speed may result in an unclear duplicate from as unexpected a source as mirror slap during the moment of exposure within the camera. My New York studio is not very far from the subway, and during the daytime there is a great deal of street traffic. These factors combine to set up vibrations in the building that are strong enough to blur the image, although the vibrations cannot be sensed most of the time by people. As a result, I have made it a habit to make exposures no longer than 1/15 sec., for duplication and am quite satisfied with the results.

APERTURE

In newer cameras, the camera's built-in metering system can determine the f-stop to use for duplication. If the camera meter in your camera does not work when a bellows or extension tube is added between camera and lens, a simple test can serve as a guide to determine future exposures when duplicating.

Generally you will be duplicating well-exposed slides. The density of these slides tends to be consistent from slide to slide. Knowing the correct f-stop for such a slide allows you to select that f-stop as a starting point whenever you duplicate another slide of normal density. Slides that are denser than normal will require a wider f-stop during duplica-tion. Slides that are thinner than normal need a smaller f-stop.

Naturally, if you change duplicating films, add or subtract filtration, or change magnification, these factors affect the exposure. Another test must be made to serve as a guide for duplicating with different film types, but filtration and magnification changes can usually be determined easily enough, and the f-stop adjusted accordingly.

To make such an exposure test and determine an f-stop guide, proceed as follows:

1. Choose a slide to duplicate that is perfectly exposed and has normal density.
2. Select magnification that is the same size as the original (1:1).
3. Make the first exposure with the camera lens wide open, using any filters recommended for the type of film in the camera.
4. Make the second exposure after stopping down ½ f-stop, and continue to stop down by half stops with each exposure until the smallest aperture available on the lens is reached.
5. Have the film processed. When it is returned, place the slides side by side in the order they were exposed. The lightest slide, taken with the lens wide open, was the first. View the slides on a light table, if possible.
6. Compare these duplicates to the original slide.

Which one most closely matches the original in exposure and density? The f-stop used to expose the duplicate that best matches the original is the f-stop that will serve as your guide in the future. The best duplicate should be somewhere in the center of the lineup, perhaps one that was shot at f/8 or f/11. If instead, the best match is the first slide, shot with the lens wide open, then the intensity of the light source used for duplication must be dramatically increased, or the shutter speed reduced, since it is undesirable to have the widest aperture as a guide. Not only is the lens not at its optimum sharpness when wide open, but the photographer is of-fered no leeway in exposure variations that might be necessary when duplicating a denser-than-normal slide. Increase the light intensity or decrease the shutter speed, and make another test.

MAGNIFICATION

Magnification greater than 1:1 requires more exposure than the test exposure. Since the exposure test was made with 1:1 magnification, it is not difficult to compute the adjustment when increasing magnification. The following table is an approximate guide. I recommend that you bracket the exposures by ⅓ f-stop on either side of the computed starting f-stop.

Magnification	Additional exposure
Same size as original (1 : 1)	Use f-stop indicated in test
1½ : 1	⅔ f-stop
2 : 1	1¼ f-stop
2½ : 1	1⅔ f-stop
3 : 1	2 f-stops
4 : 1	2⅔ f-stops
5 : 1	3⅓ f-stops
6 : 1	3⅔ f-stops

The highest magnification I generally use is about 5:1, and I use that rarely. The higher the magnification, the greater the contrast, and the more apparent and enlarged the grain structure.

CORRECTING EXPOSURE

Correcting exposure through duplication of an incorrectly exposed original is possible to some extent. Underexposed slides can be corrected by selecting a wider lens aperture for the duplication exposure. If the slide is overexposed, it is not as easily corrected, since the process of overexposure uses up emulsion on the original slide, and there is not enough strength of color left in the emulsion. A one stop overexposure can probably be improved by stopping down one f-stop for the duplicate, but if the original is two or more stops overexposed, it cannot be saved.

Exposure Test.

Color Filtration

Filters can be used to correct color balance for normal color, or to alter the color in various ways during duplication. Either CC (color compensating) or CP (color printing) filters may be used. They are available as square gels. Any CP filter must be used by positioning it between the light source and the transparency to be duplicated. Although CC filters are commonly used directly on the camera lens, for duplication they should be used in the same manner as the CP filter. Placed between transparency and light source, the filter will not come into focus, so any scratches or imperfections in the filter surface won't appear in the duplicate.

CORRECT COLOR BALANCE

Correct color balance when duplicating can usually be achieved with a slight amount of filtration. Ektachrome Duplicating Film always needs specific filtration, and the suggested filtration can be found on the data sheet enclosed with the film. Other films, such as Kodachrome, may require some mild filtration, but because the film is not manufactured for use as a slide-duplicating film, Kodak does not suggest specific filters for its use, and a test must be made. Much the same way as you made a test to determine the *f*-stop for normal exposure, you can make a test using the type of film you want to use for duplication. Proceed as follows:

1. Select a slide for duplication that has good color balance, preferably one with a normal flesh tone.
2. Duplicate the slide, using several exposure variations, bracketing by half a stop and a full stop to either side of the usual guide *f*-stop for normal exposure.
3. Have the film processed, and when it is returned to you, compare each slide to the original and select the best duplicate.
4. Compare the color balance of the original and the duplicate. If the color balance of the duplicate differs from that of the original, view the duplicate by looking through a filter that may correct the color imbalance. Change degrees and combinations of filters until you see the duplicate through filters that make it appear closest in color to the original. These filters are the ones to be used in the future when making duplicates with that same film and emulsion batch. Of course, if you change film type, or purchase film having a different emulsion batch number, the test is invalid and must be remade. For this reason, buying film in bulk is most convenient.

It's easy to observe and measure color-balance differences from one film batch to another if you have a black, or unexposed, transparency from each batch. View the unexposed transparency by holding it to a strong light source and examine the grain structure visible. Use a magnifying loupe. If the grain appears slightly green instead of gray (as Kodachrome does at this writing) you know that the emulsion batch has a slight shift toward green, and can plan corrective filtration accordingly.

If you have a color analyzer in your darkroom you might prefer to place the black, unexposed transparency in the enlarger and see what kind of a reading you get through the analyzer. The filtration in the enlarger head that produces a neutral reading in the analyzer is the filtration that should be used for duplicating with that particular film batch. The filtration, in any case, should be very slight.

ALTERING COLOR BALANCE

Altering color balance for effect can be accomplished if you use filtration when pre-fogging film for contrast control. Highlight areas of any transparency are thinner than shadow areas, and a filter placed between the light source and the transparency colors the highlight areas more apparently than it colors denser shadow areas. Fogging to control contrast is usually done with the intent of providing a neutral gray fog on the film, reducing the film's contrast. Using color filtration during the process of fogging, however, provides a color tint over the film that will be finally more apparent in the shadow areas of the finished image.

In other words, if you want to alter the color of shadow areas only, pre-fog with the desired color filtration. If you primarily want to change the color in the highlight areas, place the filter between the light source and the transparency.

Putting one color into shadow areas and a different color into highlight areas can produce an interesting effect. Both shadow and highlight areas will be influenced to some small degree by the filter color used for the other area, but each will maintain its own principal filtration. If you choose to work with colors opposite each other on the color wheel, there could be a problem, mainly with the middle range of tones. For example, using green in shadows and red in highlights would add neutral gray where the two colors cancel each other out. Shadows would hold green, highlights hold red, but the middle tones would become muddy and ineffective, washed with a gray overtone.

I use a Bowens Illumitran 3C, with contrast control to fog the film. Placing a filter over the fogging device produces that filtration in the shadows. However, sometimes I intend to make an overall color correction, requiring filtration changes in both shadow and highlight areas. Correcting highlight color requires that I place a filter between the transparency and the light source. Therefore, because the Illumitran makes both the fogging exposure and main exposure simultaneously, I must use two CC or CP filters if I plan to correct overall color, placing one over the contrast control and one beneath the transparency.

Achieving Color Balance.

Red

Green

Yellow

Blue

Magenta

Cyan

If the original is too:	Correct by the addition of:
RED	CYAN
GREEN	MAGENTA
BLUE	YELLOW
CYAN	YELLOW + MAGENTA, or RED
MAGENTA	YELLOW + CYAN, or GREEN
YELLOW	MAGENTA + CYAN, or BLUE

If you have a keen eye for slight color imbalance, selecting the proper filtration for correction will be easier for you. Often it is not simply a matter of correcting one color, but of blending various colors to get the correct balance. A color can be removed from the image by the addition of a filter that has the opposite color.

This chart can be used as a general guide, but let your own discerning eye be the final judge. Filters range in density from CC.025 for the slightest amount of color correction, to CC.50 for a more intense color. It is advisable to use as few filters as possible in combination, since the denser the filtration, the longer the exposure that will be required.

Controlling Contrast

The process of duplication increases the contrast of the original image, giving the colors snap, and adding the appearance of greater sharpness overall. If the original image is slightly soft, duplication can make it seem to be far more sharply in focus. In actual fact, a duplicate is a second generation image, and is not really as sharp as the original, but the contrast of tone and increase of color saturation act to make the image more brilliant, and apparently sharper. There are times this overall contrast is desirable, times when only the color saturation is wanted without the strong contrast, and times when contrast buildup must be severely curtailed to make a more faithful reproduction of the original.

INCREASING CONTRAST

Increasing contrast deliberately through duplication deepens color saturation, so that blacks appear blacker, whites more lustrous, and all colors more vibrant in comparison with each other. Shadow areas become darker, and highlights more glaring.

Kodachrome is the best film for increasing contrast through duplication. Each time a duplicate is made on Kodachrome, contrast increases quite noticeably, so that the first dupe is brighter, a dupe of that dupe becomes brilliant, a dupe of the second dupe is startlingly vivid, and so on, until the colors finally become overpoweringly garish, retaining no subtlety of shading whatsoever. Kodachrome 25 has a very fine grain structure, producing the best illusion of increased sharpness in the duplicate.

Ektachrome 64 can also be used to increase contrast, although it will not give colors as heavily saturated or as grain-free as Kodachrome. When additional grain is desirable, however, it is an excellent medium. Because Ektachrome is easily processed by any professional color lab, it offers a further option. Ektachrome can be used for duplicating one stop underexposed from a normal exposure, then over-developed (pushed) one stop by the professional lab. This maneuver increases contrast somewhat further than a single step of duplication, yielding more color saturation, eliminating detail in the shadow areas, lessening overall tonal shading, and increasing grain. Until recently it was not possible to have Kodachrome pushed in development at all, but the option is at last available. However, the cost is exorbitant and the wait for the return of the film can take as long as a week, compared to same day service on regular Kodachrome development that is offered in New York. I have not as yet had any need to have Kodachrome pushed, but there have been many occasions when I have had Ektachrome pushed for various reasons.

REDUCING CONTRAST

Reduction of contrast may be necessary when your aim is to increase color saturation without losing tonal range, or to produce a faithful representation of an original with very little or no appreciable contrast increase. There are several ways contrast can be controlled or reduced.

Fogging or Flashing

Fogging (or flashing) is probably the most common and acceptable way to reduce overall contrast, but it is not the method I prefer. However, it is an easier solution than masking, and many photographers are satisfied with the results.

Film is fogged by exposing it just enough to put a 2-percent fog of gray on the film emulsion. If the film were exposed to its limit, it would be exposed 100 percent, and the transparency would be clear. Were the film not exposed at all, it would produce a black transparency after development. The 2-percent fog puts only a minute amount of exposure onto the film emulsion to create a faint gray in the base tone. To produce a 2-percent fog on film, proceed as follows:

1. Load and register mark both camera and film as though you plan to make a multiple exposure, so that the film frames will not overlap when reshooting the pre-exposed film.
2. For daylight film, place a piece of white cardboard or paper in bright sunlight and take an exposure reading with the camera's built-in meter or a hand-held meter. For tungsten film, bounce the light from a floodlight onto a white wall, or light a sheet of opal plastic or glass from behind with the floodlight, and take the meter reading.
3. Reduce the indicated exposure by six stops. For example, if the meter indicates a reading of $f/2$ at 1/250 sec., stop down to $f/16$ at 1/250 sec. You can also use the indicated exposure setting, and make the fogging exposure through a 2.0 neutral-density filter. (Reducing the exposure by four or five stops instead of six produces a greater fogging effect.)
4. Expose the entire roll of film, making sure that no image whatsoever is in focus. It is not necessary to see the texture of the paper, wall, or plastic . . . only to expose the film to the light reflecting from this surface.
5. After exposure, rewind the film, stopping just as you feel the film leader come off the rewind spool, and before the leader can be rewound into the film cassette.

Mark the film cassette so that you know the film is pre-fogged. When ready to use it for duplication, place it in the camera and realign film and camera registration marks as for multiple exposure, making sure the camera is cocked and the rewind knob tight.

Proceed to duplicate with the pre-fogged film, using the exposure you would normally. It is not necessary to pre-fog Ektachrome duplicating film, since it is made to be low in contrast.

Some duplication systems, like my Bowens Illumitran 3C, have a built-in fogging device. Between the copy lens on the camera and the transparency to be copied, there is a clear piece of glass resting at a 45-

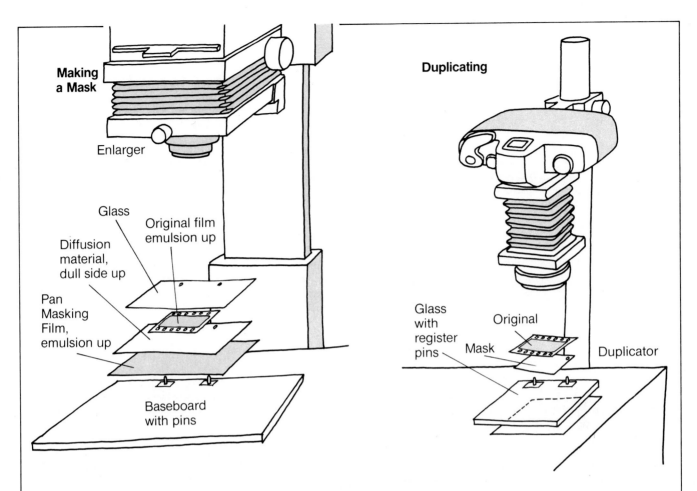

Making a Mask

Enlarger

Glass

Diffusion material, dull side up

Original film emulsion up

Pan Masking Film, emulsion up

Baseboard with pins

Duplicating

Glass with register pins

Original

Mask

Duplicator

degree angle to both lens and slide. Behind the glass is a dim, adjustable light source that flashes white light onto the glass during exposure, thus producing a slight glare that effectively fogs the image as it is duplicated. I use this device primarily when I want to add color to the shadow areas by placing filtration over the contrast control. My chief complaint about the Illumitran is that it offers no constant source of light behind the contrast control to serve as a modeling light, which would allow the photographer to preview the effect the color filtration will have on the image. I finally built such a light into my Illumitran, coordinating it with the light from the contrast control, so that it is brighter or dimmer according to the contrast setting selected.

When I first began duplicating, I used to fog film for contrast control. I tried every recommendation and variation, but have yet to find a fogged duplicate that satisfies me. Compared to the original, a fogged duplicate has an overall gray under-

tone from the fogging that makes colors muddy, eliminates subtleties in shadow areas and makes the overall color less crisp. I now fog during duplication only when I want to specifically change or intensify color in the shadow areas through filtration.

MASKING

A highlight mask, made with Kodak Pan Masking Film, is the absolute best way to make a near perfect duplicate. Normally, an exposure that produces excellent detail and tone within the shadow areas of the duplicate results in highlights that are washed out. The mask, placed over the original, tones down the highlights, reduces contrast range, and extends the tonal scale of the image. Moreover, saturation of individual colors can be controlled specifically.

Making a highlight mask for contrast control is more time-consuming than fogging, but the results are well worth the effort.

Minimal darkroom equipment is needed for contacting the Pan Masking Film with the original transparency, and for developing the masking film. The Pan Masking Film is actually a black-and-white film, but is sensitive to all colors of light, and must be developed in complete darkness.

Normal film has an anti-halation backing that prevents an exposed image from being diffused by light reflecting off the film's backing material. Pan Masking Film does not have this type of backing. Light passing through the emulsion of the Pan Masking Film is faintly diffused, so that the edges of the exposed image are not hard. This makes it ideal for masking, since it produces no obvious delineation when sandwiched with the original, but serves its purpose of holding back the light through highlight areas.

To make a highlight mask, the Pan Masking Film is first contact printed with the original transparency in the darkroom. Exposure time controls the density of the

mask. Ideally, a mask should be fairly thin, resembling an underexposed black-and-white negative. Deep shadow areas of the original should be totally clear on the mask to allow retention of all detail in those areas when the duplicate is made. Highlight areas on the original are gray on the mask. A very thin mask is desirable when your aim is to retain faint detail existing in delicate highlights that would otherwise burn out during duplication.

The contrast of the mask is controlled by the length of development time given the Pan Masking Film. The longer the development, the more contrasty the mask, and the less contrasty the final duplicate.

In the process of making the mask, you can use color filters to selectively intensify colors from original to duplicate. You may want to intensify the blue sky of the original. In that case, the Pan Masking Film, in contact with the original, is exposed to heavy yellow filtration over the enlarger light while the exposure is made. Use filtration opposite to the color you plan to intensify, as the filter passes its own color freely, but holds back exposure in the opposing color. Therefore, with the use of a yellow filter, the negative mask remains clear in the area where blue exists on the original, because only minute exposure has been allowed in that area. When the duplicate is made, the clear area does not mask the blue, but allows it to expose unmasked. The blue then appears brighter on the duplicate. The contrast of the remainder of the duplicate is controlled by the otherwise normal mask.

All other colors are influenced to some degree by the process of filtration in masking. In this case, each color is affected depending on the amount of yellow or blue within the color composition of the original transparency. The mask itself will be somewhat denser in any primarily yellow area, causing that area to require a slightly longer exposure when making the duplicate.

Learning to control color intensification through masking is a sometimes frustrating, often rewarding, always time-consuming process. It is essential that you make tests and keep notes. Degrees of filtration, density, and contrast influence the outcome.

To make a mask for a 35mm original, I buy sheets of 4×5 masking film and cut each sheet into four pieces, each 2″×2½″. Because all steps with masking film must be done in total darkness, working with the film takes practice and preparedness. Everything necessary should be set up beforehand so that you will not be searching for tools in the dark. I arrange guide marks I can feel on the paper cutter, so that the film can be lined up and cut easily in the dark. When I cut it, I also make a tiny diagonal cut to remove the upper right-hand tip of each 2″×2½″ piece, to serve as a code notch, making sure that the emulsion is facing me when the notch is made.

I have purchased a Condit register pin system for use when duplicating. It allows me to punch two holes, each $1/16$ inch in diameter, into both the original and the mask. That way, after the mask is punched, exposed, and developed, it can be placed with the original over the pins again, and be aligned exactly for duplication. My contact printer is also made with the same pins, so I can be sure of perfect registration during each step of the process.

The main problem with using a register pin system is that it is difficult, especially in total darkness, to punch the tiny pin holes precisely between the sprocket holes of the 35mm film. To overcome this problem, I tape a piece of extra film (any kind will do), with black photographic tape, along the sprocketed edge of the 35mm slide, abutting film edges. The registration holes can then be safely punched in mask and original without worry about the placement of the sprocket holes. Of course, the taped addition should not be removed until the masked dupe is returned from processing, as you may discover that exposure changes are necessary in duplication, and will want to use the same register-pinned mask and original in combination once again.

For many years, I did not have a register pin system. If your budget is tight or you seldom make dupes, you can certainly make masked dupes without register pins. You must then take extreme care to perfectly align the mask and original by sight, preferably over a light table, before duplicating.

To make a mask with Pan Masking Film, assemble the following items in the darkroom:

1. Paper cutter or scissors to cut the film into small pieces. Be sure some type of guide system for sizing can be used in total darkness.
2. Register punch system if you have one.
3. Contact printer.
4. Trays for film developing
5. Kodak D-76 developer mixed one part developer to one part water at 68–75°F, or Kodak DK-50 mixed one part developer to two parts water at 68°F.
6. Enlarger.
7. Kodacel matting. This is the light-diffusing material that is used as a backing for the plastic protective cover of any 4×5 or 8×10 transparency. It can be purchased through most photo supply stores. You need only enough to cover the area of the mask and the enlarger lens.
8. Pan Masking Film.
9. The original transparency, or group of transparencies to be masked.

Once these items are assembled, proceed to make the mask.

1. In total darkness, cut the sheets of 4×5 Pan Masking Film into four pieces, each 2″×2½″. I usually cut 5 sheets at a time, providing me with 20 pieces. Each small piece should be notched in the upper right-hand corner, emulsion facing you, to provide a code notch. Replace the film in the box, and turn on the light.
2. Place the contact printer under the enlarger. I have an old-fashioned contact frame; it is loaded with the film to be contacted,

then closed, secured, and turned over for its glass to be uppermost when printing. If your contact printer loads from the side that remains facing the enlarger, then you must reverse the order of material placed within it, and in that case will begin with the Pan Masking Film, so the light must be turned out at this point. If your contact printer, like mine, must be turned over, proceed with the next step in normal room light.

3. Put the original transparency into the contact printer, emulsion side facing the glass.

4. Place the Kodacel matting material over the original transparency, so that the diffused side of the Kodacel faces the glass. At the same time, put three thicknesses of Kodacel matting over the enlarging lens to produce the most diffused light possible. If you don't have enough Kodacel matting to cover the enlarger lens, use white facial tissue (but not over the slide).

5. If you intend to mask for intensifying any color on the original, place a filter over the enlarging lens that is the opposite of the color to be intensified. If you use a filter, the exposure will have to be increased by a factor that depends on the filter's density.

6. Turn out the room light, and all safelights.

7. Place a piece of Pan Masking Film on top of the original transparency and the Kodacel matting, so that the film's emulsion faces down toward the glass. (The code notch should be in the upper-*left* corner.)

8. Turn the contact printer over so that the glass faces the enlarger, and the original transparency is now layered on the top, over Kodacel matting and Pan Masking Film.

9. Make the exposure with the enlarging lens wide open. My average exposure is 5 seconds, but with heavy color filtration over the enlarging light, the time

Original.

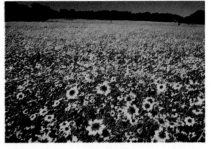

Adding contrast by unmasked duplication on Kodachrome 25.

This field of coreopsis flowers, shot with a 18mm lens, was underexposed and low in contrast. A duplicate on Kodachrome 25 increased contrast and corrected exposure.

can increase to a 15 or 20 seconds. You must make a test to determine the normal exposure time for your mask. Remember that length of exposure governs the density of the mask, and the mask should preferably be no denser than a slightly thin, underexposed negative.

10. Tray-develop the Pan Masking Film for about 2 minutes. Remember that development time governs the contrast of the mask, and the longer the development time, the more contrasty the mask. The more contrasty the mask, the less contrasty the duplicate will be.

When the masking film has been developed, washed, and fixed, turn on the room light and examine the mask. It should have the appearance of a somewhat underexposed normal negative. Especially if you are beginning to work with masking, you should make several variations on exposure and development times. Keep close records on each variation. I also recommend making variations using different filtration, so you learn what to expect in color intensification with each color filter. I find it convenient to number the variations, writing details in a notebook, then scratching the variation number into the emulsion of the $2'' \times 2\frac{1}{2}''$ mask, naturally keeping the scratch away from the area of the image itself.

Once the mask is dry, it can be used to make the duplicate. Both mask and original should be thoroughly cleaned, blown free of dust with compressed air, and brushed with a static eliminator brush. Alignment is best done on a light table. I have a $4'' \times 5''$ piece of glass that has register pins, and I can place both original and mask onto the pins for exact alignment. Otherwise, alignment must be done carefully, visually registering mask beneath original, so that the emulsion side of the mask and the emulsion side of the original are both facing you. A piece of $4'' \times 5''$ glass, even if it's not register pinned, is ideal to use as a secure base during alignment. Tape all edges down with black photographic tape, making sure that the mask is on the bottom, the original on top, and that the emulsion side of each faces up.

When the mask and original are taped onto a piece of glass, glare from the glass can interfere with the process of duplication, and perhaps even fog the film. Therefore, I always use black photographic tape to form a border about an inch wide around the sandwiched mask and original.

Once the mask and original are perfectly aligned, you may proceed to make the duplicate. Always copy the original with the mask beneath it, nearer the light source, and the original on top, nearer the camera copy lens. The emulsion side of the original should face the lens, since that offers the sharpest, best quality image.

Duplicating Sandwiches

Any two or more slides that can be successfully sandwiched can be duplicated as one slide. Because the sandwich is composed of more than one image, it will most likely be denser than a single, normal slide, and exposure must be increased when duplicating. Each slide that is to be sandwiched should be removed from its cardboard mount, cleaned thoroughly, and then taped in alignment as desired with the other layers of the sandwich. Taping all layers over a piece of 4″×5″ glass is the best way to conveniently handle the sandwich. If slides are taped flat on the glass, all should remain in focus when making the duplicate, but it is wise to stop the copy lens to about $f/11$ to maintain a good depth of field on the images. The more important image should be on the top of the sandwich, nearest the copy lens, emulsion side up.

Some people like to sandwich a slightly overexposed slide of textured material (wood, stone, cement, marble, leaf, cloud, rippling water) with another slide. This technique usually sets my teeth on edge, as I find it rather corny, and have rarely seen examples I liked. However, if you try this technique, you should know that the textured slide will tend to decrease the overall contrast of the duplicate. To regain the contrast, make the dupe with Kodachrome. Place the textured slide farthest from the copy lens, and focus carefully on the other slide.

The textured slide may also have its own color cast, so to avoid contamination of the overall duplicated image, you may need to correct the color with CC filters. Avoid the color cast problem by using a textured slide that is actually a black and white negative, if you like, as that will add no unwanted color tone into the duplicate.

When I saw the graphic lines of the power substation electrical grid, I knew it would make an interesting element for a photograph, but was not sure what I might eventually do with it. I photographed it with a 20mm lens, aiming toward the white, overcast sky for a colorless background. Months later, while waiting in the office of a client, I noticed the light fixture on the ceiling had several clear light bulbs at the end of spidery arms. I was early for the appointment anyway, so I placed rainbow streaker and stellar burst filters onto a 50mm lens, and amused myself in the waiting room by photographing the light fixture. I swirled the camera during a one second exposure. When the two images were sandwiched together, the swirling lights worked as I'd hoped, providing a feeling of power and energy for the electrical grid. For convenience, I duplicated the two slides together. The image was used in a presentation for Westinghouse, and later ran as a cover for *Photomethods* magazine.

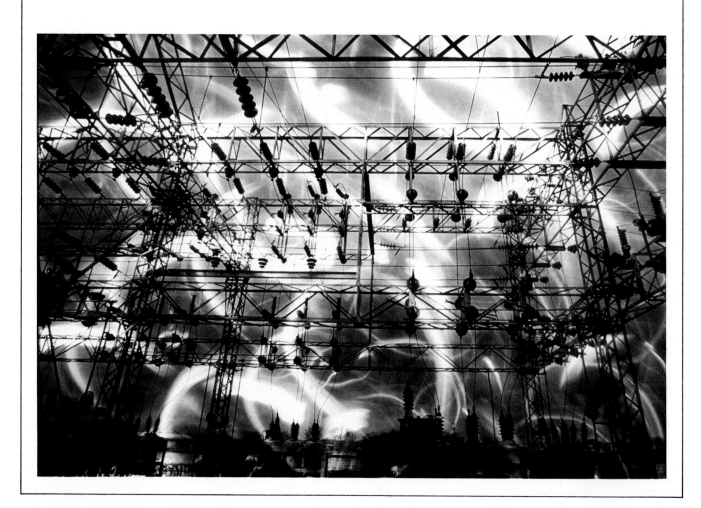

When we traveled across the United States with my roll of full moon exposures in a separate camera, I was limited to exposing only 36 frames on landscapes across the country. Maybe they were so successful for me because I knew I had to be choosy, but often I did feel the restriction, and, knowing better scenes might be ahead, restrained myself from shooting the scene at hand. Today I would no longer take that approach, because I know that waiting for me back in the studio, I have a selection of full, quarter, and crescent moons, perfectly exposed against a self-masking black night sky. Whenever I return from a trip with a group of pictures, I can select the best, then add the moon by double exposure while duplicating, producing the same result. Because I may also mask the original for better contrast or intensification of colors, the duplicate double exposure is probably superior in quality to any

regular double exposure of that same subject.

All the same general principles for in-camera multiple exposure also apply when doing a multiple exposure in the duplicator. Camera and film should be register marked for multiple exposure.

To position elements, it is often necessary to move the original slide until just the right composition appears in the camer's viewfinder. I again tape the original to a piece of 4″×5″ glass and place the glass on top of the transparency holder in the duplicator. When the slide must be moved for composition, I can move the entire piece of 4″×5″ glass, and be sure the slide itself will not shift since it is taped to the glass.

Sometimes the element I need for multiple exposure is a fairly large element within the area of the original slide image, but I want to make it smaller when it appears in the duplicate. If I move the camera far enough away to properly size the element, the lens views not only the element, but the transparency mount, the photographic tape border, the 4″×5″ glass, and perhaps even the table that the duplication system is resting on. To mask the offending background, I cut a tiny hole (perhaps ⅜ inch in diameter) in a piece of black paper. Holding the black paper between lens and transparency, I move it up and down until the right degree of masking is achieved, with the total element visible and the background masked out. The mask must be then held steady at that position while the exposure is made. Some elements may of course require that the hole not be perfectly round, but be shaped to accommodate their own form. Smaller f-stops on the copy lens produce a sharper, more visible edge to the mask, while wider f-stops make the mask edge much softer.

I arrived at Great Sand Dunes National Park in Colorado just before sunset, and found the composition I wanted to photograph. However, the sun set behind a cloud bank in late afternoon, depriving me of cross-light for the effect I wanted. I returned the next morning before dawn, but the direction of the light was wrong for the composition. I waited there all day, watching the occasional clouds and hoping for a good sunset. As late afternoon approached, another cloud bank seemed to rise from the western horizon, obscuring the sun, while the rest of the sky remained clear. At last, the sinking sun dipped into an opening in the clouds and lit the dunes perfectly. I shot with a 20mm lens. The crescent moon was photographed with a 300mm lens on a clear night. I double exposed the two images together in the Illumitran slide duplicating device, positioning them carefully.

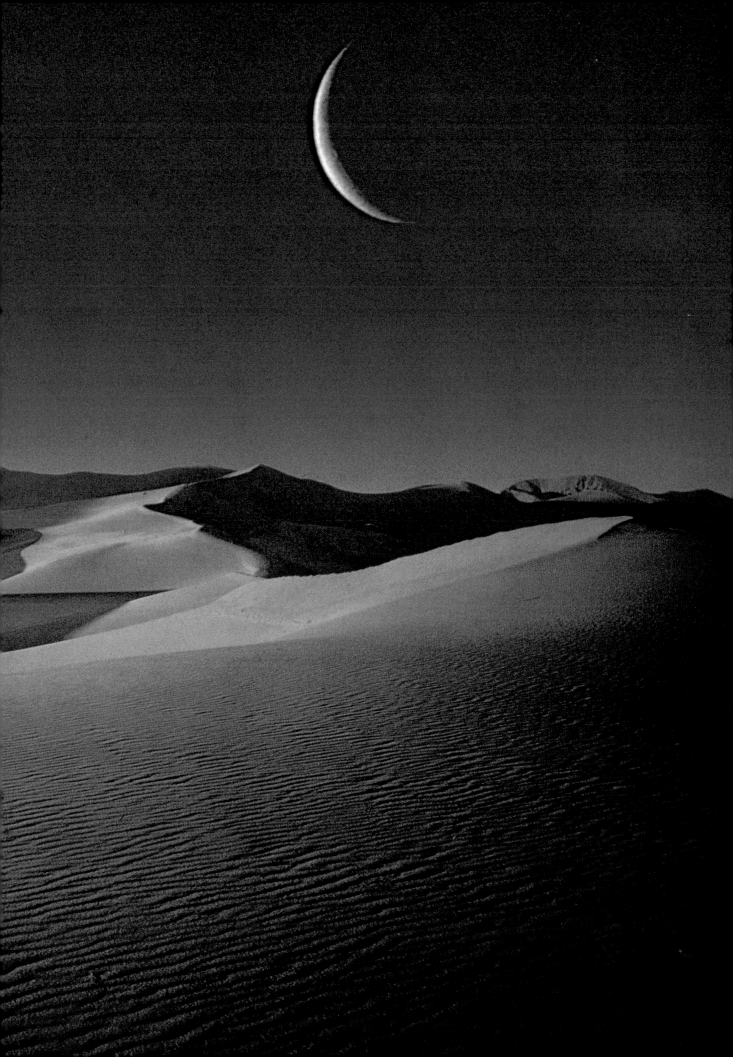

The peas and pearls was shot in ten minutes in our living room. We then steamed and ate the peas, freshly picked that afternoon from our garden. I placed peas, pod, and pearls on a blue foil illustration board sprayed with water, arranging them so that the pearls seemed to come from the pod. I lit the still life from the side with a portable strobe in a white cardboard box, and with a white reflector card on the other side to add highlights to the pearls. From the original 35mm Kodachrome 25 slide, larger-format duplicate transparencies can be made.

There may be times you want to make a 4×5 or 8×10 duplicate of a 35mm or 2¼″-square slide. Enlarged duplicates make excellent and impressive portfolio pieces, and many professional photographers prefer to show their portfolio this way. A viewer tends to take more time with the individual images, and can appreciate the nuances in the image. I have several formats for portfolio presentation, and one of them is a series of enlarged dupes. When I show them to art directors, they often comment, "I didn't know you shoot 4×5 too!" If I don't want to disabuse the art director of his opinion, I imitate Marie's uncle, a wise gentleman who meets disconcerting statements with a smile and a pleasant, noncommittal nod. It works well for him, and it works for me too!

Enlarged duplicates are not only showy, but are easier to retouch than 35mm or 2¼″-square transparencies if retouching is necessary for reproduction.

Enlarged dupes are made in the darkroom under the enlarger, using Ektachrome duplicating film, available in sizes of 4×5, 5×7, or 8×10. I prefer to buy only 8×10, as I can then make any size I want without concern about changing filtration with different emulsion batches. The recommended filtration is included on the information sheet packaged with the film. Using a dichroic enlarger, it is easy to dial the filtration without bothering to mix and match CC or CP filters, although they can certainly be used. If you do use filters, place them above the original transparency, in the enlarger's filter drawer.

When I worked in Los Angeles at the beginning of my career, I was primarily interested in fashion photography. One day I was given what was to me a very important assignment: to photograph dresses of a famous, very pretentious, and opinionated California fashion designer. Usually the designer himself went on all shootings, but for some reason he was unable to accompany us on this particular day, and his nervous assistant was ordered to oversee the shoot. The designer specified I shoot only 8×10, but he wanted a good selection of images from which to choose, and there were several dresses to shoot.

We took twin models, a stylist, hairdresser, makeup man, my assistant, and the designer's assistant, and headed to Mexico for the location shooting. We had only one day in Mexico to complete the assignment, and we hired a station wagon and local driver. I had been unsure of how easily I could reload 8×10 film on location, so rather than take the chance of ruining any film while loading, I brought thirty 8×10 film holders in a specially made cherrywood case, figuring that sixty sheets of 8×10 should certainly be enough to cover the assignment well. To photograph some additional shots for my own portfolio (since all the 8×10 film was going to the designer), I brought along my Hasselblad and a few rolls of film. As my assistant changed film holders, I clicked off a couple of frames of 2¼″-square on each of the dresses.

When the last 8×10 film had been shot and the sun was fading, we all heaved a great sigh of relief. Even the designer's assistant stopped worriedly fluttering around the set. We were hot and thirsty, and began to chatter about dinner and cold drinks. My assistant packed all the 8×10 film holders in their custom cherrywood case, and I casually tossed the 2¼″-square film into a camera bag in the back of the car, telling the Mexican driver to please back up so that we could load the rest of the equipment.

I turned away for a moment, but the roar of the car's engine and squeal of tires made me whirl around just in time to watch the enthusiastic young driver smiling broadly at the models while he impressively gunned the car rocketing backwards. It came to a crunching halt as my assistant leaped out of the way, and the rear wheel landed squarely over the cherrywood case, splintering it into a thousand pieces and crushing the 8×10 film holders where they lay. I thought for awhile that the designer's assistant might have a heart attack on the spot, and wondered in a detached part of my mind where I would take him for medical treatment. Fortunately he survived, but he was as crushed as the cherrywood, and a pall of gloom hung over the whole group as we headed back to Los Angeles.

Once the 2¼″-square film was developed, I immediately selected the best images and duplicated them onto 8×10 Ektachrome duplicating film. About three 8×10 originals had survived the accident, but they were visibly superior to the dupes, and I left them at home when it came time to present the shots to the designer. I was accompanied to his office by the morose assistant, whose teeth were clenched in a desperate imitation of a smile as we entered the boss's presence.

Because the process of duplication is plagued with the battle against dust, there were indeed spots here and there on a few of the images. The designer asked why, and I ad libbed, stating truthfully that it had been dusty and windy on the set at times. I could see the assistant roll his eyes heavenward. Finally the designer's face broke into a wide smile. "See," he chastised his sweating assistant, "I told you that only 8×10 gives this kind of quality." Nodding at the assistant, he remarked, "He wanted to shoot 2¼!" I tisked in sympathy, and the assistant and I exchanged glances, but nothing was ever revealed until now of the actual source of those 8×10 images!

To make an enlarged duplicate, proceed as follows:

1. Place the original transparency, emulsion side up, in the enlarger's negative holder. Normally a negative or transparency would be placed in the holder emulsion side down. However, the image will be projected onto the emulsion side of the large format transparency film, and that will eventually be viewed through its shiny backing side. Therefore, if the original is not also positioned emulsion side up, the enlarged duplicate will be viewed with the image reversed.

2. Put a piece of plain paper into the enlarging easel. Size and compose the image onto the paper, focusing it as you would when making a print.

3. If you have a dichroic head enlarger, dial in the filtration recommended by the data sheet enclosed with the duplicating film, or use a combination of CC or CP filters.

4. Calculate the exposure. At first you must make some tests to determine what the average exposure should be for your enlarger, with a normal density slide, onto whatever size duplicating film you have chosen. For my enlarger, a normal 35mm transparency enlarged to 8×10 calls for $f/11$ at 15 sec.

5. Have the duplicating film processed. Duggal Color, a lab in New York, and probably one of the finest in the world, recommends the enlarged dupe be underdeveloped by ½ stop if you are looking for a tonal range similar to that of the original 35mm transparency.

If the dupe needs even less contrast, it must be made by using a mask of Pan Masking Film over the original. Position the mask on top of the transparency in the enlarger, with both emulsion sides facing up. The mask will provide a duplicate with full tonal range. Be aware it will require additional exposure time to compensate for the additional density of the mask. Top custom labs that make special reproduction duplicates always mask the original before enlarging. If you have a glass negative carrier, put both original and mask on the glass and tape them flat. Otherwise, I recommend taping both to the 4"×5" piece of glass you have used in masking. Be sure to tape a perimeter of black photographic tape around the original and mask, to prevent glare from the glass from fogging the dupe. Before making any duplicate, be sure glass, mask, and original are thoroughly clean.

If you find you would prefer more contrast in the enlarged duplicate, you can underexpose the film as much as a full stop, and have it pushed (overdeveloped) the same amount. Remember that exposure controls density, development time controls contrast.

If the enlarged duplicate is not sharp enough, and you are sure your focus was exact, the fault may lie with the enlarger. A diffusion enlarger makes an image with less contrast because it is an unfocused light source. Light from a condenser enlarger produces harder edges in the image, and darker shadows. The disadvantage of using a condenser enlarger, however, is that any dust on the original, and any grain inherent in the original, become much more apparent. Although the image sharpens with the use of the condenser enlarger, you must decide if the increased visibility of grain structure and dust is worth the trade.

A Quick Exposure Reference

Processing an enlarged Ektachrome duplicate can take time, whether you process the Ektachrome yourself or have it done by a lab. If the exposure you have estimated is far from the mark, several tests may be required, using up time and material. Once you have made a properly exposed, enlarged duplicate from a normal 35mm transparency, you can use that original and duplicate to establish a standard exposure with black-and-white paper that will give you an idea of the exposure time required on any original. When you make the enlarged duplicate, naturally you keep notes as to exposure time and f-stop. Refer to those notes, and use the same 35mm original to make an exposure in the enlarger onto black-and-white paper. I prefer Polycontrast Rapid. After development, the print should look like a negative with a good tonal range. In the future, when you are unsure of the proper exposure for an original, make a black-and-white test, and compare the test to the print made from the first original, because that exposure time produced an excellent duplicate. If the print made from the test shows the same tonal range as the print made from the exposure time of the first original, you know you have approached a perfect exposure for an enlarged duplicate of the transparency in question. However, to save time, if you plan to make enlarged duplicates with some regularity, buy yourself an inexpensive enlarging exposure meter that can immediately inform you of the exposure needed. It will pay for itself immediately in material saved from improper exposure.

When making duplicates, cleanliness is next to impossible, unless you are well-armed with film cleaner, compressed air, and a static removal brush. Film tends to collect dust, especially when static charges build. A duplication device generates static charges. Since duplication increases contrast, the dupe turns a dust speck that was almost invisible on the original into an obvious blemish with a hard, noticeable edge.

If the slide is dirty, clean it with film cleaner. It may be necessary to remove a slide from its cardboard mount and soak it for 15 minutes in 16 ounces of 62-75°F water to which you have added one capful of Photo-Flo. With a piece of cotton, gently dislodge dirt clinging to the surface, then blow the slide dry with compressed air.

Whenever you clean slides, do so away from the light table, another static source. Inexpensive static eliminator brushes are available from most camera supply stores. They eventually lose their power to neutralize static, and may need to be replaced every few months.

Scratches on the transparency can sometimes be eliminated if they appear on the shiny film backing, and not on the emulsion side. Apply a tiny amount of a scratch removal substance, like Edwal No Scratch, and rub it in circles over the scratch with a clean finger. This should fill in the scratch and eliminate its hard and apparent edge. Petroleum jelly may also be used for this purpose. Wipe away any excess of scratch remover or jelly. Scratches on the emulsion side of a transparency are almost impossible to eliminate, although the same technique can be used to somewhat soften the hard line in the scratch. Avoid scratches by storing the slides properly.

Dust and dirt are always difficult to eliminate, but especially when duplicating sandwiches or masked originals. Multiply the problem by the number of surfaces involved, and you can see how rapidly the problem escalates. Consider too, that any filters used must be clean, since even dirt that is out of focus can have its effect on the image by graying areas or showing up as unfocused blotches in the dupe. I protect filters by covering them with translucent plastic or storing them carefully when not using them. I also always keep a can of compressed air within reach, ready to blow away dust as it accumulates.

Don't let dust ruin all your efforts in making the perfect dupe. This rather mundane and non-technical aspect of duplication may be one of the very most important, so be willing to spend the time and effort in cleaning and caring for the slides.

Fight the buildup of dirt and dust on transparencies with canned compressed air, a static elimination brush, an anti-static gun, or a static removal cloth.

How to Make a Slide Duplicating System

Before I could afford to buy an Illumitran, I built my own illuminator to provide a consistent light source for duplication. This system can be used with either tungsten or electronic flash. Before you build one, you must be able to have on hand a camera, bellows, copy lens, and sturdy copy stand or tripod.

MATERIALS

To build a duplication illuminator, you will need the following materials:

I chose tempered masonite, ¼-inch thick, to construct the main body of my illuminator, but you may prefer plywood or shelving material. Scrap material is available at most lumber yards for a cheaper price, and the lumber yard should be able to cut the material for you. Have them cut the masonite or plywood into seven pieces:

- four pieces 8″×12″ for the top and sides
- two pieces 8-inches square for the ends
- one piece 7¾″×10″ for the reflector that is placed within the box.

At the lumber yard, also order three strips of wood, each 1-inch wide. One piece should be 5⅝-inches long. Two pieces should be 4⅝-inches long. These pieces will provide the platform for the slide carrier.

If the lumber yard will do so, ask them to cut holes in three of the pieces of masonite or wood you purchased for the body of the illuminator. Some lumber yards will not cut holes, and you must drill holes along the same lines in these pieces. The drilled holes will work as well, but it is easier to have everything prepared by the lumber yard, if possible. Have the holes cut as follows:

Two narrow slots, perhaps ½-inch wide and 10-inches long, should be cut along both 12-inch edges on one of the 8″×12″ pieces. The slots should be about 1″ from each 12-inch edge. This piece is to be the side of the box, and the openings provide a convection cooling system to vent the box when bulbs are lit inside.

On a second 8″×12″ piece, one hole must be cut that is 5⅝-inches square. It should be positioned about 2 inches from the 8-inch edge of the material, and centered with respect to both 12-inch edges. This opening provides a window for the light source, and you will be making the duplicates over this window.

If you plan to use electronic flash as the light source, measure your flash unit and have a hole cut to accommodate it in one of the 8″×8″ pieces, perfectly centered within that square.

On the second 8″×8″ piece, have a small hole drilled in one corner to serve as the exit hole for the electric wire.

- If you don't own an electronic flash unit, but plan to use electronic flash as the light source, purchase a small strobe unit, preferably one that can run on electrical AC current as well as batteries. Units run solely by batteries can run out of power just as you are about to make the best dupe, and usually when stores are closed so that more batteries are not available.
- A 15-watt bulb should be used for composing and focusing. It allows you to work for long periods without worry about heat build-up.
- If you plan to use a tungsten light source for duplication, a 150-watt enlarger bulb should be purchased, too.

For wiring the 15-watt and the 150-watt bulbs, purchase:
two toggle switches
two small porcelain light bulb receptacles, each about 2-inches square at their base
one double-wire extension cord with plug attached.

- From a glazier or plastics supplier, buy one piece of opal glass or plastic, 6-inches square. This is the light-diffusing material that is placed over the window in the box, and upon which the filter holder rests.
- Black illustration board, 1/16-inch thick, is used to make the slide holder. You will need enough to make two pieces, each 5⅝-inches square. Illustration board is easily cut to size with a utility knife or a razor blade.

- Fast drying strong glue, available in a lumber yard, serves to put together an illuminator of masonite. You may need tape to hold the sections in place as the glue dries. If your illuminator is made of wood, use small nails instead of glue to hold it securely together.
- If you want to make the extra effort, you can purchase two small hinges for the top of the box, so that the hinged top can be easily opened for changing burned-out bulbs. If you prefer, you may decide to attach the box lid only with tape for easy access to the bulbs.
- Wrinkled aluminum foil is used to line the entire box to maximize light output.
- Flat white paint should be used to coat the angled light-reflective surface within the box. Wrinkled aluminum foil cannot be used, since it might create a hot spot on the transparency being duplicated. If no white paint is on hand, you may decide to glue white paper over the reflective surface, and this will serve as well.

ASSEMBLY

If the lumber yard has pre-cut the material for you, a duplication illuminator is not difficult to build. One thing you must consider is that all cuts must be made on a perfect square. When copying any slide, it is essential that the slide be perfectly parallel with the copy lens, or one portion of the image will be out of focus. Should you choose to cut the material yourself, be absolutely certain it is cut without minute slopes or curves on the rectangular edges. To assemble the duplication illuminator, proceed as follows:

1. Glue wrinkled aluminum foil onto one side of all pieces of masonite or plywood, except the 7¾″×10″ piece that will become the light reflective surface within the box.
2. Mount the two porcelain light bulb holders onto the 8″×8″ square end piece. If you are planning to use electronic flash, this is the piece that has the hole cut to fit your flash unit.

3. Mount the toggle switches onto one of the 8"×12" pieces. This piece will be the front of the box.

4. Glue or tape the opal glass or plastic over the window cut into the 8"×12" piece that will become the top of the box.

5. Glue the strips of 1-inch wide wood over the glass as shown on the diagram. This is the filter holder, used to keep filters from sliding too freely on the opal glass.

6. With a mat knife or razor blade, cut two pieces of black illustration board into 5⅝-inch squares. Cut a perfectly centered hole in one square, so that the hole measures 2¹/₁₆"×2¹/₁₆", with a notch cut on one of the inside edges as shown in the diagram. This piece will go on

the top. Cut a perfectly centered hole in the second square, so that the hole measures 1¹³/₁₆"×1¹³/₁₆". This piece will go on the bottom.

7. Glue the two cut pieces of illustration board together.

8. With the piece of illustration board having the smaller center opening positioned on the bottom, glue or tape them to the top of the filter holder. This is the slide holder, made to contain a 35mm slide.

9. Glue the masonite (or nail the wood) so that all the bottom and side pieces of the box are assembled. Leave the top open.

10. Using the extension cord, wire the lights according to the diagram shown. Cut and use sections of wire where necessary, as shown.

11. Paint or cover with white paper the 7¾"×10" piece of masonite or wood. Position it inside the box at a 45-degree angle, as shown. This reflector evenly distributes the light onto the slide, and prevents heat build-up directly beneath the opal glass or plastic window.

12. Screw the light bulbs in and plug the extension cord into an outlet. If you are using electronic flash for duplication, position the flash unit into its opening and plug it into an electrical outlet.

13. Place the top onto the box, hinging it or taping it in place.

14. Add your own copy stand, camera, bellows, copy lens, and the slide you want to duplicate, turn on the lights, and you're ready to begin duplicating!

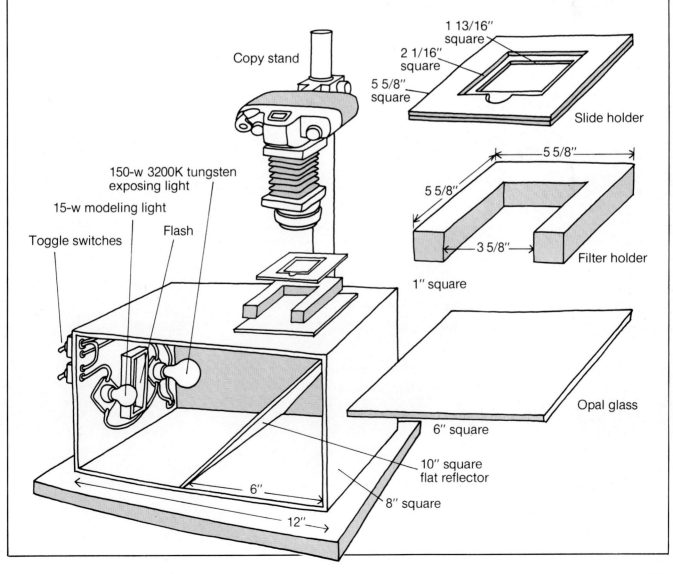

Copy stand

1 13/16" square

2 1/16" square

5 5/8" square

Slide holder

5 5/8"

5 5/8"

3 5/8"

Filter holder

150-w 3200K tungsten exposing light

15-w modeling light

Flash

Toggle switches

1" square

Opal glass

6" square

10" square flat reflector

6"

8" square

12"

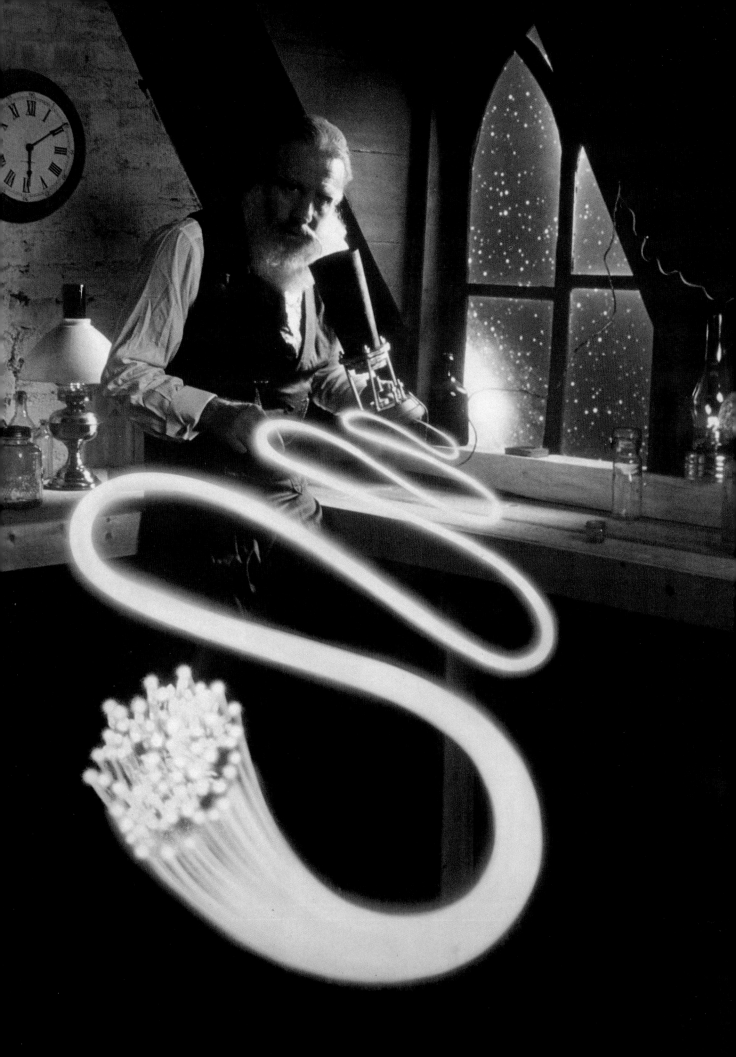

COMBINING IMAGES BY DARKROOM MONTAGE

Mechanix Illustrated magazine wanted a photograph demonstrating telephone communications spanning the decades, showing Alexander Graham Bell using the telephone he had invented, with fiber optic cable snaking toward the camera to represent the latest technology of sending words as pulses of light. Bell himself had actually experimented with voice transmission through light.

We built a set similar to Bell's lab, and actor Jan Layton was Bell. I photographed him with a 50mm lens, and lit the set with one large bank light near the camera position. A strobe with umbrella was placed behind the window to simulate window light. A front-projection screen behind the window was used for the starfield view, symbolizing the timeless universe.

To add the fiber optic cable, I photographed the cable end against black with a 50mm macro, light eminating from the cable end. I then took a piece of 11″×14″ black paper and drew the snakey outline of the pattern the cable would weave from Bell toward the camera. I cut the pattern out, laid the paper on a light table, and photographed the cutout from several perspectives with a 20mm lens and Mist Maker filter for luminescence.

I then took the three elements into the darkroom, sketched and sized them, and printed each successively on 8×10 Ektachrome duplicating film. I first printed the image of Bell in the set, as that was the most important for placement of the other images. The second image was that of the cable, and since it was a cutout within black paper, the black provided a self-mask. Finally, the fiber optic tip was printed in place, also self-masked. Later, retouching softened and added glow to the fiber optic tip. Art director: Andy Steigmeier.

Darkroom montage is an excellent method of combining elements so that their edges are softly blended, without hard lines to divide or define where one leaves off and another begins. Because montage provides a natural look to the combination of elements, it is often the best method to use to produce an otherwise impossible blending.

As with any planned element combination, previsualization is the key to success. I lay out on the light table all the transparencies containing the elements I intend to blend. Before I can begin the actual montage, I may have to go through several steps to be sure the elements I select will fit together acceptably. The step may be as simple as flopping a transparency so that the subject faces the other direction, or it may involve duplicating to increase grain to match the grain on other elements. I may have to change the color balance of one or more chromes so that they are all consistent, appearing to have been shot on the same day, at the same angle, and from the same viewpoint, with consistent lighting from one element to another.

Looking at a group of transparencies on a light table while trying to imagine an end result in montage is not nearly so useful as comparing the transparencies with a sketch of the planned blendings. Assuming the elements agree in grain, color balance, and lighting, the sketch reveals immediately what is needed from the elements with regard to proportion, positioning, and perspective. Proportionate sizing of elements can be achieved in montage by moving the enlarger up and down, or by changing enlarger lenses. Positioning can be done by moving the easel or flopping the chrome. Perspective must be visualized within the elements before you begin. Make a rough freehand drawing to coordinate all these things satisfactorily before you set foot in the darkroom.

As with any of the special effects I do, I want the montage to be startling, but only in its message, not because it is in any way a jumble of ill-fitting elements. If it deals with an unreal subject, it must still be real enough to allow the observer to suspend disbelief for a moment, and become caught up in the feeling of the image. If the subject is believable to start with, the montage should appear so real that there is never any question in the observer's mind that this combination of elements existed as an actual, natural image.

Select montage over other special effect methods when elements must be isolated or removed from backgrounds that are in some way undesirable, or when you want to gently blend subject edges while controlling the degree of image overlap. Because you can control the size, position, relationship, and color balance of each element as you work, montage is the technique that is most versatile and controllable. I use this method more than any other.

Photographing Elements for Montage

A montage is a combination of elements, each usually from a separate photograph. Most elements I use, either from stock or photographed specifically for that montage, have a black background. The black serves as a self-mask for the subject, so that when I print the montage, only the subject exposes, while the remainder of the picture area is blocked from exposure by its black background.

Montage allows a photographer to compose and size the element in the darkroom, so stock elements are more useful than they might be in another technique like multiple exposure, where each element must be exactly sized and positioned on the original 35mm film frame. Variations on "space" elements, planets, stars, and the moon, are always within my stock file. Even though I do use these stock images, however, most elements are photographed individually for the montage I am working on at the time. This is out of necessity when I plan a montage for an assignment that must conform to a detailed layout and use the client's product as the subject element.

When I photograph elements for montage, I do more than simply place each against black velvet and shoot. Each must be lit optimally for its own good features, while retaining a clean image edge, dimensionality, depth, and continuity of lighting with respect to the whole. If any image element is to be diffused, I do so during shooting, rather than in the darkroom, because it achieves a greater luminosity that way. Each element is shot with many minor variations. I can then select the best of these for the final elements to produce the montage.

Model standing in set built to resemble Alexander Graham Bell's laboratory.

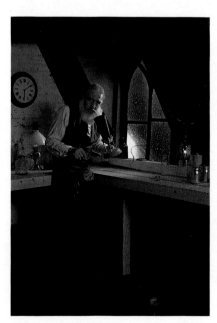

Simulated fiber optic cable, a cutout in black paper.

Actual fiber optic cable ends.

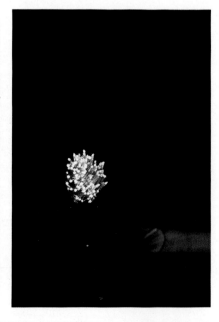

SIZING ELEMENTS UNDER THE ENLARGER

A sized sketch should be made of all the elements you plan to montage. This is a more exacting procedure than just the rough drawing you made originally to get an idea of the placement, positioning, and perspective of the selected elements. The sized sketch must be made by using the enlarger to plan the practicality of the montage combination. Although elements may appear to fit well in your rough drawing, in actuality there may be difficulties that arise that you had not foreseen.

Always put the most important image element into the enlarger first to make the sized sketch. The placement, size, and composition of this element determine what area of the picture remains for the additional elements. If the montage is a simple one, perhaps of sky and landscape, the landscape is the more important section. Its placement determines the horizon line, and the slant of its shadows indicates where the sun or moon, if visible, must be placed. When the montage is more complex, it is usually self-evident which of several elements is the most important. You know which element you want to attract most attention, or to be most prominent.

To make a sized sketch, proceed as follows:

1. With the room light on in the darkroom, select a piece of paper on which to make the sketch. It must be the same size as the paper or duplicating film you will use for the montage. A smaller piece would not contain all the elements, and a larger piece would not show the proper composition in relation to the finished size of the montage.
2. Place the most important element in the enlarger.
3. Turn the room light off; turn the enlarger light on. I have a rheostat to dim or brighten the overhead darkroom light. This enables me to dim the light sufficiently at this point to see the elements projected by the enlarger while maintaining enough room light to view the entire sketch of the elements.
4. With the paper in place beneath the enlarger, size and compose the element as you intend it to look in the final montage.
5. Carefully trace the general outlines and more important features of the element. The tracing need not be detailed and elaborate, but should provide a clear perimeter of the area you will expose in printing this element.
6. Remove this element from the enlarger, and replace it with succeeding ones, sizing, composing, and tracing each as you proceed.

When the sketch is complete, with all planned elements traced, turn off the enlarger and turn the room light on. I like to take the sketch out of the darkroom and have a cup of tea while I study it. Do the elements fit? Are there any errors in proportion that may be corrected by changing the enlarger lens while printing that particular element? Are there areas where colors blend unexpectedly and change color in the blending? Listen to what your instinct tells you. If there is something that bothers you, study the sketch until you can decide what must be changed, rather than eagerly rush to make a montage that will not be satisfactory. On the occasions when I have tried to intellectually override my instincts, I have regretted it, and usually ended up remaking the montage anyway. If the elements just don't work, you may indeed have to spend more time in reshooting them, or in searching your files for others better suited to the idea. Once I've selected the elements that I believe will conform to the needs of that particular montage, there are various things to be considered in preparation for doing the montage in the darkroom.

MATERIALS

Print or transparency material, on which to montage, is selected by the requirements of the assignment. Because I generally make a montage with the intent of having it reproduced as an ad, editorial page, or book cover, I almost always montage onto 8×10 duplicating film, rather than onto paper. The film provides an 8×10 transparency. Occasionally a client may ask for the final form to be a print, but this is rare. If you are making a montage for yourself, you may want to have a print to frame and hang, and may decide to use paper as a material on which to montage. No matter which you choose, the procedure is the same.

The only technique I would not recommend is making prints from color negatives. Probably 99.9 percent of my work is done on Kodachrome color transparency film. Although you may be one of those rare people who can mentally translate colors and images from negative color film, I am not. I find it very difficult to translate negative color in my mind sufficiently well to plan an exacting montage. I prefer to see what I am going to get, and the use of transparency positives allows me to select color blendings with some precision, as well as showing me clearly and precisely what the image itself looks like.

This sized sketch serves as a guide, but I always make another sketch as I proceed with the actual montage. I find it simpler to make a second set of tracings than to attempt to fit each element again exactly within the perimeters I had previously sketched, since the procedure involves raising and lowering the enlarger and shifting transparencies to change element position. The two sketches will be almost identical anyway, but may vary minutely for convenience sake.

MASKING OFF AREAS OF THE MONTAGE MATERIAL

Masking areas of the montage material so that it does not receive exposure is necessary as you place elements on one or another segment of the material. Every photographer who works in the darkroom learns very quickly to dodge out or burn in those sections of a print that must be either lightened or darkened.

When the background of an element is undesirable, an isolation mask may be necessary to separate the element for a montage. Black paper is used for the mask, its center cut out to be half the size and the exact shape of the selected element. The element is printed through the opening, while the black paper holds back the background. Keeping the mask moving slightly while holding it halfway between paper and enlarging lens provides a softer element edge for better blending into the montage.

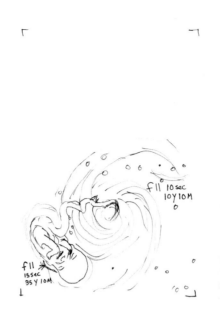

Holding back the light of the enlarger, or dodging, prevents the light from striking the paper or the duplicating film. Obviously, the less light allowed to strike the paper, the less exposure in that area. If no light reaches a portion of the paper, that area remains blank, ready to record a different image. Whether making a montage on paper or duplicating film, first one section is exposed and another held back, then the reverse exposure is made as elements are blended into the montage. When the first element is exposed, all remaining areas must stay unexposed. As each successive element is printed, the area already exposed and the area reserved for future exposures must be held back, and kept from receiving any light. Otherwise, the overlapping edges will be too broad, and be severely overexposed, while portions of elements bleed through each other undesirably.

Dodging Tools

Tools for dodging may be as complex or simple as suit the needs of the photographer. I find it easiest to use my hands for dodging, as they are the tools that are the most flexible and respond most quickly to my thoughts. If the area I want to hold back is too small for my hand to be used, I cut out a small piece of paper and tape it to the end of a wire.

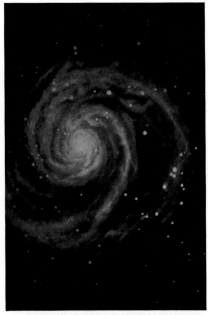

Self-Masking Elements

Self-masking elements are convenient to use. When the entire background of the transparency is black, the black acts as a mask for the enlarger light, and only the subject prints onto the paper or transparency under the enlarger. I often shoot elements against black velvet in the process of multiple exposure, and find it equally convenient to shoot montage elements against this background so that the element is the only transparent section of the chrome, allowing the enlarger light through for easy control.

Isolation Masks

An element isolation mask may be necessary when the element is intricate, or is surrounded by a complicated and busy background. Using your hands or a simple dodging tool may not be sufficient to block out the background satisfactorily when the element has elaborate edges or a convoluted perimeter. The element isolation mask must be half the size of the planned image that is to be printed on the montage material, whether paper or duplicating film. To make an isolation mask, proceed as follows:

1. In the darkroom with the lights on, place the transparency with the complicated element to be masked into the enlarger.

2. When making any montage, you will make a sized sketch of elements in their planned positions, working out the placement as you sketch the projected outline onto a plain piece of paper. Use this sketch as a guide for making an element isolation mask, placing it beneath the enlarger and fitting the projected outline of the projected complicated element into its properly sized, sketched outline on the paper.

3. The element isolation mask must be about half the size of the element as projected onto the montage material. Measure the distance from enlarging lens to paper. Let's say the distance is 20 inches. Half of that is 10 inches, so you must move the enlarger down until it is 10 inches from enlarging lens to paper.

4. Turn the room light out and the enlarger on to more clearly see the projected image on the paper. Replace the sketch with a piece of cardboard or use the back of a rejected doubleweight paper print. A thin piece of paper would be too floppy to serve as a mask. Trace the complicated element in the center of the cardboard or the paper. You need only trace the perimeter of the element, but be certain it is traced carefully.

5. Turn off the enlarger, and turn on the room light. With a mat knife and very sharp, new blade, cut along the outline of the element, so that the element is completely cut away from the paper, and throw the cutout element away. The paper with its center removed along the lines of the element perimeter is now the element isolation mask.

6. Print and montage the elements you have selected. When you print the complicated element, the enlarger lens will again be properly spaced at 20 inches from the paper, as you selected for this particular element size. The mask should be held halfway between the enlarging lens and paper, at 10 inches. The open cutout area allows the element to print through, but the remainder of the light is held back by the mask, and the unwanted background does not print onto the montage material. Always keep the mask moving slightly to prevent a hard edge from forming around the perimeter of the element printed.

COLOR BALANCE

Color balance, even when using elements slightly different in tone, can be easy if you have a color analyzer and a dichroic color head en-

larger to dial minute variations of color filtration as you print each element. However, I get along well without an analyzer, and have learned to estimate filtration well. If the original elements vary wildly in color balance, I may decide to correct their differences through duplication before attempting a montage. Most elements vary only a modest amount. A warm orange sunset, for example, differs in color from a landscape photographed in midafternoon on a blue-toned, overcast day. To combine them satisfactorily, the landscape must be warmed in color by filtration supplied by the dichroic enlarger or by the use of CC filters.

Elements originally shot on different film types may vary in color balance, even though they were shot with all other considerations equal. Kodachrome, right now, is slightly greenish in tone, but it is warmer overall than Ektachrome, which is slightly blue. These base tones may vary with time, as Kodak uses different chemical batches to produce the film emulsion. A concern for the minute variations in film base tone may seem like nit-picking, until a montage results where flesh tones differ, or areas that are supposed to be white seem slightly off true white.

Even when carefully using an element isolation mask, there will inevitably be some color blending of background tones around elements in a montage. If several elements are montaged on a single photograph, each having a different color background, the areas between elements may pick up unwanted color blendings. Where red blends with blue, the area will be purple; where it blends with green the area will be gray. You must always consider the result of color overlap when planning a montage.

REGISTRATION

A registration system should be used to position the film or paper in exactly the same place on the easel each time. The process of montage requires you to remove the paper or film from the easel between each successive exposure, storing it out of the way in a light-tight box, while you change elements and line up sizings with the aid of the guide sketch. Although the easel itself may be moved quite a bit in order to conveniently line up projected elements, the montage material must be replaced so that it is consistently in the same position within the easel, or elements will not fit in the montage exactly as planned. Should the material shift in the easel, the guide sketch will no longer be accurate, and elements may overlap or move too far from their assigned positions.

I have a Condit register punch system that allows me to punch the paper with small guide holes along one edge. The paper can then be replaced over the register pins to hold it in the same position within the easel for each successive exposure. Most prints I make are borderless, so I simply trim off the edge of the print having the two punched holes. Before I could afford to buy a Condit system, I made my own. You can too, and intructions for making a simple register punch system for printing can be found in this section.

If you use Cibachrome Print Material or Ektachrome 8×10 duplicating film, as I do for montage, it can be quite difficult to press them down well enough over the register pins to produce holes, without suddenly breaking through the hard plastic base and finding that your thumbs are neatly register-punched too. I find that if I put a coin over the top of the paper or film where I must press into the pins, the coin serves as a shield for my fingers.

An 8 × 10 film holder provides a perfect registration easel for keeping a sheet of 8×10 duplicating film or paper in exact place during the process of montage. Film or paper can be left in the holder between montage steps, rather than replaced in a box, thus lessening the chances for misregistration.

Buy a second-hand film holder, and remove both dark slides from the holder. Because you need a white surface for easy sizing, spray one side of each slide flat white. The sizing sketch can be made directly on the painted surface in pencil,

The art director at Bobbs-Merrill Publishing Co. wanted a book cover to symbolize birth in the future. I suggested a fetus emerging from the depths of space, its umbilical cord trailing off into a spiral nebula.

I vaguely remembered that in the Hall of Man of the Museum of Natural History in New York, there was a life size white plaster model of a fetus. When I went there, I found the model in a glass case. Behind the model was a plethora of diagrams and information making a confusing background for the image. I photographed it anyway, using Kodachrome 25. The tungsten lights within the case produced a warm tone similar to a flesh tone. The spiral nebula in space was made with glitter on black velvet.

The art director had requested a print for reproduction, so I chose Ektachrome 2203 RC paper which produces color prints from transparency positives and takes approximately 12 minutes to process. The center of the nebula was the point from which the umbilical cord must seem to emerge, so I placed the nebula in the enlarger first. I composed and sketched the element to leave the top of the print unexposed, so the book's title could be placed in that area. I kept the enlarger light from exposing where I planned to place the fetus. Some star bleed-through did not concern me, as I reasoned the fetus might seem more other-worldly if stars could be glimpsed through it.

After exposing the nebula, I positioned and sketched the fetus so that the umbilical cord trailed into the center of the nebula. I used a black paper isolation mask to block the background behind the fetus. Without the isolation mask, the montage would have been impossible, but with it, I produced the result I had imagined before photographing the elements. Art director: Linda Holliday.

Futurelove

A Science Fiction Triad

Anne McCaffrey,
Joan H. Holly,
and
Jeffrey A. Carver

Introduction by Gordon R. Dickson

then erased for the next series of elements in a new montage. The holder provides the added convenience of two places for fitting film or paper, one on each side. A second montage can be done on the second side, but if you want to keep each identified, label each dark slide "A" and "B" for easy reference.

Load the film with Ektachrome duplicating film or paper for the montage, and you will notice there is about ⅛ inch of space on the end that might allow movement within the holder. To prevent this, tape the edge of the film or paper to the holder, then replace the dark slides. Tape two sides of the film holder firmly to the baseboard of the enlarger to hold it securely in place. Because the film surface is about ⅛ inch beneath the white surface on which you will be making a sketch and an initial focus, it is necessary to make a focus adjustment for the exposure. Do this by *raising* the lens of the enlarger a minute fraction before you expose. A grain magnifier can demonstrate the change needed, and practice will show how much the adjustment must be each time.

If you have an ordinary easel, you can make stops for the paper or film, so that as you push the material into the easel the stops serve as a guide to hold it in place, fitting it into the same position each time. Make stops from cardboard strips and glue or tape one along the back and one on either side of the easel so the paper fits snugly. This is not as exact as using a register punch system or film holder, but it is better than using the easel without these guides.

EXPOSURE

Determining exposure for a montage is no more difficult than determining exposure for each of the separate elements that make up the blending, since each element is usually exposed into a previously unexposed section of the print or film material. Both Ektachrome duplicating film and any printing paper provide the photographer with a starting guide for normal exposure. If the montage depends on printing one element directly over another so that each bleeds through and blends with the other, exposure time on each element must be reduced so that overexposure does not result, washing both images out.

I highly recommend the use of an enlarging exposure meter. It costs no more than an additional camera lens, and can pay for itself with the first box of paper or film saved from incorrect exposures. I admit that I have gotten along for many years without such a meter, and have become quite adept at guessing exposures. However, my business has increased now to the point that I cannot afford to waste time with guesses and tests. I find an exposure meter indispensable for immediate, exact readings.

As you raise and lower the enlarger when changing composition and sizing for various elements of the montage, you will have to change the f-stop or exposure time. I prefer to find the best f-stop for the enlarger lens I'm using, then change exposure time according to the distance of the light from the print material. The nearer the light source, the shorter the duration of exposure needed. I prefer to change time rather than f-stop because I can vary the exposure in increments as small as seconds, while it is more difficult to minutely vary f-stops with consistent exactness.

Since duplicating film must go to a lab for processing, you may decide it is not worth the time to wait until one test is completed before you see the results. Bracketing exposures and making two or three variations may achieve the result desired without the necessity of reviewing the test results and remaking the montage. If the montage is complex, however, requiring several elements to be exactly positioned, a test may be the most economical and best way of determining the exact exposure required for each element. Of course, if you are montaging on printing paper, you can easily make a test and develop it yourself to determine variations needed in exposure.

KEEPING NOTES

Keeping notes is essential when making a montage. For ease and convenience, I find it best to keep notes on the same paper I have used for the sketch of sized elements as I proceed with each step of the montage. Within the traced perimeter of each element, I write the f-stop and exposure time used, the distance from enlarging lens to film or paper, and any color filtration selected for that particular element. I store all these sketches with notes in a separate box, marked "montage sketches," on the darkroom shelf. Unfortunately, in the heat of making some montages, I sometimes forget to put these papers properly away. Should the montage need some corrections, I want to be able to refer to the notes, read the original exposures or filtrations, and change them as necessary. I have often looked in vain for the sketches, only to learn that various assistants I've had over the years have discovered them, wondered at the old piece of paper with all the squiggly lines and apparently random notes, and then thrown the paper out in the interest of keeping the darkroom neat. I may groan loudly, but I hardly blame a new assistant for thinking the sketch to be scrap. Assistants who've worked with me awhile know immediately that the paper is just one of Don's crazy montage sketches, and quickly file it away.

COMBINING ELEMENTS OF DIFFERENT SIZES

Changing the enlarging lens is one way to cope with the difficulty of having too small or too large an image element to be conveniently montaged. It may not be physically possible to raise the enlarger head high enough to print a small element large enough, or to lower the enlarger head enough to print a large element small enough. I have enlarging lenses ranging from 40mm to 200mm, and because they each offer different projected image sizes, I sometimes find it convenient to change lenses while montaging

various elements rather than try to raise or lower the enlarger head to extremes. The exposure should not change more than a small amount, as long as the enlarger head remains in the same approximate location with regard to distance from the print material, and the same *f*-stop is maintained from one lens to the next. Usually the change of lenses is sufficient to size the element, and only a small adjustment up or down is necessary. Once the image is again properly focused, I can proceed quickly with the montage.

KEEPING THE PAPER OR FILM ORIENTED

Remembering which end is up can be a problem when doing a montage, as the paper or film must be removed and replaced several times

from its light-tight box during the course of the montage. It is incredibly easy to turn the paper the wrong way, resulting in a montage that is half upside-down. The duplicating film provides the photographer with a code notch in the upper right hand corner to forestall exactly such confusion. I make a small dog-ear in the upper right hand corner of the paper to serve as a similar guide.

I often do more than one variation of exposures as I proceed with a montage. Thus when I have properly sized and positioned an element using the sketch, I may do three variations in exposure time of that element on three separate sheets of film or paper, one right after the other. When I am ready to expose a second element, I need to know which sheet should get the shortest, which the middle, and which the longest exposure of the second ele-

ment, to correspond with the exposure times of the first element. In other words, one sheet should have all the short exposures, the next all the middle-range exposures, and a third all the longest exposures. However, in the dark, it is impossible to tell which sheet is which, and although you may replace them in the box in a specific order, it is likely you will become confused as the montage proceeds. To forestall this problem, I again dog-ear the corners. Duplicating film can also be dogeared. The first version is dog-eared only on the upper-right-hand corner. The second on the upper-right and lower-right, and the third on the lower-left as well as upper- and lower-right. These tiny folds have saved me a great deal of frustration, and allow the montage to be done quickly.

I spent a strenuous half-hour chasing these three beautiful white horses around a farmer's field in Oklahoma, but the background was an uninteresting collection of winter-bare shrubs and small stunted trees. I looked through my stock file for various backgrounds when I returned to New York, but nothing seemed to give the drama I wanted until one evening I combined a photograph of a red sunset sky with one of mist in the heavily forested mountains of northern California. The mist and red sky combined to give the appearance of a smoky fire. I realized this would be a dramatic background, just the

thing for the three white horses.

Before I began the montage, I made a duplicate transparency of the sandwiched sky and misty mountains. Duplication intensified the color of the sky and the higher contrast made the soft mist more like thick smoke. The duplicate also gave the advantage of having to deal with only one element, instead of two separate elements for sky and mountains.

Since the photograph of the horses was the most important element, I placed it in the enlarger first and made the exposure. During exposure, I held back the area above the horses' heads, where I planned to

montage the second element. I also wanted to darken the foreground, so I held back some light in that area too, making it underexpose on the Ektachrome duplicating film. When I exposed the sky and mountains, I held back the area already exposed on the horses.

The result was just what I had been looking for. The horses seemed to be fleeing a fire instead of an annoying photographer. The montage was simple enough, but the combined image took on new drama, and has since been leased several times from my stock agency, a lucrative reward.

A Typical Montage

The process of montage is easy enough once the elements are prepared and you understand the steps.

1. With the room light on, place the first element in the enlarger, and place the sketch paper beneath the enlarger in the register-pinned or prepared easel.
2. Turn the room light off, the enlarger on, and trace the outline of the properly sized and composed element. Turn the enlarger off.
3. In the dark, replace the sketch with the paper or duplicating film. Be sure it fits exactly in the easel. If you have made a register punch system, press the paper or film into place, punching the tiny holes along the edges that will hold it in perfect registration. The film takes a bit more effort to punch.
4. Make the first exposure, holding back the remainder of the printed area from receiving exposure at this time. Replace the film or paper into its light-tight box. Be sure the upper-right-hand corner of the paper is dog-eared. If you plan more than one exposure variation, replace the film or paper immediately with a fresh piece, double-dog-eared, and after changing exposure or filtration as you intend, make another exposure. Return the double-dog-eared paper or film to its box, and if no further exposure variations are desired, proceed to the next step.
5. With the enlarger off, turn the room light on. Immediately take the sketch showing the outline of the first element and note on its the exposure time, f-stop, filtration, and distance of enlarger lens to print material, including any variations from one sheet of film or paper to the next.
6. Replace the first element in the enlarger with the second. Turn the room light off and the enlarger on.
7. Again position the sketch paper beneath the enlarger, making sure it fits exactly as it did before. Size and compose the second element with regard to the first. Turn the enlarger off and remove the sketch from the easel.
8. Again place the first sheet of film or paper on the easel, making sure it fits exactly. Make the second series of exposure variations, holding back the enlarger light from striking any area but that being exposed with this particular element.

Continue the above steps with each element to be montaged; sizing, positioning, sketching, exposing, and keeping notes until all elements have been exposed and the montage is complete. Develop the film or paper as you would normally.

This is a photograph of my friend Maximillian, who lives in the mountains of Southern California. I have always seen Max as being very close to nature, and wanted to show this in a photograph. I shot the original picture of him in a California field with an 18mm lens. The sunset in the montage is from a photograph taken in Maine with a 500mm mirror lens. The arc of sunbeams was the result of reflections within the lens. The fire was photographed in a fireplace in New York, using a 50mm macro lens.

Maximillian was the most important element in the montage, so I placed the image of him in the enlarger first, exposing onto Ektachrome duplicating film. During exposure, I held back the enlarger light from striking the duplicating film both above and below Maximillian.

To achieve the effect of sunbeams from palm to palm, I had to raise the enlarger considerably, since only a small section of the Maine transparency was to be used. Once the image was correctly sized, I exposed, holding back the area below the sunbeams and the area where the image of Max's head protruded into the sunbeam arc. If I had not done this, his head would have been veiled by tree trunks on the island in the Maine transparency.

The fire was exposed last. I wanted a natural looking bleed-through of other images behind the flames, so I held back primarily the areas of Maximillian's body where I did not want image bleed-through. The black sooty wall of the fireplace provided a self-mask for the rest of the fire transparency.

This montage is one of our favorites. Titled, "The Healer," it was selected to be shown in an exhibit that traveled throughout Japan.

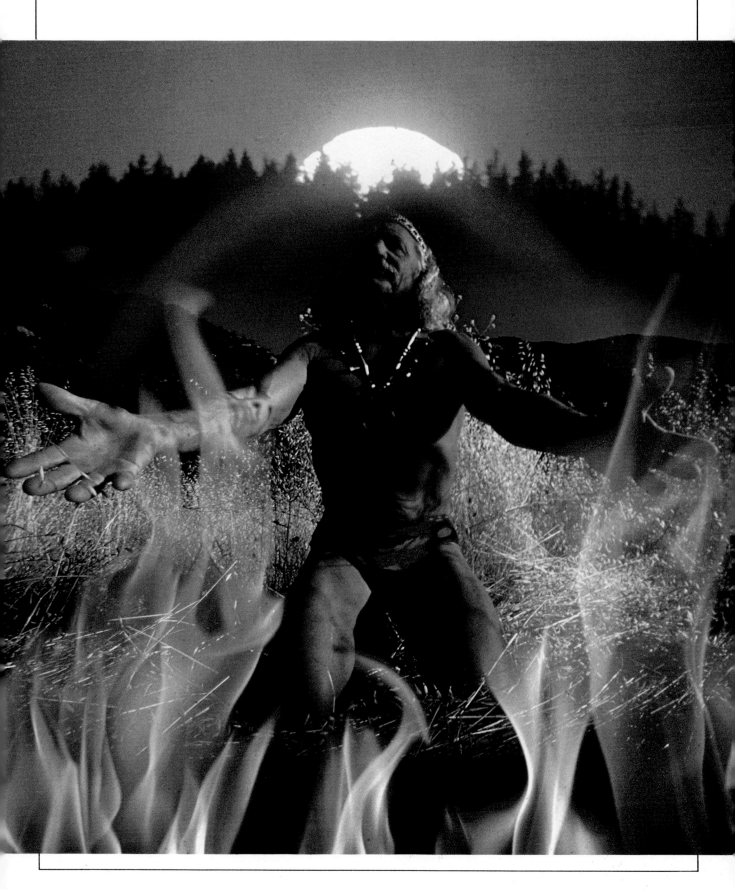

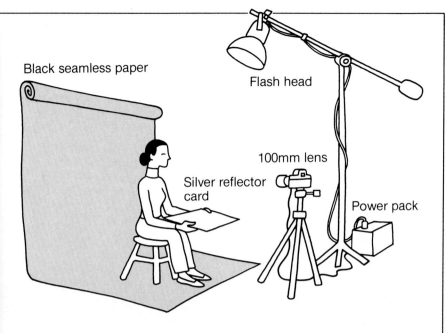

Black seamless paper

Flash head

100mm lens

Silver reflector card

Power pack

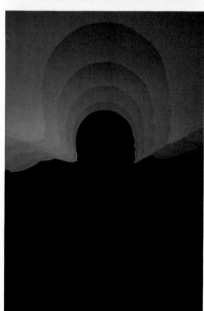

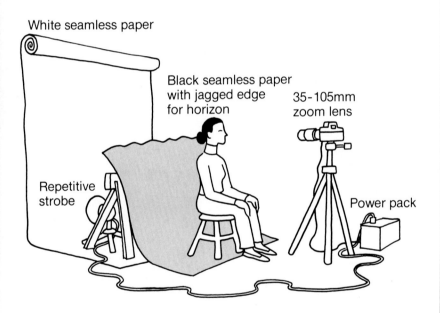

White seamless paper

Black seamless paper with jagged edge for horizon

35-105mm zoom lens

Repetitive strobe

Power pack

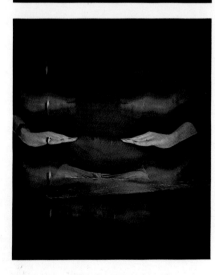

An art director mentioned expanding intelligence and gave me the idea for the photograph on the cover of this book. The original idea was refined and developed, and a camera added to bring it specifically into the concept of special effects photography. A montage was my selected technique, but each element had to be photographed first.

The model, wearing a black turtleneck sweater, sat in front of a black velvet background. She was lit with a strobe above and in front of her. The strobe was diffused with tracing paper. A cardboard snoot directed the light primarily at a silver foiled reflecter card the model held in her lap to bounce light toward her face. I debated with myself whether to shoot her with eyes open or shut, and finally decided to do both, symbolizing inner and outer awareness. I divided the required exposure time, allowing half with eyes open, half with eyes closed. The entire face received two flashes, adding up to a perfect single exposure. With the camera set on "B," and using a cable release to prevent any blur from movement as the shutter was fired, I manually flashed each exposure. A 35–105mm zoom lens at its 35mm focal length sized the face as I wanted it within the film frame. I was far enough from

the model to prevent undesirable distortion from the wide angle.

The hands were photographed with the same lighting. A scrim placed in front of the lens blocked the camera's view of the model's face. I used the 35–105mm zoom, again at 35mm for the same perspective, using a rainbow repeater filter on the lens.

The expanding colors around the model's head resulted from the use of a repetitive strobe and a zoom lens. The model and camera remained in their same positions. I replaced the black velvet background with one of white paper. A horizon line was made by cutting black paper and positioning it between the model and the white background. The repetitive strobe was placed behind and below

the model, aimed at the background, and set for 8 to 10 flashes per second.

While the repetitive strobe flashed, I used a zoom lens for a one second exposure, zooming from wide-angle to telephoto, and then from telephoto to wide-angle on the next exposure, seeking variations. I had taped different color gels together in a string, and during some of the exposures, an assistant moved the gels up and down in front of the camera lens. The gels provided layers of different colors. One variation was made by placing a 47 Contrast Blue filter over the lens. As I zoomed from 105mm to 35mm, the layer of color in the center of the image continued to pick up exposure from the repetitive flash as the zoom

proceeded to 35mm. The layer nearest the face was therefore a lighter blue than the layer farthest away, producing graded tones of blue. This was the version I finally chose.

The silver camera is an actual camera body coated with silver spray paint. I placed the camera against black velvet, lit it with four lights, one on each corner for lighting uniformity, and shot it with a 50mm macro lens.

The glow around the camera was a separate shot. I placed the 35mm transparency of the silver camera in the enlarger and traced the projected image on white paper, also tracing the outline of the rectangular film frame for size reference. I photographed my drawing with 35mm Kodalith film, producing a transparent

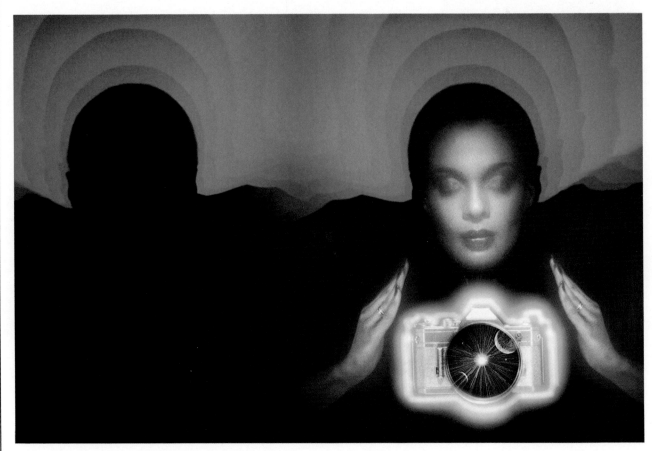

outline of the camera within a black film background. I then placed the Kodalith image in an Illumitran duplicating device, sizing it 1:1, by referring to the traced film frame size (now also a clear line on the Kodalith), and rephotographed the image onto Kodachrome 25, using a diffusion filter to add luminosity.

When all the elements were photographed, they were montaged in the darkroom onto a 16×20 sheet of Cibachrome CPS 462 paper. I had to size the image to fit the book jacket layout, so that the jacket could be reproduced exactly 1:1 from the print for the best quality in the finished jacket.

Because the expanding layers determined the background and sizing of the other elements, I printed this element first. The transparency was exposed for the front cover, then flopped to fit the back cover. Each had to be exactly positioned during exposure so that the layers aligned consistently around the wrap cover. During each exposure, I dodged the enlarger light along the overlapping edges, so that no hard line would become apparent where they blended. A 47 Contrast Blue filter was placed over the enlarging lens to add additional color saturation, since Cibachrome tends to be somewhat weak in the blue range of the spectrum.

The model's face was sized and spaced to fit properly within the silhouetted layers and exposed into the montage. The hands had originally been shot with a rainbow repeater filter that gave a ghost image in prismatic colors. I decided I did not want that effect in the final print, however, and so I dodged out the ghost image as I exposed the hands. Because I wanted the hands balanced, I decided to use one hand, and flopped the transparency to print the same hand again. That provided me with two hands in exactly the same attitude. I divided the necessary exposure, using 1/3 to print the hands without manipulation, and 2/3 to print with diffusion mainly on the palms, while dodging the backs of the hands. That produced lighter, slightly diffused palms, that would appear to be lit from the glowing camera.

The silver camera was positioned, sized, sketched, and exposed between the hands. During the exposure, I dodged the center of the lens because the original shot had some reflections in the lens glass, and because I planned an additional image in the center. The image I made of the diffused outline of the camera was printed slightly out of focus, sized to fit exactly around the camera. Again I dodged the lens center to be sure no exposure contaminated the area. Finally I printed the image of the neutrinos into the center of the lens. A cardboard mask with a small round hole, through which I exposed, helped me to print only in the center of the lens while blocking the rectangular edges of the film frame from being exposed. I wanted some neutrinos to appear to break away from the center of the lens and fly out, so I kept the mask moving enough to expose a few streaks reaching beyond the perimeter.

The process of printing this montage took two hours. Because of minor variations in filtration and positioning, I printed the cover several times before I was satisfied.

An art director called me one afternoon, looking for a photograph she hoped I might have in my stock file. She wanted a picture of a pickup truck zooming along a road somewhere in the red desert country of the Southwest, preferably along one of those roads that lie across the red earth like a dark ribbon to a distant horizon. When I searched my files, I found what I thought would be the ideal shot, but when I showed it to the art director, her face fell. The image, she told me, had to fit the horizontal format of a wrap cover, so that the important features of the image remained on the book's front cover, and the rest wrapped around to the back cover. The composition of the photograph would have wrapped to show the truck on the front cover against an uninteresting flat landscape, and the red buttes and mesas in the distance would have been relegated to the unimportant back cover. "Otherwise, it's perfect!" she assured me.

Undaunted, and eager for a quick sale, I returned to the darkroom and made a montage. When I returned to her office the next day, I was able to give her the photograph, composed for a wrap cover. I had moved the distant mesas forward, recomposing them so that they would not only appear on both the back and front covers, but enlarged and much more striking. From that time on, she has referred to me as, "That photographer who can move mountains." In my youth, I lifted weights and aimed to build my strength, but it was not until I worked with special effects that I discovered mountains could be moved with mind power only!

MAKING A REGISTER-PIN ENLARGING EASEL

A very simple system for register-punching paper or duplicating film for use under the enlarger can be easily made, and works very well.

MATERIALS

Gather together the following:

1. Three flat-head thumb tacks. Push pins will not work.
2. A file or wire clippers to blunt and shorten the points of the tacks.
3. A piece of plywood or plaster board to serve as an easel. I use a 20″×24″ piece of plaster board because it is heavy enough to remain thoroughly stationary during the process of montage, and large enough to accommodate a 16×20 print, if necessary.
4. Duct tape.
5. Black paint, preferably in a spray can for easy application.
6. Two cardboard strips with perfectly straight edges, each about 1-inch wide and as long as the two unequal sides of the easel. In my case, the strips are 20 inches and 24 inches respectively.
7. A discarded print on which to practice.

ASSEMBLY

To assemble the register punch proceed as follows:

1. File or clip the points of the thumb tacks until they are shortened to no more than ¼-inch or so high. Be sure the remaining point is not so sharp that it will register punch your fingers as well as the print or film material.
2. Take the easel out of the darkroom and spray paint it black.
3. Push the points of the thumb tacks each through a piece of duct tape, so that the point is visible on the nonsticky side of the tape. Using the cardboard strip as a straight-edge guide, tape the thumb tacks down along the top edge of the easel so that they are in a perfectly straight line.

If you plan to print only on 8×10 duplicating film, you will need only two thumb tack register pins, spaced about 7 inches apart. If you will be printing 11×14 paper with regularity, place the pins about 13 inches apart. Should you intend to vary the size and material with which you print, consider placing three register pins at conveniently spaced intervals. How you position them is up to you. The only thing you must be certain of is that they are securely taped down, and in convenient positions for you to find easily in the dark when replacing paper or film. I use pieces of glow-in-the-dark tape next to each pin. They should also be as close to the perimeter of the paper or film as possible, so that they will not intrude on the area of the image.

4. Place the two pieces of cardboard along the easel's top and right edges and tape them in place, so that they form a right angle, and provide a perfect stop for any paper placed within their angle. Use the practice print to fit them properly.

Again, you must decide where to position the cardboard stops, according to the requirements of the material you plan to use. Since the stops are only taped in place, they may be moved when you change from using 8×10 duplicating film to 11×14 paper. The cardboard stop along the top edge of the sheetrock must be just slightly above the register pins to allow you to line the paper or film up within the angle of the stops, and still have sufficient room along that top edge to punch it without splitting the edge of the material. About ¼ inch should be enough distance from pins to stop.

A regular enlarging easel has a frame to hold print material down flat. This system does not. For most material this may not be a problem, but some color paper has a tendency to curl when it is placed on a flat surface. I tried using double faced tape to hold the paper flat, but found it was so sticky it often slightly tore the backing of the print as I pulled it away. I finally found that the best method of holding material flat is to spray the central portion of the easel with a fine coat of rubber adhesive, so that it is just barely tacky. (Don't spray inside the darkroom, or you will have to breathe the fumes from the spray.) Avoid spraying the cardboard stops with adhesive. As the adhesive dries, it becomes less sticky, but a fine coating should last about an hour as you work with the montage material. I have used this method with both paper and duplicating film. Occasionally a small amount of adhesive may stick to the back of the duplicating film, but can be easily detected even in the dark by running your fingers across the surface of the film backing. Should you find any lingering adhesive, wipe it away with a cloth. It rolls up easily from the film backing. The adhesive does not need to be removed from the easel, as it will be thoroughly dry within a few hours.

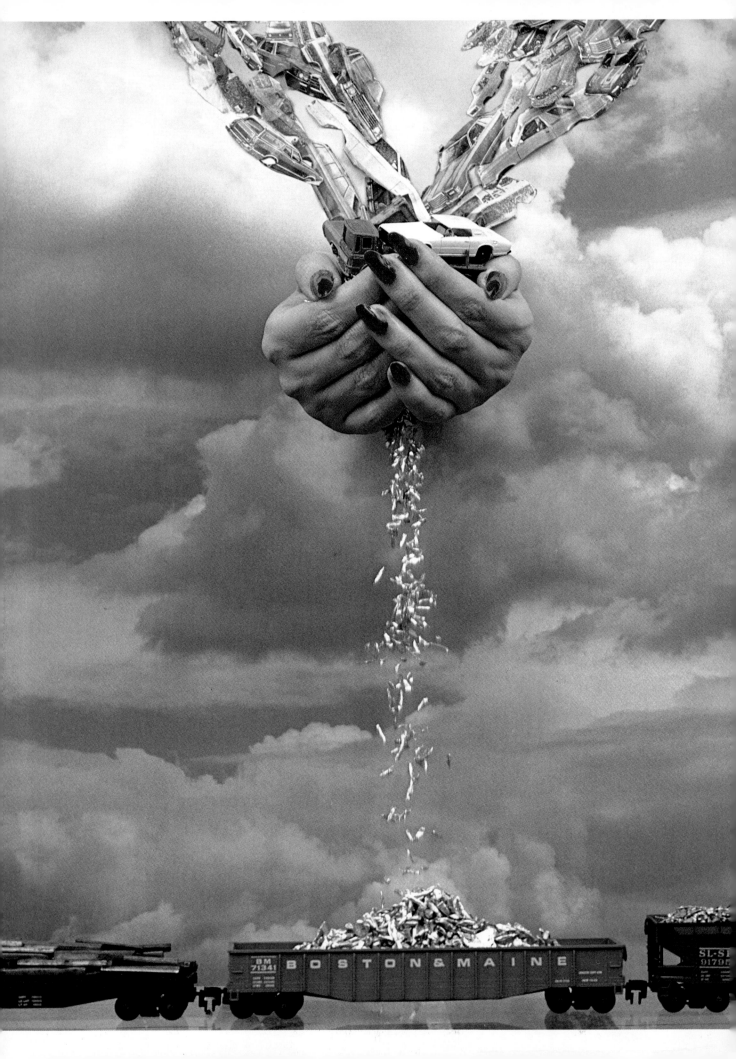

London Iron & Steel Co., in Atlanta, Georgia, processes junked automobiles into various component metals. Because the processing area was so vast, and the sight of rusting hulks of automobiles not particularly interesting, I decided to provide an annual report cover shot that was more conceptual than realistic.

From a transparency of clouds that I had in my stock file, I made a 20×24 print and mounted it on mat board. I cut holes in the print to allow the hands to come through the image. I took quite a few small prints of cars, crumpled them a bit, cut off the tires so they would look like the discarded autos, and mounted them with rubber cement onto the cloud print so they seemed to be pouring into the hands from space.

The trains were models, placed in front of the print. We filled the cars with metal chips of different types, using aluminum chips in the center car. The model's hands were placed in the cutout hole, and filled with aluminum chips. On top of the chips, I placed a few toy cars to provide dimension. I called out, "One, two three, POUR!" The model opened the cup of her hands as I shot with a motordrive. The aluminum chips did not pour into the train, because they would have bounced too much, but actually into a box on the floor behind the train.

Some photographers view collage as something akin to cutting out paper dolls—an occupation for children on a rainy day. Used creatively, collage can solve photographic problems, provide enormous creative leeway, and bring related elements together. Collage can produce an image that, because of its complexity or intricacy, will hold a viewer's attention far longer than a simple image. However, I have seen collage done badly by professional photographers who, in my opinion, went beyond the fine line of reality into bad taste. I certainly believe reality is stretchable through imagination, yet even the wildest monster movies or futuristic space films hold our attention only because we can momentarily suspend our disbelief. It is only when images step over the bounds of possibility that they become laughably corny or disappointingly unbelievable. Collage provides a tool to play with the possible. If you choose to juxtapose jarring versions of elements, try to do so with humor and compassion, the two ameliorating factors in any suspension of reality. You may then realize that collage is an enjoyable and profitable way for even a grown-up photographer to pass a rainy day.

Select collage over other special effect methods when there are elements or images that must be tightly blended or interwoven, or when elements need well-defined edges. Use collage when other methods of combining would be too time consuming, or would cause a softening of the edges. Collage can be used to remove an element from an otherwise distracting or undesirable background. With this method you can also piece together an otherwise impossible element combination to be used in an additional photograph as a prop. Collage is ideal when there are too many elements to interwork conveniently by using any other method.

Choosing Elements for Collage

Choosing images and elements to be used in a collage can be as time consuming and demanding as any technical process. The images must work within the chosen theme, must be able to provide a cohesiveness of tone, intensity, mood, and depth of field. Additional images may have to be printed from your stock file when elements must be sized or color coordinated. It can help to make a list of elements you expect to use in the collage if it is complex, and then to decide on the necessity of shooting new elements not immediately available in stock. Remember that if the collage is to be published or exhibited anywhere outside your own home, there are copyright laws that prohibit use of images created by other photographers or artists, unless those images are very old, or have otherwise come into the public domain.

Reynolds Metals Co. was justly proud of recycling 4.5 billion aluminum cans. That many cans would go to the moon and back four times, a strong symbolic and graphic image. We decided to use only one representative string of cans to reduce image clutter. Reynolds shipped me several hundred cans by mail, causing the mailman to remark that whatever was inside must be badly broken to judge from the rattle! I had a platform made of foam core, and glued cans to the top and front so it would appear there were thousands, rather than hundreds, of piled cans. Spaces on either side of the set called for more cans, but since we did not have them available, I decided the problem could be solved later with collage. My assistant and I cut successively smaller sections of aluminum tubing to represent the receding cans. We strung cans and tubes on a long aluminum tubular wire, suspending it from the ceiling. The tube was looped where I planned to insert the moon.

Paul Hayden, Vice President and General Manager of Reynold's recycling, was the model. I photographed him with a 20mm lens, a single umbrella above and in front of him for lighting. One strobe beneath the set provided a horizon light on the blue paper background. A print of the image was made for retouching and refining the lines circling the moon. I made additional prints and cut sections of cans from each, gluing them to the main print on the sides of the set. The image of the moon was sized, printed, cut out, and also glued in place. After retouching, the print was photographed on 8×10 transparency film for the final version that was sent to the client.

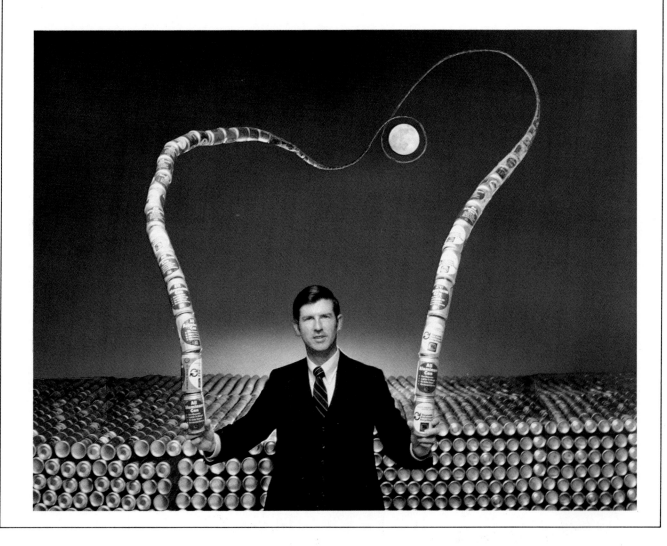

CUTTING OUT THE ELEMENTS

Glass should be used as the base on which to cut out the element from the print. It provides the very best surface for making a clean cut. A piece of conveniently sized plate glass with polished edges is ideal. I put glass over the translucent plastic of my light table to facilitate the cutting.

Tape the print to the glass for stability. As you cut, turn the entire piece of glass so that the cuts are continuously being made in the same direction. This is much easier and produces a better edge than trying to cut a stationary element by running the cutting blade in various directions around its perimeter.

An utility knife with a no. 11 blade is the ideal tool for cutting. A scissors just cannot make the clean cuts available from the knife. Bevel the cut so that it slants slightly and undercuts the edge.

Bend the undercut edge of the finished cutout by placing it on the glass surface and gently running your finger along the cut edge to press it down. The goal is to have the emulsion side of the image bend around the cut edge and hide the raw paper seam. Use only gentle pressure, or the edge may bend too far and create a disturbing crack in the emulsion.

Retouching with water-soluble photographic colors may be necessary should the bent edge crack. Sometimes the bend itself picks up too much reflection, and it is better to camouflage the raw paper edge with retouched color. To match the retouching colors with the color of the image emulsion, mix the colors at only half the emulsion intensity. Apply them along the raw edge of the paper with a small brush, then allow the color to dry before applying another coat, if necessary. Sometimes the colors intensify as they dry. It is always better to have the retouched edge be a bit lighter in tone than the emulsion, if an exact match cannot be made. A dark edge shows up as a hard, emphasizing line around the element, and makes it too conspicuous. After some practice with the colors, you should be able to match emulsion color and intensity with little trouble for a perfect effect.

SIZING THE FINAL IMAGE

Sizing the collage is essential as you plan the mounting. When elements are interwoven and positioned to hide edges, what seemed like more than enough material may not fill the area you intended. Lay the mounting board on a flat surface and position the elements before

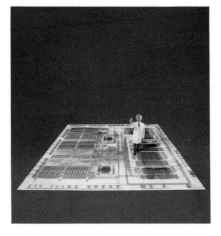

applying any adhesive. If you plan to copy the collage with 35mm film, size it properly for that film frame. Should you want to copy a square collage onto 35mm film, placing the finished collage on a black background as you recopy will mask the edges and frame the square.

MOUNTING THE ELEMENTS

Equipment

Mounting equipment is simple and basic. Heavyweight fiber mounting board is an excellent base for mounting the collage, and is available at any good art supply store. Rubber cement or a spray adhesive can also be purchased there, and either is preferable to any other

Place the print on a sheet of glass to obtain the cleanest edge when cutting out the subject. Use water-soluble retouching colors to lightly tone the edges of the cutout so that they blend with the colors in the subject itself.

type of glue, since each allows the element to be peeled up and repositioned if necessary. It is almost inevitable that you will want to peel various elements up as you work. If rubber cement or adhesive sticks to the emulsion side of a print where it is not wanted, it can be removed with a little lighter fluid or lacquer thinner on a paper towel or piece of lint-free cloth. Avoid using cotton swabs or balls, as they often leave fuzzy traces of cotton hair and lint.

Procedure

The process of mounting can be tedious. If the collage has been well planned and laid out, the job will be easier. Remember that edges will overlap, so you may not want to place an important central element first, only to have its edges disappear under successive, surrounding layers. I usually prefer to begin at the edges and work toward the center, if the collage is complex. Try to blend adjacent tones so that the eye flows from one area or scene to the next. An element exemplifying motion, such as a flying bird, can be used to draw the eye in a desired direction. If two or more large elements abut each other, the seam they make can be hidden by covering it with another small or narrow element.

This photograph, shot to advertise leg jewelry, was made the day the astronauts landed on the moon for the first time. I photographed a model against a white background, using a 50mm lens and lighting with one white umbrella directly above her knees. I used Ektacolor negative color film and made two prints, each of a different leg position. One negative had to be flopped to print legs faced in opposite directions. The legs were cut from each print, mounted on mat board, and the excess board was cut away. Edges were spot-toned to match the legs. I made the "moon surface" by tapping sand (20 bags worth) with a ball at the end of a long pole. A dark blue seamless paper was unrolled across the wall to make a background 9-feet high by 25-feet long. I placed the legs in the sand, lit them with tungsten spotlights with pink gels. A low lighting angle produced deeper looking craters from the crosslight. One front light without a gel lit the legs. Using High Speed Ektachrome tungsten film, I photographed the legs with a 28mm lens to provide curvature for the "moon."

Rephotographing the collage is, to me, the final logical step. If it is to be reproduced and published, the collage should be presented to the client as a single chrome or print that inevitably looks more professionally finished than a group of pasted images, no matter how neat they are. I usually have made the collage with the intent of using it as a prop or element in another photograph, and rephotographing has been my goal from the start. Even if I were planning to hang it on my living room wall, I would still make a copy. No matter what the final disposition of the collage, eventually its edges may begin to peel away from the mounting board. I want to have a copy of it in the best condition possible, freshly finished and perfect. I may also want to include the collage in my portfolio, and to do this I need a 35mm transparency for viewing.

Equipment for Copying

Camera equipment used in copying the collage is determined by what the intended use of the copy will be. If I want to show it in my carousel slide tray, obviously I need to copy it in 35mm. If I plan to present it to a client who will reproduce it for publishing, I will probably copy it with a larger format camera, either 4×5 or 8×10, so that it will lose as little quality as possible in the process of copying. The best lens for copying is a flat-field lens, designed for reproducing a flat-surfaced image on the flat film plane. A macro lens or a good enlarger lens is ideal. Naturally, a sturdy tripod for the camera is also a required piece of equipment.

Lighting equipment consists of two lights. I use two strobe heads, each with its own 250-watt modeling light, and each within a 12-inch aluminum reflector. To provide sufficient diffusion and eliminate a hard glare, I cut a layer of tracing paper to fit the opening of each reflector, and tape the paper in place, making sure there are no gaps around the perimeter. With the appropriate film for color balance, you can certainly use tungsten light for copying, but be sure the bulbs do not get so hot they burn the tracing paper or melt the polarizing gel you may use.

Copying Procedure and Lighting

Hang the collage, or place it flat against a wall or straight surface for copying. Make sure the collage is not on a slant, as it might be if framed and hung by a picture wire, because that will cause an inexact focus from one part of the collage to another. If the collage is in a frame, there should be no glass or plastic covering it to add reflections.

Position lights at a 45-degree angle to the collage, one on either side, so that the aluminum reflectors are at about the midpoint between the top and bottom of the collage. Aim the lights so that they evenly cover the whole collage. It may be necessary to move the lights back to achieve even coverage. Use an incident light meter to read the collage from end to end, if possible, or look carefully to see that no one part seems to be getting more or less light than another section. Because the image elements on the collage may be at slight angles to each other, you may find they seem to reflect the bright aluminum of the reflectors or the chrome of the tripod. If this seems to be happening, you may have to move farther away from the collage, keeping the camera position dark by turning off nearby auxiliary room lights or by covering the tripod with black paper or velvet.

Polarizing the light used in copying will eliminate unwanted reflections. (This same process can be used when copying any flat art to eliminate reflections.) Purchase polarizing gels in sheet form from a photographic lighting supplier or from a store that specializes in a variety of plastic products. The gels are relatively inexpensive and well worth having just for this purpose. Each sheet is usually square. You need two sheets, one for each light, so each must be large enough to cover the opening of the 12-inch aluminum reflector without any gap.

After the lights and the collage have been properly positioned, stand at the camera position and hold the two sheets of polarizing gels in front of you, one in your left hand, and one in your right. Viewing the collage through them, turn each so that the *least* amount of polarization occurs. This is the point at which the gel seems most transparent. When each shows the least polarization possible, make a notch with scissors, or use a marking pen to denote the top of each. That way the top is easily recognized and neither gel will be positioned in such a way as to cause cross-polarization. Tape the gels to the aluminum reflectors, making sure that each gel totally covers the 12 inch opening and fits over the tracing paper. Be sure the marked edge is at the top of the reflector.

Finally, place a normal polarizing filter over the lens on the camera. View the collage through the camera with both copy lights on. Turn the polarizing filter on the camera lens until the *most* possible polarization occurs, when the filter seems the darkest. You will see reflections disappear, and color saturation increase on the collage at that point. Unless you are using a through-the-lens meter to determine exposure, remember that you must open up 1½ stops to compensate for the loss of light caused by the polarizing filter. In any case, it is advisable to bracket your exposures, since a normal exposure may not be the one you want when you view the copy.

ENHANCING IMAGES BY POSTERIZATION

A pharmaceutical client wanted an image of a man glowing with color in specific body areas. The art director and I discussed using the Sabattier effect, but it was my opinion that the technique is neither totally predictable nor controllable. There were other options.

The image might be made with computer enhancement, but that technique provides no control over specific sections of a subject. If one part of the body was made to change color, the rest would have to change in relation to it. That technique was rejected. Thermography, a process of reading heat produced by the body as variations in color shown on a screen, was another possibility. Thermography equipment is expensive, and requires a technician to operate it properly, but my main objection was that the image is easily recognizable as a thermogram, and that did not fit the idea. Lazer posterization, done on a machine, gives an incredible number of variations, but those I have seen are monotonously similar to each other, and lack the glowing quality called for on this assignment.

Posterization, using masks I had made myself, was the one method that fit the concept. It enabled me to select the exact color and intensity of any specific body area, and to make the selected area glow. Marie's cousin Richard Walsh was the model. Art director: Jim Horne.

I've always advised photographers to shoot color film, reasoning that a black-and-white image can always be made from a color photograph, but the process cannot be reversed. Posterization, though, does produce color images from black-and-white originals. (In fact, if the original is in color, it is first converted to black-and-white to make a posterized image.) The color in posterized images is not realistic, and it is not meant to be.

In posterization, subtle tones are removed and essential shapes are emphasized by the strongly defined areas of color. To add colors to the image, high-contrast derivatives of the original are photographed in various combinations through colored filters. The principles are simple, but the variations that can be produced from a single original are endless.

Posterization is a time-consuming process. The most time should be spent in making the decision about what image to posterize. It seems to me this is the step where photographers go astray, choosing an original with too many elements, or selecting one only because it has a great many tonal variations to use for producing the defined color areas on the posterization. I suspect that posterization is usually done without a clear idea of what will result, but more in the nature of an experiment, to see what will happen when colors are added in the posterization process. This is something akin to a baker tossing together a bit of flour, an egg, and some sugar in random amounts, and trusting that an interesting cake will result. The result usually falls flat.

I prefer to posterize a strongly graphic image, and almost always shoot the original specifically for posterization rather than select an image from my stock file. In fact, I generally turn to posterization for a very specific job requirement, and then only when another process cannot be found to produce the effect I need. The process of posterization is too long and involved for experimentation without a clear and specific idea or need.

Graphic shapes without background clutter are ideal subjects for posterization. The color chosen for each posterized area should add interest, enhancing the image, rather than become a disturbing or confusing element. Color is used to create strong emotional reactions, symbolize emotions or ideas, or draw attention to a specific area of the image. I prefer to use the term *image color enhancement* to refer to the process of posterization.

I use the process most often for pharmaceutical advertisement, where the intent is to symbolically convey the effect of a symptom or a medicine on the body. Thus red might symbolize fever, heat, or pain. Blue may be soothing, or represent cold. Black might be seen as a diseased area. Glowing yellow-white may seem to represent pure health and energy. Whatever colors I use, I want the subject to appear as though it glows from within with a luminosity of its own. Were it not for the glowing effect, posterization would probably not interest me as a special effect. I usually select intense, pure colors for their strong eye appeal.

Procedure for Posterization

EXPOSURE TESTS FOR FILTERS

Before beginning any posterization, it is necessary to have an exposure guide for each of the color filters you plan to use. By doing some exposure tests as a first step, you can have them developed and returned in time for consulting as you begin posterization. I prefer to shoot Kodachrome 25 for the final posterization of colors, since it is such a fine-grained film with excellent color saturation. Tests for exposure should be made on the film you plan to use.

Assemble the filters you intend to use for posterization. I prefer color-separation filters because their colors are strong. CC filters are too softly toned for the results I seek. I use a 25A red, a 47B constrast blue, a dark green, a bright yellow, and a diffusion filter (usually Spiratone's Mist Maker). For other effects, you may want to use additional colors.

The process of posterization requires a light source over which the tonal separation masks are photographed, using various filters on the camera lens. A light box makes a good light source. Even a piece of opalescent glass or plastic over a tungsten light is acceptable. The home made box for duplication is also an excellent light source, and I recommend using strobe in conjunction with a tungsten modeling light.

Place the first of the selected filters on the camera lens, aim at the light source, and shoot, beginning exposures with the widest f-stop available, and continuing at ½-stop intervals until the smallest f-stop is reached. Switch filters, and begin again. When each filter you plan to use has been exposed this way, send the film to be processed. When it is returned, line the slides up in order, going from lightest to darkest. On each cardboard mount, write the shutter speed and the f-stop used to achieve that particular color saturation. For convenient viewing, place the slides in plastic sleeves, and you have a ready exposure guide for selecting exactly the degree and tone of

color saturation needed when making the final posterization. You will find that the variety of exposure gives a good variety of saturation, eliminating the need for a light, a medium, and a dark filter of any particular color.

MAKING THE MASTER POSITIVE

Posterization can be achieved by starting with an original color transparency, a black-and-white negative, or a color negative. I never use a color negative and will not discuss it here, although you may use the same basic steps to proceed from that original to a posterized image.

Making a continuous-tone negative or positive is the first step in the process of posterization. If the original image is a black-and-white negative, you are ready to begin. If, however, the original is a color transparency, it will be necessary to make an internegative, a black-and-white negative on ordinary panchromatic film such as Kodak Plus-X. Panchromatic film is sensitive to all colors, and will hold the transparency's tonal range.

Make the internegative either by enlarging the image from the 35mm transparency onto 4×5 panchromatic film, or by contact printing the two films, emulsion to emulsion, under the enlarger. I prefer to make a 4×5 internegative, because its large size makes it easy to view and handle. Develop the panchromatic film in the recommended developer. I use Plus-X film and develop it in D-76, diluted 1:1. The internegative should have a normal tonal range with normal contrast.

Once you have a black-and-white negative of the original, you can make the master positive. I use Kodalith Ortho Film 2556, Type 3, for the master positive and the tonal separations. I prefer to buy it in 4×5 sheets and cut it to size if necessary for working with 35mm film. Most often, however, I enlarge the 35mm original onto the 4×5 Kodalith for easier viewing and handling in making the posterized image.

I highly recommend the use of a register punch system and register

pins for exact placement of the sheets of film as you proceed. For this process, you must have a professional register punch system; the home made system that suffices for making montages will not be precise enough. A good registration system costs no more than a good lens, and is just as valuable for the photographer interested in perfecting his or her craft. Posterization is inexact without one.

Assemble the following materials in the darkroom:

1. Register punch system, punch and holder with pins.
2. Dektol developer.
3. Kodalith line developer.
4. Stop bath or water rinse.
5. Fixer, preferably rapid fix.
6. Kodalith Ortho Film 2556, Type 3 (usable under red safelight).

To make the master, proceed as follows:

1. Place the black-and-white original negative (or internegative from transparency original) into the enlarger, and size it so that the image size is correct for the 4×5 Kodalith film master. If you prefer to make a contact printed master the same size as the original, cut the 4×5 to size. One sheet of 4×5 makes four pieces, each 2″×2½″. In either case, the emulsion of the negative should face the emulsion of the Kodalith. Cover the contacted negative and Kodalith with a piece of glass to keep them flat.
2. Make an exposure. I begin with an exposure of 10 sec. at f/8. Your beginning exposure may differ, according to the power of the enlarger light.
3. Develop the exposed Kodalith in Dektol developer, mixed 1 part developer to 3 parts water, for approximately one minute. When the film is in the fixer, turn on the room light.

The result should be a high contrast positive, retaining a range of tones in the important areas, but nevertheless being overall quite contrasty. You may have to make several

versions with different exposures and development times in order to produce the result you want, with sufficient tonal range. This high contrast positive is the master, and from it the tonal separation negatives can be made.

If you see quite a few pinholes when viewing the Kodalith master, it may be due to underdevelopment of the film. Clean the original negative well, and make another master with at least a full minute development time. Kodalith film tends to show every speck of dust that had been on a clear area of the original negative as a hard, contrasty pinhole in the dark area of the Kodalith positive. If cleaning and redevelopment do not eliminate all the pinholes, use a small brush and Kodak's Opaque liquid to cover them up.

MAKING THE TONAL SEPARATION MASKS

The master is used to produce tonal separation masks. A positive master produces a negative separation mask, which in turn is used to produce another positive separation mask. I usually make five negative and five positive separation masks. The density of each mask is varied by its exposure time. The result is five variations of negative masks, each of which differs from all of the others in its range of tonal density, and five variations of positive masks, each of which differs from the others in the same way.

It is advisable to register punch all sheets of film to be used as masks, as well as the master. That way, each will remain in perfect registration with all of the others during any further step in posterization. Register punch the master and ten sheets of unexposed 4×5 Kodalith before proceeding. If you plan to use a small (35mm or 2¼"-square) size master, cut the 4×5 Kodalith, and then register punch ten pieces to correspond with the register-punched 35mm or 2¼"-square master.

The size of the master used determines the method of proceeding. Because I have made a 4×5 master, I proceed by contacting that master with another sheet of 4×5 Kodalith film. If you have chosen to work with a 35mm or 2¼"-square master, you may either contact that master with Kodalith for the same size mask, or use the enlarger for making a 4×5 mask. Unless you have a built-in register pin system in the enlarger,

Art director Bob Barravecchia at *Modern Plastics* magazine had a black-and-white photograph of a man standing at a plastics control panel. It fit perfectly with the text and format of an article in the magazine, but he wanted a color image. He asked if there was a way I could add color to the black-and-white. I made several variations using posterization.

however, choose the contact method, and make the mask the same size as the master.

To make the negative tonal separation masks, proceed as follows:

1. Place the unexposed Kodalith film beneath the enlarger, emulsion side up, within the register pin system.
2. Cover it with the master, emulsion side down, so that they are emulsion to emulsion. Cover them with a piece of glass so that they remain flat.
3. Begin with an exposure of about 10 sec. at $f/4$. Expose the other sheets of Kodalith the same way, choosing 10 sec. at $f/5.6$, 10 sec. at $f/8$, 10 sec. at $f/11$, and 10 sec. at $f/16$.
4. Develop all the sheets of film in Kodalith line developer, mixing the two packets (A & B) as instructed on the package. During the first 2½ minutes of development time, no image will appear. Develop for 3½ to 4 minutes, then transfer them to the stop bath and fixer.

The result should be five high-contrast negative masks, each having different tonal ranges. The one receiving the most exposure should be completely black everywhere except in the few strong highlight areas of the original image, the black sufficiently saturated to block light if held up to a lightbulb for viewing. The mask receiving the least exposure should be mostly clear, with only a few dark areas corresponding to the deep shadow areas of the original image. The other three masks should vary in successive steps between the two extremes. If this tonal range is not achieved, it is necessary to re-expose new Kodalith masks so that degree of exposure produces a marked range from almost totally black to almost totally clear.

The masks should be dried, and then viewed on a light table. Again, there may be undesirable pinholes. Use Kodak Opaque to eliminate these pinholes. At this point, you may also decide to use the opaque to eliminate any unnecessary portions of the subject, or a distracting background. I sometimes do this to bring the image to the basic essence of the subject, removing anything that might detract from the effect I want. Silhouettes result when the background is opaqued completely away. If the background of the original image is light, and you wish to remove it, opaque the negative mask. If the background of the original is dark, opaque the positive mask. In other words, opaque the background from the mask that has the blacker background.

When the opaque is dry, make five positive masks from the five negative masks by contact printing each negative mask over a sheet of register-punched Kodalith film, as before. This time, the same exposure serves for each mask, and I generally expose for 10 sec. at $f/8$. Develop the positives the same way you developed the negative masks, in Kodalith line developer. Each positive mask is the complement of a negative mask, and each of the five sets can be placed together in perfect registration so that no light whatsoever can be seen through the matched pair.

EXPOSING THE POSTERIZED IMAGE

Previsualization is the key to successful color combinations. When all of the positive and negative masks are developed and dry, lay them out on a light table, each with its complement mask. For the posterization, combine a negative and a positive so that selected areas of gray tone are visible and not blocked by black. For the exact isolation of area needed, you may decide to combine more than two masks, perhaps choosing two negatives and a positive, or another such combination.

Decide what colors should dominate what area of the image, and what colors you want to have a glow or halo effect. Mix and match combinations of negative and positive

X-ray

Kodalith high contrast master from original.

masks to plan the result. Make a list of planned combinations, showing the masks combined and the filter to be used ("#3 pos. + #2 neg., Green," for example).

If no available combination makes the exact area you want to color accessible, it may be necessary to remake a negative or positive mask so that it reaches further on either end of the exposure scale. For example, expose it for 10 sec. at f/2.8 or f/22. An alternative solution might be to remake the same positive or negative mask again exactly as before, and use the Kodak Opaque to black out additional areas for specific control. It is inadvisable to opaque selective areas on the original five sets of masks, other than for pinholes and background elimination, because each of the original masks may be needed for producing other combinations as you proceed.

If you want select areas of the image to glow, use a diffusion filter when working with those areas, placing the diffusion filter over the

color filter. The overall image should not be diffused, but selected areas provide a glow for the subject. The image will be quite luminous in the diffused area, so it is necessary to take care not to overexpose, or that area will burn out.

I cannot overemphasize the importance of keeping notes in the process of posterization. As long as the positive and negative masks are retained, there is always the possibility of exactly repeating the steps necessary to achieve a previous result. Notes must be kept on each exposure. To make the posterization of the man, I exposed only ten frames of Kodachrome 25, but because of the variety of combinations used, and the planning involved in each, it took me three hours. Had I not kept careful notes, it would be almost impossible to exactly repeat any one of the resulting combinations. Notes should cover the combinations of negative and positive masks used, the exposure time given with each combination, and the filter, or filters, for each mask combination.

To expose the posterized image, prepare the following:

1. Whatever color filters you plan to use, and a diffusion filter if desired.
2. Camera and tripod.
3. Cable release, preferably one that can be locked to hold the shutter open.
4. Light box or light source over which the masks can be placed for exposure.
5. Register pins. I use movable Condit register pins that can be taped onto the glass or plastic cover of the light source. Use one of the pre-punched Kodalith masks to position the pins before taping them in place. Although posterization can be done without registration pins, it is such a time-consuming process that I want to make it as exact as possible so that I can be sure the result is worthwhile.
6. A lens cap to be used as a shutter when exposing with strobe. If tungsten is to be the copy light

Set of 10 Kodalith positive and negative masks for posterization.

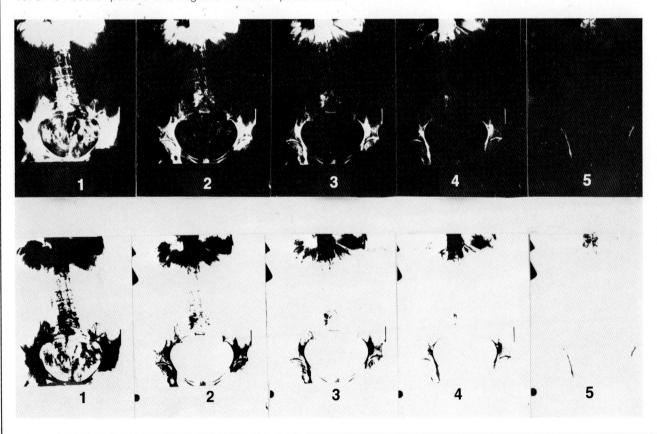

source, the process can be complex. My solution is to buy a second-hand leaf-type shutter (the cost should be minimal) and mount it onto the retaining ring over the filter retaining ring on the camera. It can then be set as desired for each exposure time while the camera's shutter itself remains open and the camera is set on "B."

7. A piece of black paper or opaque material such as cardboard. This is used to prevent flare from around the mask from contaminating the exposure. Cut the center area out to form a 4″×5″ rectangular window, in which the masks can be placed. The black paper should cover the entire area of the light source, with the exception of the 4″×5″ window.

Then posterize the image, proceeding as follows:

1. Put the movable register pins on the glass or plastic cover of the light source, positioning them with the aid of a pre-punched mask, and tape the pins in place.
2. Cover the remaining area of the light source surface with the black paper or opaque material, so that the 4″×5″ window is directly beneath the camera and the pins are correctly within it.

It is helpful to tape the paper in place.
3. Position the camera for copying, so that it is parallel to the glass or plastic cover of the light source.
4. If the camera can be set for multiple exposure without film advance, so that successive exposures can be made on one frame of film, do so. If the camera does not offer this option, set the shutter on "B." The lens cap can be used for a shutter between exposures, blocking the light as you change masks.
5. Select and position the first set of masks.
6. Select the desired filter for use on that section of the image, and place the filter on the camera. It is important to preview the color result by looking through the filter as you view the masks. Since the camera remains set on "B" throughout the procedure, you must view the filter not on the camera, but by holding it before your eye. Remember that any overlap of colors during the masking process will blend those colors. If opposite colors, like red and green, are allowed to overlap, the area will become gray or black, depending on the exposure variation used.
7. Refer to the exposure test showing the degrees of saturation of-

fered by various exposures on each color filter, and choose the exposure for the color saturation needed.
8. Expose the first mask combination with the first filter. If you are using strobe for the exposure, it is necessary to manually trigger the strobe while the camera remains on "B," replacing the lens cap after exposure.
9. Proceed to make each exposure on the selected mask combination with the selected color filter. When the final exposure is complete, release the camera shutter, and advance the film for the next set of exposures.
10. Be sure to keep careful and complete notes on each step of the process. This is, as I have said before, a most time-consuming process. Impatience leads to mistakes, however, and it is necessary to invest the time for a good result.

I always use Kodachrome 25 to make the final posterized image. Prints are ineffective in comparison. I have the added incentive of being able to use the 35mm transparency that results, either in my portfolio, or with my stock agent for future sale of rights. Should it be necessary to have a print, one can be made easily enough from the transparency.

At a *Focus 2000* workshop, one of the participants and I discussed ways of using X-rays photographically. Some time later, I was delighted to receive a selection of discarded X-rays from this friend, and I decided to do something out of the ordinary with them. I wanted make a portfolio piece to show my pharmaceutical clients, demonstrating the exciting visual possibilities in an otherwise ordinary X-ray image. Posterization was an ideal technique to provide the black and white graphic X-ray with glowing, vibrant color. The portfolio piece did bring me additional pharmaceutical work, and rarely fails to make the viewer remark on its visual impact.

There've been no secrets kept in this book; the whole bag of tricks is open in your hands. Of course, while you're reaching in for a closer look, I'm working on a new bag! The only thing I can't share with you is my next idea—because I'm not aware of it yet myself. After playing with my bag of tricks, though, you should have a few ideas of your own. Explore them. Use them. Enjoy them. Especially, share them. Everyone likes a good bag of tricks.

INDEX